# CREATIVE
# PHOTOGRAPHY

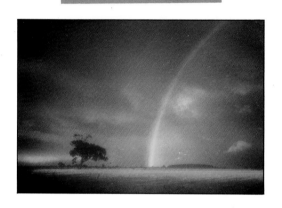

# RD HOME HANDBOOKS

# CREATIVE PHOTOGRAPHY

Contributing editor
## Michael Langford

The Reader's Digest Association, Inc.
Pleasantville, New York

This is an RD Home Handbook
specially created for The Reader's Digest Association, Inc.,
by Dorling Kindersley Limited

First American edition, 1991
Copyright © 1991 by Dorling Kindersley Limited, London
Text copyright © 1980, 1981, 1982, 1991 by Michael Langford
and Dorling Kindersley Limited, London

Published in the United States
by The Reader's Digest Association, Inc.,
Pleasantville, N.Y.
Published in Great Britain
by Dorling Kindersley Limited, London
Printed in Singapore

Designed by Phil Kay Design,
Ickleton Road, Elmdon, Saffron Walden, Essex CB11 4LT

Library of Congress Cataloging in Publication Data

Creative photography / contributing editor, Michael Langford.—1st
    American ed.
        p.       cm.—(RD home handbooks)
    Includes index.
    ISBN 0-89577-379-1
    1. Photography.    I. Langford, Michael John, 1933–.
II. Reader's Digest Association.    III. Series.
TR146.C775   1991
771—dc20                                          90-23348
                                                      CIP

# CONTENTS

# INTRODUCTION

Photography is an active and creative medium. At a basic level, using a simple, automatic camera, the photographer must make decisions about the content and composition of a photograph. At an advanced level, photography offers a vast range of creative possibilities. This book explores the world of photography from the practical details of the equipment to the widest range of its uses.

In its early years photography suffered from the fact that it combines elements of both art and science. Today most people agree that it can be both. Photography is a medium – it is the person who determines the balance between its art and its science in the images produced.

Combinations of seeing and recording skills are required in the use of all visual media. In photography you must have some practical knowledge of equipment and materials, as well as a grasp of compositional guidelines, if you are to exploit the camera's possibilities. In the early days of photography, the technical aspects were awesome and limiting – it was necessary to place cameras on stands, to make complex exposure calculations, and to master lengthy darkroom processes. In contrast, today's cameras are easy to use.

Sophisticated modern equipment and films now make picture-taking possible under almost any conditions. Because of this the photograph has become an important medium, whether in books or magazines, on television, or in exhibitions, and there is now a sufficient body of work available to see what a vast range of subjects and approaches is possible.

**Finding pictures**
*It is important to look at ordinary things in terms of color, texture and form.*

The photographs we take do not have to resemble those taken by other photographers any more than our expression of personality through choice of words, dress, or decor must be similar to that of other people around us. Remember that photography should be enjoyable. Technicalities and rules should enable you to take the photographs you want, not restrict your freedom. It is important to know what you want from a photograph: whether you are taking family snapshots or creating special effects, there is little point in using a technique just for the sake of it.

This book tells you all that you need to know in order to both improve the quality of your shots and take your own individual style of photographs. *Cameras and Equipment* gives information on the camera types and accessories available, explaining how they work and what their main uses are. *The Art of Photography* deals with taking the picture itself, starting with the ability to see what will make a good shot and the way in which different camera controls will affect the look of the picture. The rules of composition, the use of light and color, and how one might use different equipment in different circumstances are examined. *Photographing Different Subjects* outlines the different approaches and techniques that are appropriate for areas such as landscapes, wildlife photography, and taking portrait shots of people and babies. *Processing and Printing* covers everything you need to know in order to develop your own pictures, giving you complete control over the results. The *Special Effects* chapter tells you how to use all of the equipment and techniques detailed in the rest of the book, from lighting set ups to the darkroom, to achieve "unreal" results. At the end of the book is a guide to identifying and correcting faults, and a glossary which explains the more technical terms of photography.

**Simple composition**
*Experimenting with different approaches, while also keeping basic guidelines of composition in mind, will help you to make the most of a subject.*

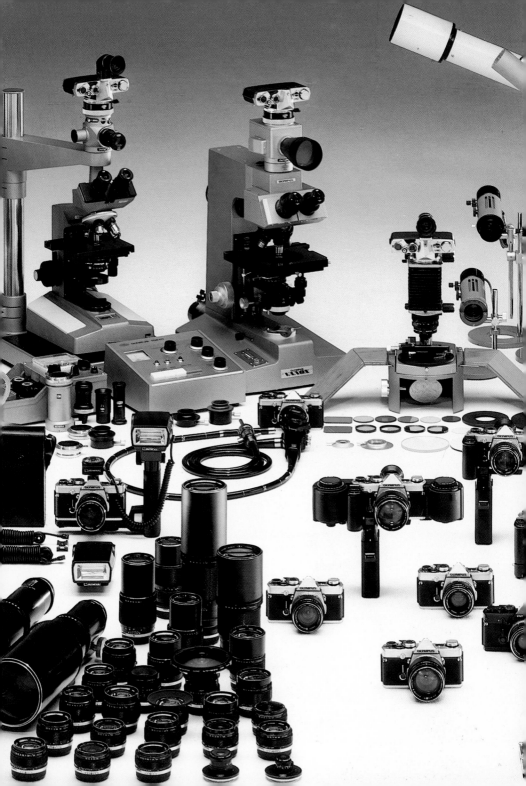

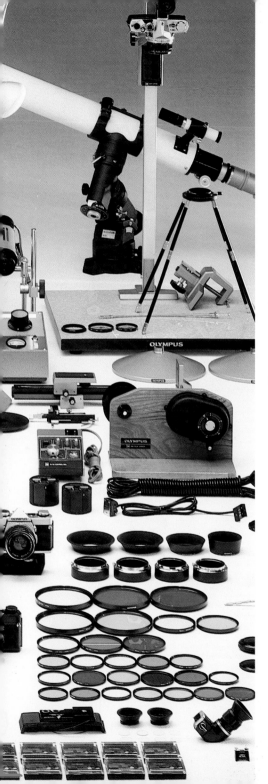

# CAMERAS
# AND
# EQUIPMENT

This section is concerned with the "machinery" of photography – equipment by which you control what you see in the viewfinder and translate it into film image. Cameras, which were once large, primitive wooden boxes, have become diminutive devices packed with electronics. Optical, electronic, and engineering advances have been perfected to the level where cameras are so ingenious that even a novice can take exceptionally good pictures. The functions of cameras, films, lenses, lighting, and general photographic accessories are explained in detail, and features are compared from the point of view of the accuracy and control of visual results they make possible.

**Complete camera system**

*This 35mm system offers a wide range of equipment. There are several cameras, with varying degrees of automation. The accessories include close-up equipment, bulk backs, motor drives, and different types of flash unit. Lenses range from fisheyes to telephotos and zooms. Professionals can buy or rent equipment for using cameras with microscopes and telescopes.*

# Camera principles and parts

Looking at the range of cameras available, it is easy to be confused by the diversity of models and formats, all offering different features. But to understand how light is directed to the film surface, most of the refinements must be stripped away, leaving the features essential to all cameras.

Basically, every camera is a light-tight box, holding light-sensitive film at the back, and fitted at the front with a hole covered by a lens. The lens elements may be fixed in one position, which greatly limits the lens's ability to focus selectively on different parts of an image. In other cases the lens may shift forward or backward to focus on objects at varying distances.

A hole, or aperture, in a diaphragm just behind the lens helps to control the brightness of the image. This is usually variable in size, so that it is possible to select a small hole in bright lighting conditions or a larger one in dim light.

Somewhere in any camera there must be a shutter. This prevents light from the image from reaching the film until the photographer is ready to shoot. The shutter also controls the length of time that light is allowed to act on the film. With all but the simplest cameras, there is a choice of several shutter speeds.

Despite these basic similarities, modern cameras offer many extra features. These range from automatic light measurement and exposure setting to interchangeable lenses, powered film wind-on, and auto-focusing. A number of cameras are completely automatic in their technical settings but, in practice, this tends to limit creative photography options.

---

## THE CAMERA AND THE HUMAN EYE

In several respects the photographic camera and the human eye are quite similar. The eyeball has a clear lens at the front, behind a transparent outer layer, the cornea. It is able to focus an image on the back of the eye – a light-sensitive network of millions of cells called the retina – just as a camera lens focuses an image on a film. A pigmented iris situated near the lens slowly enlarges or reduces its effective diameter in response to changes in lighting conditions, in the same way that a photographer changes aperture size on a camera.

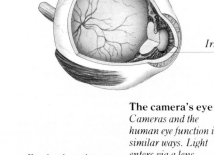

*Retina* — *Cornea* — *Iris*

**The camera's eye**
*Cameras and the human eye function in similar ways. Light enters via a lens (cornea and lens in the eye) and passes through a diaphragm (iris), which expands or contracts to regulate it. Now focused, light reaches the film (retina), in the case of the camera by means of a shutter. Cameras also have a viewfinder as a sighting device.*

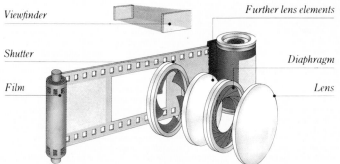

*Viewfinder* — *Shutter* — *Film* — *Further lens elements* — *Diaphragm* — *Lens*

# The viewfinder system

Each of the main camera types has a different form of viewfinding. The simplest is a tube-like optical sight built into the camera body close to the lens. Since the photographer looks through it directly at the subject, this is known as a "direct vision" viewfinder. The other system is "reflex" viewing, in which a mirror reflects light from the lens itself to a viewing screen.

The direct vision viewfinder is both cheap and compact, but because it shows the subject from a viewpoint slightly to one side of the lens, it is not very accurate. This can be deceptive in tightly framed scenes, and the degree of viewpoint error increases as the subject nears the camera.

In a single lens reflex (SLR) camera, light coming through the lens is reflected up by a mirror, through a prism, to the viewfinder. The mirror flips out of the way to expose the film when pictures are taken.

Twin lens reflex (TLR) cameras allow you to see the image through a separate top lens, which is identical to the picture-taking lens. This system is excellent for focusing but has the same drawbacks as direct vision.

Sheet film cameras give absolute accuracy of both framing and focus. Light travels directly to a focusing screen, which you must replace with a film holder containing a piece of sheet film for every exposure.

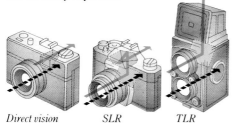

*Direct vision*        *SLR*        *TLR*

*Sheet film camera*

**Viewfinders**
*Only in SLR and sheet film cameras does light reach the viewfinder (blue line) through the lens, as light reaching the light-sensitive emulsion (broken line) does.*

# The lens

You can think of the simple converging lens as a magnifying glass. If you look at an image formed by a magnifying glass, though, you will see that it has several defects. When the center is sharp, the image around the edges is blurred and distorted, and there is a general mistiness about the whole scene.

Camera lenses may consist of many elements arranged in groups – often six or

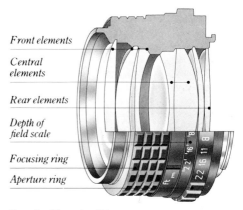

*Front elements*

*Central elements*

*Rear elements*

*Depth of field scale*

*Focusing ring*

*Aperture ring*

**Standard lens for 35mm cameras**
*This typical design makes use of both converging and weaker diverging elements. Precise optical engineering must be allied to a sufficiently rugged construction to withstand a normal amount of wear and tear.*

more pieces of glass. This complexity is necessary to correct the optical errors associated with a single, simple lens.

A camera lens can capture sharp detail provided it is at the right distance from the film plane. Once this distance is correctly set to give a sharply focused image of a distant object, the distance between the lens and image is called the focal length of the lens.

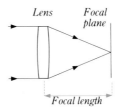

*Lens*    *Focal plane*

*Focal length*

**Focal length**
*The lens converges subject light to a point of sharp focus on the focal plane. With a simple lens and a distant subject, the lens-to-plane distance is called focal length.*

## Lens design for different cameras

The requirements of lenses for different format cameras vary greatly. Much has to do with the area to be filled, the weight and size of the lens itself, and the degree of enlargement of the resulting film image.

### Simple and complex lenses

*Lenses for very basic cameras, with limited picture-taking ability, may have equally basic optics. The simple 110 pocket camera (top) has just a single plastic lens. The lenses of quality 35mm and sheet film cameras (center and bottom respectively) are designed to give brighter, more detailed images. Such lenses have several elements, each of which plays a part in controlling specific aberrations, but they still form a converging lens when they are combined.*

## Different lenses

The angle of view of a lens depends on its focal length and the size (measured across the diagonal) of the picture format. Standard lenses have an angle of view of about 40°–45°. To capture a larger scene you will need a lens with a short focal length (wide-angle), and to concentrate on distant objects a lens with a long focal length (telephoto) is necessary. One option is a dual lens, in which some elements move, and others slide in to change the focal length. Another is a zoom lens, which can be adjusted to any point in a given range. These are built in on direct vision cameras. On other types the standard lens can be removed and another put in its place. This allows the camera to take a variety range of lenses, or a zoom lens, to suit every situation.

The immediate effect of changing to a wide-angle lens is that more of the subject appears on the focusing screen, with everything made slightly smaller. Foreground detail is increased, and perspective steepened.

The characteristics of telephotos are the same as for all long focal length lenses. They magnify the image, narrow the angle of view, and tend to flatten perspective.

With a zoom, you have available a continuous range of precise focal lengths between the longest and shortest extremes of the particular lens, rather than the separate focal lengths that are associated with changing from one fixed – length lens to another.

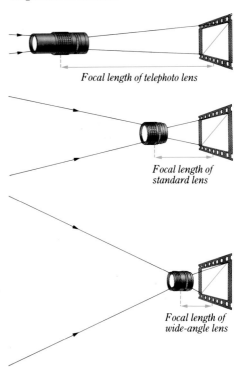

*Focal length of telephoto lens*

*Focal length of standard lens*

*Focal length of wide-angle lens*

### Focal length and angle of view

*The focal length of a standard lens is similar to the format diagonal. Lenses with longer or shorter focal lengths must be placed farther from or nearer to the film to focus the image, and give a narrower or wider angle of view.*

## FOCUSING THE LENS

Most camera lenses cannot focus on very close and very distant objects at the same lens-to-film setting. Simple camera lenses are often fixed in a position that will bring into sharp focus most of a scene in front of the camera.

Most cameras now, however, allow you to focus the lens. This may be indicated by a scale of distances, or a number of preset symbols.

Viewfinder screens will often have indicators built in to help you to see when the lens is focused. Some cameras also offer automatic focusing systems.

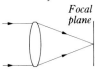
*Distant subject*
*Focal plane*

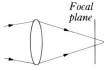
*Near subject unfocused*
*Focal plane*

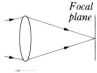
*Near subject focused*
*Focal plane*

*Lens moves away from focal plane*

**Focus and subject distance**
*Light from a distant subject (top) travels in near-parallel lines, and is brought to focus at the film plane. With the lens in the same position (center), diverging light from a source nearer the camera would, however, be brought to focus at a point behind the film plane. Therefore the lens has to be moved nearer the subject (bottom), so that light can be focused on the film plane itself. A lens with an adjustable focus control allows you to compensate for subject distances, within the constraints of that lens.*

## Split field circles
With this type of screen the image detail in the central circular area appears split in two when the image is out of focus. As you correct focus, the two halves come together.

**Split field** (right)
*A double wedge in the focusing screen has two intersecting surfaces. When light is unfocused (right), the image appears discontinuous, or split. Focused sharply on the plane where the surfaces meet (far right), the image that appears in the viewfinder is seen as continuous. At this point the subject will be captured on film as a clear, sharp image.*

## Microprism rings
Many screens have a microprism ring around the central area. This breaks up the image into a shimmering pattern until focus is perfect, when the ring becomes clear.

**Microprism** (right)
*In a ring surrounding the split image is a group of microprisms. Unfocused light disperses in a shimmering effect (right), appearing as a cluster of points. Accurately focused light is sharply defined as single points (far right). The ring area of the focusing screen will show the subject or scene clearly, and a sharp image will be recorded.*

## Rangefinder systems
Some direct vision cameras use a rangefinder viewing system. This produces either a double or a split image in the viewfinder when the image is out of focus. As you adjust the lens focus control to the correct setting, the two images come together into one.

*Unfocused*          *Focused*

*Unfocused*          *Focused*

**Rangefinder focusing**
*The eye sees the subject directly through the viewfinder. Light also enters a rangefinder window. From here it is reflected by a mirror, which pivots as the lens is focused, into the viewfinder. You see a double or split image (above left) until focus is correct, and the two images are superimposed (above right).*

## Autofocus lenses

Some cameras have fully automatic lens focusing systems. There are three main ways in which a lens can "sense" a particular subject distance – either by comparing contrast, by scanning with invisible infra-red radiation, or by measuring with sound waves.

Contrast-comparing autofocus works in a way similar to an optical rangefinder. The autofocus unit gives one fixed view of the subject, and another via a pivoting mirror linked to the camera's lens focusing control. Both views are projected on to light-sensitive electronic panels. These compare the patterns of light and dark, and halt the lens movement when the image contrasts are identical. The lens starts off in the infinity position (close to the camera body), but then moves forward as you begin to press the shutter release until it is halted by the "in focus" signal.

Infra-red (IR) autofocus systems send out a narrow beam of invisible IR light from one window and use a pivoting mirror to scan the scene. Another window, backed by an IR detector cell, acts as a receiver for the beam reflected by any subject within the system's target area   as outlined in the camera viewfinder. Depressing the shutter starts the scan, and then both the mirror and the lens movements stop when the strongest signal is received by the detector.

The ultrasonic system uses inaudible 1/1000sec "bleeps". A transmitting disk sends out the signal and a timing circuit measures how long it takes for the sound to reflect back from the nearest object in the scene. The unit controls a rapid-drive motor which shifts to focus the lens.

## The aperture

Apart from lens focusing, the other major control found on the lens varies the size of the lens aperture. On inexpensive cameras, the aperture control may simply shift a piece of metal containing holes of different sizes across the back of the lens. However, more elaborate cameras have a series of blades, called an iris diaphragm, that reduce the aperture.

Over the years an internationally agreed scale of "f numbers" has been devised, and appears on virtually all iris diaphragm controls. The higher the f number the smaller the aperture: f16 is one-sixteenth the focal length of the lens, whereas f4 is one-quarter.

### Aperture control

*As the aperture increases in size, more light is admitted and the image becomes brighter on the viewing screen. Each f stop on a rising scale (usually between around f2 and f16) halves the amount of light entering the camera. On a descending scale, the amount of light is doubled at each stop.*

*Wide aperture*

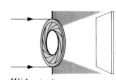
*Small aperture*

## The shutter

A shutter must let light pass to the film and act evenly on it for a precisely measured time. Shutters on the simplest cameras have a single, spring-loaded blade, or a rotating disk with a cut-out section, called a sector shutter.

### Leaf or bladed shutters

Multibladed lens shutters have cutlass-shaped, thin, metal leaves that swing open or shut when a ring is rotated. A spring controls the opening and shutting stages, but there is an adjustable pause between the two. These shutters are most often used on 35mm compact cameras and rollfilm TLRs. Sheet film cameras also have leaf shutters.

1    2    3

**Leaf shutter**
*These shutters are built into the lens itself. The rotation of the ring moves the leaves out of the way. Counter-rotation closes the leaves after exposure.*

## Focal plane shutters

Focal plane shutters operate as close as possible to the film surface. Most of them consist of a pair of opaque fabric blinds. The blinds follow each other across the film surface, forming a gap between them that allows light to expose the film. Focal plane shutters have a constant blind speed, and you vary exposure by altering the width of the slit between the blinds. The narrowest slits give the fastest speeds. At about 1/60sec the slit becomes as wide as the picture format itself.

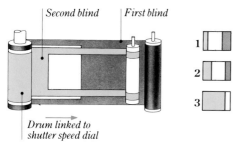

*Second blind*     *First blind*

*Drum linked to shutter speed dial*

### Focal plane shutter
*Two blinds, located immediately in front of the film, follow each other in sequence according to the speed setting. Some blinds travel vertically.*

In 35mm cameras fabric focal plane shutters move horizontally. A growing number of these cameras now use focal plane shutters with two or three metal blinds, traveling vertically. Since the blinds cover a shorter distance, the shutter can be more compact and rapid.

### Shutter speed

Like the aperture scale of f numbers, there is a universally adopted series of shutter speed settings. Each change of setting either halves or doubles the time the shutter remains open.

The simplest cameras with sector shutters may have only two speeds, marked in weather symbols, or linked to "film type" settings. Leaf or bladed shutters tend to have a maximum speed of 1/250sec or 1/500sec. Most focal plane shutters have a fastest setting of 1/1000sec and a slowest speed of 1sec. For longer times you select the setting marked "B" and keep the release depressed for as long as required. The fastest speed safe to use with flash is marked clearly on the dial.

# Film transport systems

The most popular film sizes are 110, 35mm, and 120 rollfilm. There is also a range of sheet film sizes. In general, the larger the film size the better the quality of the final result.

110 film comes in a plastic cartridge, ready to drop straight into the camera. After the last exposure, you remove the whole cartridge. With 35mm film, you position the film on one side of the camera and attach the end of the film to a fixed "take-up spool" at the other side. After the last exposure you wind the film back into the container before opening the camera. Rollfilm is wound up inside opaque backing paper. You fit the roll in one side of the camera, and attach the start of the paper to a spool on the other. After the last exposure, all the film and paper will be on the take-up spool, which you can remove for processing. Sheet film is loaded singly in a special holder.

*35mm film*     *110 film*

*Rollfilm*     *Sheet film*

### Film loading
*35mm film is loaded into one side of the camera, and rewound after exposure. 110 cartridges simply drop into the camera and do not need rewinding. You load rollfilm into one side of the camera, and wind it across. Sheet film is loaded in darkness in a holder.*

# Camera types

Although basic camera types have changed very little over the years, there are many different styles. Simple "aim and shoot" fixed focus cameras are the easiest to use, but do not always produce the best pictures. 35mm format cameras now range from sophisticated automatics to manual versions which give the photographer complete control. At the other end of the spectrum are the latest hybrid cameras and still video cameras.

## 110 cameras

110 cameras are basic, take-anywhere models, mostly with fixed focus and exposure, which you load with a drop-in cartridge. They take shots one-quarter the size of standard 35mm format negatives or slides, so pictures are less sharp, as enlargement shows up the film's structure and exaggerates any blur from camera shake.

The 110 format is commonly used today in disposable cameras. These are cheap plastic bodies, purchased already loaded with the film. The whole camera is sent for processing.

## 126 cameras

These are fairly basic cameras for casual photography, which take square pictures of almost the same area as regular 35mm format. Film comes in drop-in plastic cartridges. These cannot position the film with the precision of a 35mm camera, however, and image quality is poor as a result.

Often, only one exposure setting is possible, so you must always either take your photographs in strong daylight, or use flash.

## Disc cameras

These are pocket size, and take a flat disc of film that records fifteen very small exposures. The format lends itself to a shallow camera design with a direct viewfinder, and the lens is usually fixed focus. This sharply records subjects down to about 3ft (1m). Some disc cameras make light readings and exposure settings automatically, cover a wide range of conditions, and give fast wind-on after each shot, but image quality is poor.

# Instant picture cameras

Polaroid instant-picture cameras allow you to see results immediately. Prints are the same size as the image formed inside the camera, so cameras are relatively bulky. A typical print measures 3 × 3in (76 × 76mm).

Instant picture cameras have a direct vision viewfinder. Some models have autofocus; some, fixed focus. Light readings and exposure settings are automatic but most models offer darken/lighten controls.

Image quality is good, but pictures will fade in the light.

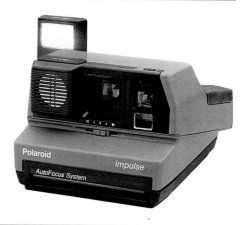

# Basic 35mm direct viewfinder cameras

A basic, direct viewfinder camera combines the advantages of 35mm format with compact, low-cost equipment. Each shot is framed in the viewfinder window, just above the lens, by looking into an eyepiece at the back of the camera. You set the subject's distance on a scale around the lens in those models that permit focusing. Even inexpensive models now often have built-in flash, as well as a degree of automatic exposure setting.

Cameras of this kind have few settings: the lens aperture and shutter speeds have such a

narrow range that it is impossible to obtain good exposures in extreme lighting conditions. The camera's tiny flash unit will only properly expose subjects up to a few yards away.

# Automatic 35mm direct viewfinder cameras

Automatic 35mm cameras with a direct viewfinder have sophisticated features, yet there is no need to know about technicalities.

The light sensitivity of the loaded film is communicated from code strips on the container to the camera's exposure meter. Film is automatically advanced and rewound.

The lens autofocuses down to about 2½ft (76cm), and subjects must be positioned in the center of the frame – although some models can lock focus on off-center subjects. A zoom or dual lens gives a choice of focal lengths.

Lenses on automatic cameras have fairly wide apertures, and a range of shutter speeds. Some cameras automatically fire their flash in dim light, others allow you to turn it off.

# Manual 35mm SLR cameras

You load a manual 35mm single lens reflex (SLR) camera with the film and wind until '1' appears in a window. In a number of models, the speed rating (ISO or ASA number) of the film has to be set on a dial. Then, looking through the eyepiece, you frame and focus the subject or scene.

Unlike a direct vision camera, with an SLR there is no difference between what is seen by the lens and what appears in the viewfinder.

The distances from lens to focusing screen and from lens to film are identical, so that everything seen as sharp or unsharp through the viewfinder will appear on film in the same way. You can change the regular lens for one with a different angle of view (wide-angle or telephoto) even in mid-film, and be able to see precisely how the subject will appear in your final picture.

SLRs accept a wide range of accessories – dozens of different lenses, close-up devices, motor-drive, extra capacity film backs, and so forth. A manual SLR allows greater control of results than an automatic version, but requires an understanding of some of the technicalities of photography, such as calculating exposure.

Manual SLRs do not necessarily cost more than automatic direct viewfinder cameras, but tend to be larger and heavier. Their versatility and the level of control that they offer make them a better type of camera for learning photographic techniques.

# Advanced 35mm SLR cameras

Advanced 35mm single lens reflex (SLR) cameras use the same principles as do manual SLRs. In addition, they offer features that exploit microelectronics: sensors, linked through computer programming, control motor driven mechanisms. An advanced SLR can be programmed in many ways to best suit subject shooting conditions or your preferred way of working. You select a mode, like choosing from a computer program menu. For example, lenses automatically focus rapidly on the main subject, and it is possible to set the camera to take a shot only if a subject is in perfect focus.

Metering modes measure light from the subject in various ways – over most of the picture, from one small chosen area, or between the brightest and darkest parts.

There are also different exposure modes. You can select a specific shutter speed and leave the camera to adjust the lens aperture, or you can pick an aperture and let the camera set the shutter speed. Another mode leaves the camera to set both the shutter and the aperture. Programs often adjust themselves to suit the lens being used, and most advanced SLRs will automatically sense film speed.

Motor drive and automatic rewind are available, as well as electronic flash that couples with the camera's autofocusing and exposure circuitry. Some cameras allow you to

shoot a rapid "burst" of three to four frames, each given a slightly different exposure.

Most of the functions of advanced cameras rely on battery power. Battery failure will therefore disable your equipment. Another disadvantage of a highly technical camera is that it may be a source of confusion or missed pictures if you do not understand its modes. You may be paying for features that you never use. On the other hand, an advanced camera is adaptable to different levels of expertise, and therefore very versatile.

## Rollfilm cameras

Rollfilm cameras give a picture three to five times larger than regular 35mm cameras. Consequently, definition and tone qualities in both prints and slides are better. Rollfilms produce pictures 2¼in (6cm) wide by 1¾ to 3½in (4.5 to 9cm) long, according to the size of the camera.

Most rollfilm cameras are box shaped, with an interchangeable lens in front and a focusing screen on top. Most models feature removable camera backs which you load with film. If you have several camera backs, you can switch between different film types (color and black and white, for example) at any time, even in the middle of a roll. Rollfilm cameras are designed with either direct vision, SLR, or TLR viewfinder systems.

Direct vision rollfilm cameras provide manual settings of focusing, aperture, and shutter speed. Electronic features, if any, are mostly limited to a built-in light meter. There is often an optical rangefinder focusing aid.

A few rollfilm SLRs look like scaled-up 35mm SLR cameras. Controls are located in the same positions as on any manual SLR. Cameras like this, however, do not use interchangeable backs.

The TLR rollfilm camera has two matched lenses, mounted one above the other on a panel. Distances between the top lens and focusing screen, and the bottom lens and film, are always identical.

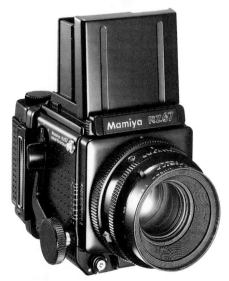

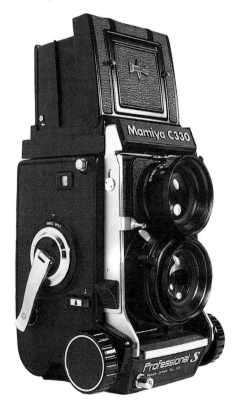

# Bridge cameras

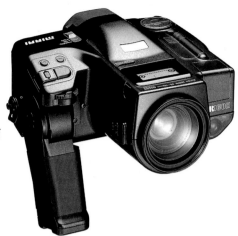

These 35mm cameras combine some of the controls and features of an SLR with the convenience of a direct vision camera. Each model has an unconventional shape, contoured to fit the human hand. Most of these cameras are SLRs, but without lens interchangeability, manual control, or the multi-program options of conventional SLR cameras.

The camera has a minimum of controls for shooting, lens zooming, and film transport – using buttons that fall naturally under the fingertips. There is built-in flash, plus a good range of automatically selected shutter speeds and aperture settings.

# Weatherproof and waterproof cameras

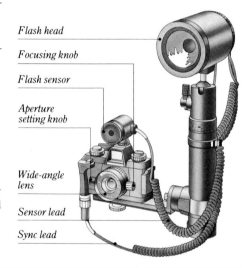

*Flash head*

*Focusing knob*

*Flash sensor*

*Aperture setting knob*

*Wide-angle lens*

*Sensor lead*

*Sync lead*

Special 35mm direct-viewfinder cameras have moisture-proof bodies and sealed controls. These "weatherproof" cameras can be taken safely into the rain – but not underwater, where there is added pressure.

Waterproof cameras can be submerged completely for underwater photography, although only down to specified maximum safe depths, which vary from camera to camera.

Most weather- and waterproof cameras now have automatic focusing. Others offer a manual focusing scale, marked in oversize figures for easy visibility. There may be a form of automatic exposure, and flash is often built in.

# Panoramic cameras

In these cameras, a pivoting lens scans across a scene, and gives a long, narrow picture. Usually this includes 180° of horizontal detail, although some cameras record a full 360°.

The film is 35mm or rollfilm according to the model, and is exposed through a vertical slit at the rear of a drum containing the lens. When you press the shutter button, the drum rotates on a vertical axis: the lens scans the scene and the slit sweeps across the film.

Panoramic cameras have a direct viewfinder, and there are manual controls for aperture and shutter. A spirit level is a likely feature.

# Leica (M series) cameras

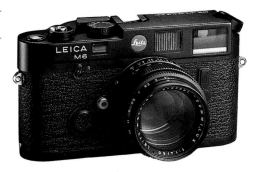

The M-series Leica is a precision-made 35mm direct vision camera that accepts a range of interchangeable lenses in the same way as a single lens reflex camera.

Lenses range from a 21mm wide-angle to a 135mm telephoto, and when a lens is fitted the viewfinder frame lines automatically change to show the limits of the picture – except for the 21mm lens, which needs a separate finder on top of the camera. The Leica has a rangefinder focusing aid.

Camera electronics are limited to an exposure meter – either an accessory that clips on to the top plate or a built-in type reading through the lens. The latter detects light reflected from a white zone on the shutter blind. An exposure readout system in the viewfinder signals when the right shutter speed and lens aperture have been set.

The Leica is really a specalist camera, and all the equipment is extremely expensive. Because it is quiet and compact it is popular with those professionals who specialize in candid photography and reportage work. It is also a collectors' camera.

# Electronic still video cameras

Still video cameras do not use film. A light-sensitive electronic image sensor takes the place of the film, and reads a color exposure as a stream of signals that are magnetically recorded – typically, on to a spinning 2in (5cm) floppy disc within the camera body. The disc can contain 25 pictures. A few cameras record on to a stationary "smart card."

A disc or card is insensitive to light, and can be removed at any time. You can replay picture-by-picture on to a television screen wired direct from the camera, or use a replay unit similar to a video cassette recorder.

Still video cameras are either direct viewfinder or SLR designs. Direct viewfinder types have a flat body similar in size to a pair of binoculars, and the standard lens has an 11mm focal length. A built-in rechargeable battery powers the image sensor, recording system, and other camera circuits. The camera can also be run, via a charger unit, directly from a household electric supply.

Buttons on the camera select record or replay, flash or no flash, extra exposure for backlit subjects, selective erasure of unwanted recorded frames, and single or continuous shooting. The camera is programed to record a shot on the next available track or card space, automatically skipping any recorded picture not earmarked for erasure.

The running costs of still video cameras are very low, and the results can be viewed on a television immediately after any shot. All "after processes" can be electronic, and color or tone changes and special effects are possible through the use of an electronic console, instead of working in a darkroom.

Image resolution is poorer than that of the most grainy film, especially if you want a result on paper rather than on a television screen. Models that record on to rotating discs need about one second to run up to proper speed before you can shoot.

# Accessories

Today's cameras are complemented by a range of accessories. There are meters to help you to calculate exposure, tripods and clamps to prevent camera shake, automatic shutter releases, attachments for close-up work, and motor drives for action photography. Be careful when choosing your accessories, as some of the attachments available are intended for more specialized work and may be of little use in everyday photography. Close-up equipment, for example, can be expensive, and is limited in use unless this area is a particular interest of yours. A great many other items, however, can be used to make general photography much easier, and to extend your range as a photographer. Tripods, in particular, are almost indispensable. In general it is best not to buy a whole range of accessories at once, but to build up your stock of equipment gradually, buying each new item as you find that you need it. Some other items are essential for protecting and cleaning your equipment when it is not in use.

contrasty scenes, or backlit subjects, it can be very inaccurate. Override devices such as exposure compensation and exposure holds can help this problem, but are not always fully accurate. An off-camera meter provides the answer. It allows you to make highly selective exposure measurements, using either reflected or incident light readings, or a combination of both. Once you have set the appropriate film speed on the meter you can read the recommended exposure settings from the calculator scale.

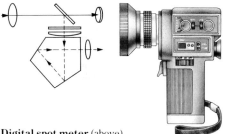

**Digital spot meter** (above)
*This silicon cell meter uses an SLR system. Subject angle of view is 9°, but readings are taken from a center spot with a 1° angle of acceptance. A digital display in the viewfinder shows the exposure value, while f stops are shown digitally on the meter body.*

**Light-meter mechanism** (below)
*These meters contain a light-sensitive substance that shows resistance to the light striking it. The meter measures this, and calculates the light level from it.*

## Meters

Built-in camera metering is most reliable with frontlit scenes of even brightness. With more

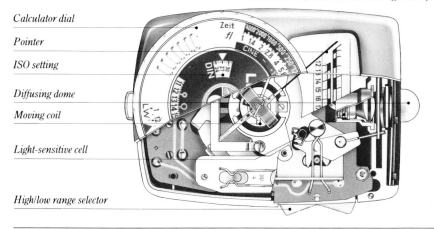

*Calculator dial*

*Pointer*

*ISO setting*

*Diffusing dome*

*Moving coil*

*Light-sensitive cell*

*High/low range selector*

# Camera supports

Camera supports come in all sizes – from simple hand grips to giant, heavy-duty studio stands. Choice depends on the size and weight of your camera equipment, the height at which you wish to work, and the value you place on the portability of your equipment.

## Tripods
The smallest tripods are table-top models. These have folding legs, and are very compact. You can set them up on a table, stairs, or on top of a wall.

The lightest full-size tripods seldom have a center column, and at maximum height the top may become slightly shaky. But these tripods are light to carry and fit into most gadget bags. Medium-weight tripods often have braced legs, and an adjustable center column that is useful when you are making small final height adjustments. Sometimes the center column will reverse, so that you can attach the camera upside down, very close to the ground.

It is essential to use a tripod head that gives you adequate control over camera position.

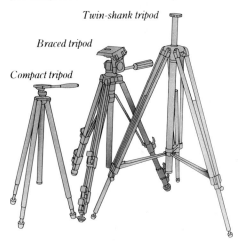

*Twin-shank tripod*

*Braced tripod*

*Compact tripod*

## Tripods
*Compact tripods are easily carried but are unsteady in high winds or when used with heavy cameras or lenses. Braced models are more stable. Twin-shank tripods are sturdiest, but they are also heavy, and awkward to carry around.*

## Additional support
*With very long, heavy lenses you may need, in addition to a sturdy tripod, the extra support of a monopod, as here, or a second tripod under the end of the lens.*

The simplest tilting top is a ball-and-socket head that you can lock at any angle. (A large one is suitable for a small camera placed on a table-top.) The most usual head is a "pan-and-tilt" type.

## Tripod heads
*The simplest tripod is the ball-and-socket head. Pan-and-tilt heads are useful for normal work. Use a balance head for maximum precision.*

*Ball-and-socket*

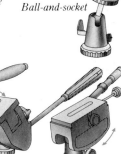

*Two-way pan-and-tilt*  *Three-way pan-and-tilt*  *Balance head*

## Hand grips
When a tripod is too bulky or heavy to carry, you can use one of a number of smaller camera supports. Hand grips are light and compact. Some types brace the camera like a rifle. Others resemble the handle of a pistol.

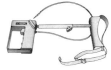

## Hand grips
*You hold the rifle grip (above left) as you would a shotgun – braced against your shoulder. Steadying the rifle grip requires both hands, so the rear grip incorporates* *a cable release. A pistol grip (above right) is held in one hand.*

# Automatic releases

You need not fire the shutter using direct finger pressure on the release button. Many cameras are equipped with a delayed action release, or you can trigger the shutter through a cable release. It is also possible to use a radio, light, or sound system, so that no direct, physical connection to the camera is necessary. With devices like these, you can take pictures at a considerable distance from the subject – provided that the camera is firmly supported and set for a particular viewpoint and focus. These releases are useful for studio work, and to prevent camera shake.

### Cable releases

The traditional cable release screws into the threaded shutter release socket found on all but the simplest cameras. As you press the plunger at one end, a piece of stiff wire protrudes from the other, and fires the shutter. Cable releases of this type are usually not longer than 3ft (1m). Twin and triple cable releases are also available, and allow you to use more than one camera at a time.

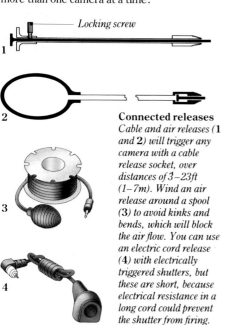

Locking screw

1

2

3

4

**Connected releases**
*Cable and air releases (1 and 2) will trigger any camera with a cable release socket, over distances of 3–23ft (1–7m). Wind an air release around a spool (3) to avoid kinks and bends, which will block the air flow. You can use an electric cord release (4) with electrically triggered shutters, but these are short, because electrical resistance in a long cord could prevent the shutter from firing.*

### Delayed action timers

Most modern cameras have a built-in delayed action shutter release. You operate the mechanical types by pushing down a lever and waiting for it to return slowly and trigger the shutter. Electronic delayed action timers are found on cameras with electronic shutters. Both types of timer provide a variable delay lasting between 3 and 12 seconds.

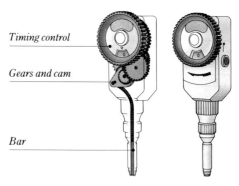

Timing control

Gears and cam

Bar

### Accessory delayed action timer
*If your camera has no built-in timer, you can screw an accessory delayed action timer into the cable release socket. The gears move around and push down a bar, depressing the shutter release. With the built-in kind, gears or electronic circuits pull down the release. Most modern cameras will have a built-in delayed action timer.*

### Remote control

With a remote control unit coupled to a motor drive you can fire the shutter from a distance. The control unit sends a radio signal to a sensor on the camera, which triggers the shutter. One disadvantage of this system is that there must always be a clear line of sight between the camera and the photographer, but they do work over considerable distances.

**Unconnected releases**
*Remote control shutter releases use a transmitter to send a triggering signal to a receiver supported in the camera hot shoe. The ultrasonic variety shown here works over about 33ft (10m).*

# Motor drives and power winders

Battery-powered motor drives are available for 35mm and rollfilm cameras. They link with the camera's internal film advance mechanism through contacts on the base of the body. There are three main types. The most sophisticated models give a continuous sequence of exposures at a firing rate of up to six frames per second. They also allow automatic advancing of individual frames.

Slightly less elaborate motor drives, often known as power winders, offer similar features but a slower firing rate – typically about two frames per second. Still simpler types do no more than advance the film, leaving the photographer to press the shutter release in the normal way. These types are generally called autowinders.

# Bulk film backs

Bulk film backs are useful in two major ways. Firstly, if you intend to take a large number of photographs over a short period of time, they allow you to buy and use film in bulk rolls, which lowers the cost per shot. Also, they remove the need to change films in difficult or unsuitable circumstances, such as during action photography, when a vital moment might be missed, or in bad weather.

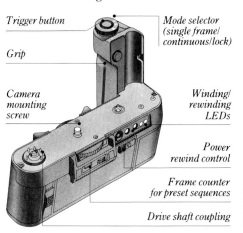

Trigger button

Grip

Camera mounting screw

Mode selector (single frame/ continuous/lock)

Winding/ rewinding LEDs

Power rewind control

Frame counter for preset sequences

Drive shaft coupling

**Motor drive**
*This battery-powered unit automatically adjusts its framing speed to the shutter speed and power source in use, up to a maximum of 6 frames per second. At this speed, you should use the mirror lock-up. This will minimize strain on camera mechanisms. You can also preset the number of exposures you want to make.*

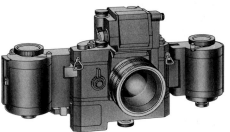

**Bulk film back**
*This film back is used in situations where it would be inconvenient to change film after every 36 exposures. It can be used for fast sequences, or set up and left to take single pictures over short periods of time.*

**Action photography**
*When the subject is moving fast, a motor drive allows you to take whole sequences of pictures one after another, without pausing to wind on. Many*

*photographers use this accessory for action photography, selecting the best frame for their needs later. Using a motor drive in this way consumes a large amount of film.*

# Types of lenses

As with all accessories, it is best to build up your range of lenses slowly. Start with a moderate (21–28mm) wide-angle and a short (100–135mm) telephoto, or similar zooms.

For other kinds of work you may find that you need lenses that have more pronounced effects, such as fisheyes and extreme telephotos, or ones with special qualities, such as mirror lenses. Some of these more unusual lenses can be rented, and it is a good idea to try them out in this way before you decide to buy. (For the uses and effects of different lenses see pp. 108–21.)

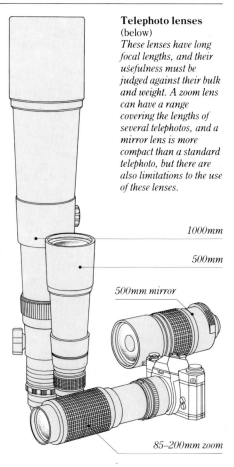

**Telephoto lenses**
(below)
*These lenses have long focal lengths, and their usefulness must be judged against their bulk and weight. A zoom lens can have a range covering the lengths of several telephotos, and a mirror lens is more compact than a standard telephoto, but there are also limitations to the use of these lenses.*

*1000mm*

*500mm*

*500mm mirror*

*85–200mm zoom*

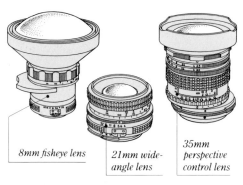

*8mm fisheye lens*   *21mm wide-angle lens*   *35mm perspective control lens*

**Wide-angle lenses** (above)
*These lenses may have additional features such as perspective control.*

# Close-up attachments

There are four main attachment types for close-up photography. The simplest is a reversing ring that allows the photographer to turn the standard lens back-to-front, spacing it farther from the film. This does not, however, allow you to vary the lens-to-film distance. Another alternative is to use a supplementary lens element placed over the standard lens.

Extension tubes are more flexible. They are tubes of varying lengths, which fit between camera body and standard lens. An extending bellows unit is more versatile still. It allows minute adjustment of lens-to-film distance.

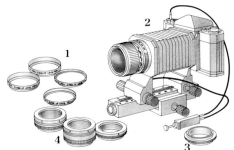

**Close-up attachments**
*Close-up lenses 1, auto bellows 2, reversing rings 3, and extension tubes 4 give different degrees of magnification and image quality. Bellows come out best on both counts, but are cumbersome, and cannot be easily hand held.*

# Filter systems

The traditional way to buy attachments is as round disks that screw into the thread on the front of the lens. The disadvantage of this system is that lens diameters vary, so you may have to buy adaptor rings for different lenses.

Several modern systems use square attachments instead. You must buy a holder with adaptor rings for different lenses, but thereafter one set of square filters and attachments will serve all lenses. (For the uses of different filters see pp. 122–7.)

With all attachments it is essential to use the correct lens hood. Holders accept a specially designed slip-on hood, while circular filters take screw-on or push-on types.

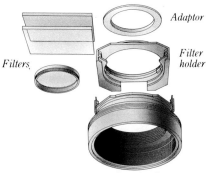

Adaptor

Filter holder

Filters

Lens hood

**Filter system**
*The system above features a holder that enables you to change filters quickly. You attach the holder to the lens with an adaptor ring, and then simply drop in the filters as you need them. The system comprises a wide range of square filters, and some circular types. These are the attachments, such as polarizers, that must be rotated in order to use them effectively.*

# Equipment for camera care

Like all precision instruments, cameras and other photographic equipment require constant care and protection if they are to continue to give high-quality results. Camera care is, however, merely a matter of following a few simple guidelines.

If you want to clean a lens, remove dust first with a camel hair brush or canned compressed air. Then wipe over the lens gently with an antistatic camera lens cloth. *Never* breathe on the lens and wipe it with a handkerchief, as this will damage the surface coating.

Never move around with your camera unprotected. Use a cap to cover the lens or, better still, a camera case. Always keep lens caps on both ends of any lenses you are not using, and store them in their protective cases. As soon as you begin building your own camera system, a carrying bag will become essential. A shoulder bag with compartments is generally best. The internal divisions prevent items from bumping against each other, and the bag is compact and usually comfortable to carry – especially if the strap is wide. The bag should be water repellent, and large enough to allow for your system to expand and to accommodate a supply of film.

For a large-format camera system, a suitcase-type unit in aluminum is the best choice. These are sold with a solid foam interior, which you cut out with a sharp knife to form spaces for each item. Such a case

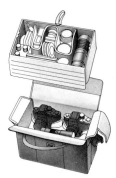

**Carrying case**
*If you use different combinations of equipment for different work, shape a separate foam insert for each. Carry only what you are likely to use.*

**Gadget bag**
*This shoulder bag has built-in compartments to stop your equipment from moving about in transit.*

undoubtedly gives the greatest protection, but is often heavy and uncomfortable to carry. A further drawback is that you have to lay the case down whenever you want to open it, so it is inconvenient to use when walking about.

# Lighting

S ince you cannot always rely on sufficient natural light, you will at some time need photographic lighting. This takes two forms: flash and studio lighting. Flash is portable, and there are a variety of units available. Studio lighting, as its name suggests, cannot be carried around, but it offers you greater control. (For guidance on using studio lighting see pp. 132–5.)

## Flash

An electronic flash can provide the cheapest form of artificial lighting, and the more you use it, the better the value. It will produce 250 to 300 flashes before you recharge or replace the battery. With manual flash guns you adjust the lens aperture to control exposure, but you can buy automatics which you can program to give the correct exposure for most subjects. There are also units that take information from the camera's sensors, which are known as "dedicated" flash units.

Most flash units are compact. Flash strength varies. Flash duration is normally 1/1000sec or less. This speed can freeze action, but you must select a shutter speed which allows the shutter to be fully open when the flash fires. On cameras with a focal plane shutter this may be as slow as 1/60 or 1/125sec, while on leaf or bladed shutters it can be as high as 1/500sec. (For uses of flash see pp. 128–31.)

### Manual units
Most manual units have fixed heads. You place them in the hot shoe fitting on the top of the camera. They usually have a simple calculator enabling you to gauge the aperture you require. Flash range will depend on the film

*Movable head*

*Calculator*
*Batteries*
*Hot shoe connection*
*Remote sensor*

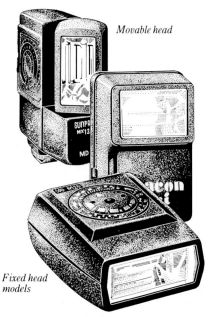

*Movable head*

*Fixed head models*

**Auto-flash unit** (above)
*An automatic flash unit has a built-in sensor that controls the amount of light reaching the subject. It works even when the beam of the flash is bounced.*

**Fixed and movable heads** (above)
*Fixed - head flash units direct their beam straight at the subject. With a movable head, the light from the flash can be bounced.*

speed in use as well as on the power of the unit. On most units one set of batteries should give about 250 flashes.

## Automatic units

Automatic units adjust flash to suit subject distance at your working aperture, so that you can achieve consistently accurate exposures. Some do this by varying flash duration, others by varying flash power. Certain units allow fine manual adjustment of power, so that you can select an aperture to give the required depth of field, or balance flash output against the available light.

The power – or the duration – of the flash is very precisely controlled by a sensor on the front of the flash unit. This measures the level of light falling on the subject, and switches off the flash when exactly the right amount of light for the aperture in use has been emitted. As long as this flash sensor is pointing toward the subject, it makes no difference whether the light from the flash unit is being aimed directly

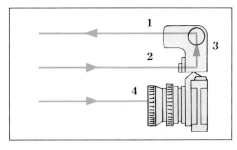

**Auto principle**
*The flash 1 is reflected back to a sensor 2 and the unit measures subject lighting 3. When it has received enough light, the flash switches off, so that light reaching the lens 4 is kept constant.*

at the subject, or bounced from a nearby wall or ceiling. The sensor still measures the light on the subject, and controls the level of the flash output accordingly.

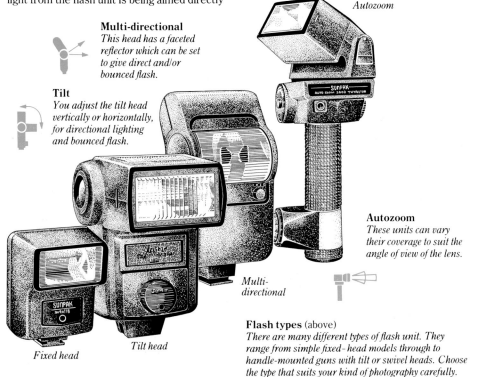

**Multi-directional**
*This head has a faceted reflector which can be set to give direct and/or bounced flash.*

**Tilt**
*You adjust the tilt head vertically or horizontally, for directional lighting and bounced flash.*

*Autozoom*

**Autozoom**
*These units can vary their coverage to suit the angle of view of the lens.*

*Multi-directional*

*Fixed head*

*Tilt head*

**Flash types** (above)
*There are many different types of flash unit. They range from simple fixed-head models through to handle-mounted guns with tilt or swivel heads. Choose the type that suits your kind of photography carefully.*

# Using studio lighting

In a studio, light is completely under the photographer's control. There are two types of studio lighting: studio flash and tungsten.

## Flash

Two types of studio flash unit are available. There are compact models which you can use both in the studio and on location, and heavier units for studio use only. Compact types have one or more lights which you attach to a power source incorporating a control unit. They allow you to fit heads of different strengths, and are portable. The large studio flash units give a stronger light. They are heavier and not portable. On these units you link the power pack to the flash head and camera shutter by means of synchronization cords.

### Studio flash
*In this model, which plugs into an electricity outlet, the flash tube and power pack are combined in one unit. The tube is behind a sheet of plastic, with a centrally placed modeling lamp.*

Manual switch

Power selector

Modeling switch

On-off switch

Mains coupling

Synch socket

Fuse holder

### Studio flash controls
*Five different power levels allow you to vary the intensity of the flash. The modeling light adjusts to the setting selected and allows you to preview shadow effects. A synchronizing cord connects the unit to the camera or a flash meter, though it can also be fired manually for special effects such as double exposure. These features make studio flash units very versatile.*

## Tungsten lighting

There are two types of tungsten studio lighting. Tungsten filament bulbs are similar to household bulbs, but are more powerful. Tungsten halogen lighting uses more expensive round and tube-shaped bulbs. It is more efficient than tungsten filament lighting, easily portable, and ideal for location work. You must handle the bulbs with care. A sudden knock can damage them, and grease marks on the bulb surface will also reduce working life. If you use them carefully the bulbs do not discolor and so maintain a constant color balance, while tungsten filament lamps will blacken with use. Both types of light are available as floodlights, to give an overall soft light, and as spotlights, for a contrasty, directional effect.

### Floodlights
*Most floods use a large, opalescent lamp to spread and diffuse the light. The wider the reflector, the less intense the light, and the softer the shadows formed. As well as the standard 500W flood **1**, there are smaller but harder broadlights **2**. A large softlight **3** bounces its own light to give softest shadows.*

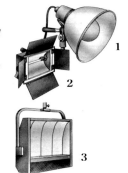

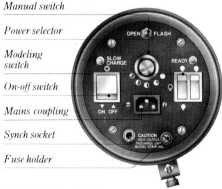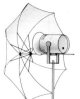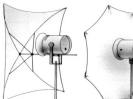

### Soft light attachments (above)
*If, instead of pointing the light source directly at the subject, you bounce it off a large reflective surface, the light will be softer and more diffused. You can use an umbrella reflector (left and center). With an umbrella diffuser (right) light bounced off the inside surface is further diffused through material surrounding the light. This type of lighting effect is often used in conjunction with a harder, more directional lighting unit like a spotlight.*

# Films

There are three types of film in common usage: black and white, color negative, and color positive. There are also different kinds of instant films. Black and white film produces negatives that give you black and white prints. Most popular today is color negative for color prints. Color positive film produces slides that can be projected.

The box your film is packed in shows all the information you require. All films have different speeds, measured in ISO or ASA numbers –

the numbers are the same in both systems. The average speeds are ISO 125 for black and white, and ISO 100 for color. Slower films of ISO 50 or even ISO 25 give a better image quality, but need slower shutter speeds or wider apertures. Faster films of around ISO 200 give a little more scope, while still retaining good picture quality. At ISO 400, grain becomes apparent, but the film allows hand-held exposures to be taken indoors or in bad lighting conditions.

## FILM FORMATS

### 110 film
*The sealed plastic cartridge drops directly into the camera. Film is attached to the backing paper a few inches from its leading end. During use, both are completely wound on to an internal spool. Be careful to place the film in the camera the right way up.*

### Peel-apart instant film
*Pulling a tab after exposure (right) brings exposed and receiving sheets together. They are then withdrawn, and peeled apart after a short time.*

### One step film
*This film is sold in packs of 10. The cardboard cover ejects when you insert the pack in the camera, and each sheet ejects after exposure.*

### 35mm film
*This film is wound on a single spool inside a light-proof metal or plastic container. In the camera the film is drawn out through a slot (light-trapped by black velvet) as the exposures are made. It is finally rewound into the container.*

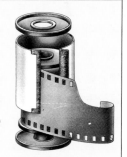

### Rollfilm
*In a rollfilm, the light-sensitive film is rolled in wider, light-proof backing paper. The film is taped to the paper about 10in (25cm) inside its leading end, which is taken up on another spool situated in the far side of the camera.*

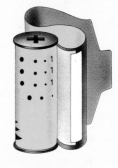

### Boxed sheet film
*Sheet film is packed in boxes, often layered with black paper. Handle in the dark, using the notch to determine the position of the emulsion side of the film.*

# Black and white films

The yellowish or gray surface of unused film is the light-sensitive layer of silver halide emulsion: colorless compounds of silver mixed with compounds of potassium. Exposure to light creates changes within the halide crystals. The emulsion now carries a latent or invisible image, which you must keep away from light until after development.

If the film is a conventional black and white type, developer chemicals first turn the most exposed areas (representing the lightest parts of the image) black or gray. The remaining parts are still creamy. The next "fixer" chemical helps to dissolve away undarkened halides so that these parts are left clear (representing the darkest parts of the image). Finally, you must wash the film to remove all chemicals and by-products of processing. The result is a photographic negative.

## Black and white slides

Some fine-grained black and white films can be specially processed to give a black and white slide. Instead of fixing, the film is treated with bleacher. It dissolves black silver without affecting undeveloped halides. The halides which remain are then fogged by light (or treated chemically). The next solution darkens the remaining halides, to form a positive image.

## Chromogenic black and white film

In the chromogenic process oxidation products of color developer combine with color couplers (present in the film emulsion) to form dyes.

Some black and white films make use of chromogenic processing. These films are designed with more than one layer of silver halide emulsion.

You can process most black and white dye films using the same process and chemicals employed for color negative film.

**Negative formation**
*These diagrams represent a greatly magnified area of conventional black and white silver halide film.*
**Latent image** *After exposure in the camera, there is no visible difference between the crystals which received light, and the dark parts of the image.*
**Developer** *Developer chemicals in water soak into the gelatin, reaching the halides and causing the light-struck crystals to form black silver.*
**Fixing and washing** *The next main solution, fixer, causes all the remaining undeveloped silver halides to become soluble. They are then removed by washing, leaving only the black silver. Dark parts of the film now represent the lightest parts of the original subject.*

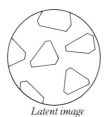
*Latent image*

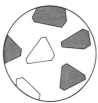
*Developer*

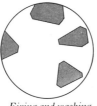
*Fixing and washing*

**Image formation**
*In the single layer of chromogenic film emulsion shown here, large shapes represent halides, and circles represent dye coupler molecules.*
**Latent image** *After exposure, no visible change occurs.*
**Color developer** *The first processing solution forms black silver in exposed areas. The by-products of this convert couplers around the crystals into colored dye. Usually this has a reddish or brown tint.*
**Bleach/fix** *The second processing solution dissolves away all the black silver and remaining silver halides. Only the colored dye molecules are left unaffected, and remain to form the final negative image.*

*Latent image*

*Color developer*

*Bleach/fix*

# CHOOSING BLACK AND WHITE FILM

For the most part, choice of black and white film means choice of ISO speed. Bear in mind that the faster the film, the coarser the grain. There is also a change in contrast – in general, slow films are slightly more contrasty than fast films. Most photographers keep to one brand of medium-speed (125 or 400) film for most work. This is an advantage because you can learn how a particular film responds to different degrees of lighting contrast and the effects of over- and underexposure. But some subjects demand different films.

Fast film such as ISO 1000 or more is a good choice for hand-held photography indoors without flash. Another reason for choosing a fast film is that it allows you to use a long lens at a shutter speed brief enough to hand-hold.

Sometimes the desire to minimise grain, rather than any other factor, dictates the choice of film. Grain appears most strongly in mid-tones and softly lit forms.

## Versatility

There will be times when you cannot predict accurately the type of lighting conditions you are likely to meet. One of the disadvantages of rolls of film over individual sheets is that you might have to finish the roll under very different lighting conditions than when you started it. The most tolerant black and white films in terms of exposure are the chromogenic dye types. Pictures can be overexposed or underexposed (by rating the film anywhere between ISO 125 and 1600 to suit the subject) within the same roll of film. You then process the film for the highest rating used. The negatives will vary in density, but they print with considerably less loss of detail than if you used regular silver image film in this way.

## Comparative film types

*The left-hand column shows enlargements from four silver image films, each exposed correctly following recommended ISO ratings and processing times. Fast film shows more grain, less image detail. The right-hand column shows enlargements made from one chromogenic film, given color processing. Each frame was exposed at a different ISO rating. Between ISO 125 and 1200, negatives remain printable, but the ISO 32 result is too over-exposed. At ISO 1200, dye images give better detail than silver images.*

*Enlarged area*

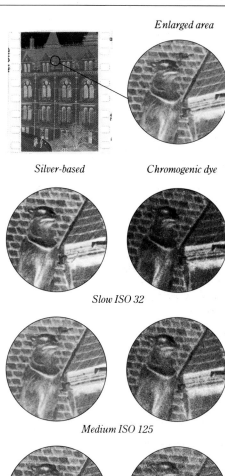

*Silver-based*  *Chromogenic dye*

*Slow ISO 32*

*Medium ISO 125*

*Fast ISO 400*

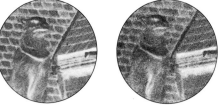

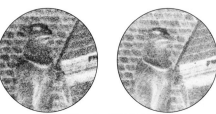

*Ultra-fast ISO 1200*

# Color films

All color films have several layers of black and white silver halide emulsions. Effectively, three emulsions are used – one responding to blue light, one to green, and one to red.

## Color negative film

Color negatives are intended as intermediates for making color prints. During processing, a single color developer solution forms black silver along with a different color dye in each emulsion layer. Then the silver is removed along with the remaining unexposed silver halides, leaving only the dye images.

### Image formation
*This diagram shows part of one color emulsion layer. Large shapes represent silver halides, circles are the couplers that form the dye.*
**Latent image** *After exposure there is no visible change to the film.*

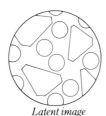

*Latent image*

**Color developer**
*Halides corresponding to red, green, or blue light in the image have developed to black silver. By-products of this cause adjacent couplers to form color dye.*

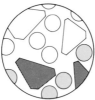

*Color developer*

**Bleach and fix** *These stages stabilize all the silver salts. Both the black developed silver and the remaining halides (with their unused couplers) are removed by washing. This leaves only the color dye image.*

*Bleach and fix*

If you could peel apart the layers of a negative after processing, the top one would show yellow wherever blue light existed in the original image, the middle layer magenta wherever green existed, and the bottom layer cyan wherever red was present.

## Color positive film

These films are designed for projection or direct viewing as slides. To create a direct positive image, the camera film is first developed in black and white developer to give black silver negatives in each layer. It is the remaining silver halides, however, that are important, because instead of fixing, the film receives an additional color development. This developer forms dye in the remaining halides, and gives a positive color image in each layer.

### Image formation
*Color slide film has a sequence of layers similar to color negative film (shown left).*
**Latent image** *After exposure, slide film carries an invisible, latent image.*

*Latent image*

**First developer**
*The first solution, a black and white developer, changes halides exposed to one color of light to black metallic silver. Neither developer nor by-products affect the color couplers.*

*First developer*

**Color developer**
*All remaining undeveloped halides are fogged chemically and acted upon by color developer. This forms black silver and creates by-products that cause the couplers attached to these halides only to turn to dye.*

*Color developer*

**Bleach and fix** *A bleach solution and fixer cause all silver present to become soluble. It is then washed from the film. Where light was absent, the film now carries an image in complementary color dye.*

*Bleach and fix*

It is possible to make a print from a color slide, but special paper must be used.

# CHOOSING COLOR FILM

There are many factors involved in choosing a color film because there is a wide range available. You must first decide on what form your final result is to take – either slide or print. If you are in any doubt, you should choose print film.

Emulsion speed is an important factor. Color films, like their black and white counterparts, all show an increase in grain size as emulsion speed increases.

When you are choosing between color slide films, bear in mind that some types are not intended for processing by the user. You must send these "non-substantive" films back to the manufacturer for developing. If you are likely to want several slides of the same subject, take several identical exposures – this gives better image quality than duplicating a single slide.

## Differences between brands

Each brand of film uses slightly different dyes, and these produce subtle variations in coloring. This is most noticeable with slide films. There are also variations in color response between different brands of color negative film, although differences here are affected by controls during printing. Choice between brands in terms of their color response is largely a matter of personal preference.

## Color balance

Another factor governing film choice is the source of your lighting. If you are shooting with daylight or electronic flash, a daylight-balanced film is the obvious choice. Other light sources have a different color content. If you want results with a normal color rendition when using studio or home lighting as the main illumination, then use film designed for tungsten sources.

If light sources in a scene are mixed, decide which part you want to show with accurate colors and choose a film type to suit that particular area. For example, if a room is partly lit by daylight and partly by household tungsten bulbs, shooting on daylight film will give areas near the windows in correct colors, but other parts will appear orange. The same picture shot on tungsten film will make the window areas appear blue, while the tungsten-lit areas

*Tungsten source*   *Daylight source*

**Daylight-balanced film response**
*The sensitivity to blue, relative to red, of color films designed for daylight-lit subjects is matched to the color contents of average daylight. Subject colors then reproduce accurately (above right). When daylight film is used to record scenes under tungsten lighting, the reduced blue and increased red wavelengths present result in a warm cast (above left).*

*Tungsten source*   *Daylight source*

**Tungsten light film response**
*Color films balanced for subjects under tungsten lighting are more sensitive to blue, and less sensitive to red, than are daylight films. This compensates for the reduced blue and richer red content of the light. Subject colors record accurately in tungsten lighting (above left), but if the film is used in daylight (above right) the results are excessively blue.*

will appear correct. Matching the color balance of film and lighting is vital for slide material and instant pictures. For color prints, though, it is much less important because you can use color filters over all or part of the image during printing. This is why few color print films (other than types intended for critical professional work) are made balanced for tungsten illumination.

# Instant films

The advantage of instant film is that the photographer can see results in minutes, rather than waiting for processing to reveal faults. If the image is not as required, the necessary adjustments can be made and the picture taken again.

There are three basic types of instant film: peel-apart (used in special cameras or in film backs for conventional cameras), integral (used in special cameras), and 35mm (used in conventional cameras). Although some instant films are inferior to conventional material, others surpass it in tonal range.

## Peel-apart instant film

Each of the three different color-sensitive emulsions in peel-apart film has a ready-formed layer of complementary dye directly below it. Developing chemicals are mixed with this dye, and these only function when an activator is present. You begin by exposing the light-sensitive material (usually paper) to the camera image. When you pull the film tab, the exposed layer is placed in contact with a sheet of receiving paper, and rollers in the camera break a pod of jellied activator as the two papers leave the camera.

**Positive material**
*Base*
*Acid layer*
*Spacer*
*Mordant layer*
*Alkaline pod*

**Negative material**
*Blue-sensitive emulsion*
*Yellow dye + developer*
*Spacer*
*Green-sensitive emulsion*
*Magenta dye + developer*
*Spacer*
*Red-sensitive emulsion*
*Cyan dye + developer*
*Base*

**Peel-apart film structure**
*The top part of the cross-section shows the positive material ready to receive the image diffused upward from the multilayered negative material. Jellied activator spreads between the two, and they remain in contact while picture formation takes place.*

Development begins at once. Where halides have been affected by light, they anchor the dye directly below them. Where the halides are unaffected by light, the underlying dye is free to rise to the top of the exposed sheet and transfer to the receiving layer. For example, in the blue-sensitive layer, parts of the original image that were not blue allow yellow dye to transfer. The green-sensitive layer causes magenta dye to rise where green was not present. In the white parts of the camera image all layers are exposed and all dyes immobilized. In black parts all three dye layers transfer to the receiving layer.

When you pull the two sheets apart, the receiving layer carries a full-color, positive image. As with slides, the one-step nature of the process means that your exposure must be accurate, and the type of lighting must suit the color balance of the material. Peel-apart instant picture film is intended for use with either daylight or flash.

**Peeling apart**
*After taking a picture, you pull the film out of the camera. Set a timer, and pull the two sheets apart after the specified period to reveal the image.*

## One-step film

Each exposure is ejected from the camera as a multilayered card on which the image appears, without any peeling apart. The image is protected by a layer of clear plastic.

The Polaroid material contains a pod of activator mixed with thick, white pigment. The pod contents are spread within the internal layers as the card passes through rollers on its way out of the camera. The pigment shuts off the layers from light while they are processing, and also forms a white base through which released colors diffuse and form the final

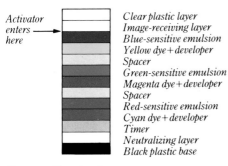

Activator enters here →

Clear plastic layer
Image-receiving layer
Blue-sensitive emulsion
Yellow dye + developer
Spacer
Green-sensitive emulsion
Magenta dye + developer
Spacer
Red-sensitive emulsion
Cyan dye + developer
Timer
Neutralizing layer
Black plastic base

**One-step film structure**
*This material has lower layers containing light-sensitive halides and dyes. The top layers are clear, receiving the dye image when released by the negative. Jellied activator enters this structure just before the image-receiving layer.*

image. Internally, the anchoring or releasing of dye proceed as in peel-apart film.

In the time that the picture is developing the image-forming layers are still liquid and can be damaged, so it is important not to bend or press the picture, as you may distort the image by disturbing the emulsion.

## 35mm instant slide system

With Polaroid's 35mm slide film, you can have slides in color or black and white in your hand, within minutes of exposure in a conventional 35mm camera or equipment utilising a 35mm camera back.

There are five films in the system: PolaChrome for the production of color slides, a high-contrast PolaChrome suitable for copying, PolaPan for black and white slide images, PolaGraph for high contrast black and white, and PolaBlue for a negative white image against a blue background. The films can be used either alone or combined.

For development the container is removed from the camera and loaded, along with a processing pack that comes with each film, into a small desk-top processor, available in a manual or motorized version.

Processing is a matter of using simple controls at set intervals. With the motorized processor, closing the lid automatically initiates the sequence of development, and times it automatically. The lid is then opened to reveal the film, back in the container, fully processed.

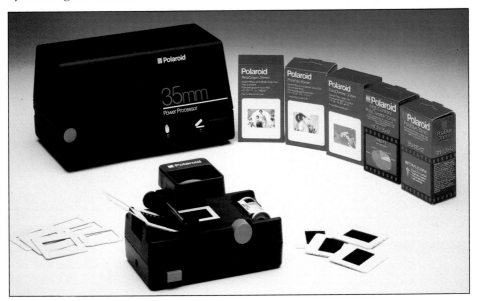

**Instant slides**
*Polaroid's instant slide film system has been developed to allow fast home-processing of a range of specially designed slide films. The system is self-contained, with its own processing unit. Processing the film is a matter of using simple controls, and takes minutes.*

## Still video films

Recording the camera image by still video (SV) methods is entirely unlike the use of film. In place of plastic coated with light-sensitive silver halide chemicals, an SV camera uses a permanently installed, flat electronic chip called a charge-coupled device. The surface of the chip is divided into a grid of half a million or so tiny, light-responsive pixels (picture elements). The greater the number of pixels the better the resolution of the image.

After each exposure the chip instantly "plays out" the picture as a stream of electronic signals. These are recorded magnetically in another part of the camera on to a surface which can be removed and replayed at any time. The chip is then ready to receive your next picture.

There are two separate and incompatible systems for recording picture signals from a chip. Some SV cameras – Sony or Canon types, for example – record on to a 2in (5cm) floppy disc spinning at about 3000 revolutions per minute. Other SV cameras – by Fuji or Toshiba for example – record on to a stationary SRAM (static random access memory) "smart card". This is about the size and shape of a telephone card and contains a number of one-megabyte integral memory chips able to digitally record 12 or more exposure frames.

**Loading still video film**
*Still video films, unlike conventional films, can be loaded or changed in normal lighting conditions. They are still susceptible to heat and mechanical damage.*

## Caring for film

All photographic emulsions are sensitive to chemical fumes, X-rays, and physical abrasion. They also contain gelatin, which is an organic substance liable to grow mold if left for long periods in humid conditions. Processed films contain dye or silver images that gradually change or fade, even if protected from light. Color films are always more susceptible to change and deterioration than black and white emulsions, both before and after exposure, because their individual layers may alter in sensitivity at different rates, upsetting the color balance.

**Storing unexposed film**
Before buying film, make sure it is not close to its expiration date (marked on the outside of each packet). Both black and white and color film should be processed by the date shown. In many cases you can extend this time by careful storage. It is risky, however, to buy film that is close to or beyond the date – color film in particular may prove slower than expected, with poor color quality. If film is stored at the right temperature and humidity, its life will be greatly extended. In the short term, you can store films at a room temperature up to 65°F (18°C). For long-term storage, film should be kept in a refrigerator at a temperature of 56°F (13°C) or lower. For extremely accurate

results you can buy a stock of film all from the same batch, and then test it for speed and color balance before use.

To protect the film against high humidity, it is sold in plastic containers or in sealed foil wrappers. If you keep the film in cold storage, it is essential to give it time to reach approximate room temperature before unsealing the container. If this is not done, moisture may condense on the film surface.

### Handling care
Temperature also affects film when it is loaded in the camera. In a closed, sealed vehicle, for example, the temperature can reach a level high enough to alter the speed or color balance of the emulsion. Always keep film away from vehicle exhausts, boiler fumes, wet paints, or solvents. Be sure to load film faster than ISO 400, and all infra-red films, indoors. As a general rule, it is always best to load all film in the shade. At airports be careful not to allow unprocessed film to go through X-ray baggage inspection, as this may cause a gray veil.

Try to have film processed within a few days of exposure in the camera, because exposed material deteriorates far more rapidly than unexposed material.

### Caring for exposed film
Do not store processed film in conditions of high humidity as this will promote the growth of fungus. Light tends to fade images over a period of time. Slides will survive projection about 250 times at 15 seconds each before any color change becomes noticeable. Even when stored in a dry, dark environment, color negatives start to deteriorate after six years, color slides after 10–25 years, and black and white silver negatives after 50–100 years.

## Picture economy

Cartridge films for the 110 format are sold in 12 and 24 exposure lengths. 35mm format film is sold in either 24 or 36 exposure lengths. Some film types are also sold in 12 and 72 exposure lengths. The number of frames per rollfilm depends on the particular format of the camera – 120 rollfilm, for example, gives 12 exposures for 6 × 6cm cameras or 10 exposures for 6 × 7cm cameras. Rollfilms with a special thin base allow 24 exposures of 6 × 6cm on a similar film spool (these are known as 220 size).

The longer the length of film you buy, the cheaper each exposure becomes. 110 film, however, is not available in bulk lengths. For the 35mm format, bulk film is available in lengths of 16ft (5m), 66ft (17m) or 98ft (30m). These are usually used in conjunction with 250-frame camera backs and motor drives. For the more modest film user, economies can also be made. Inexpensive film loaders are available to cut these lengths of film down to reload normal 35mm containers. 16ft (5m) of film will give about 115 exposures, and reduces the cost per frame by about 50 per cent. Bulk film is also sold for rollfilm cameras.

· CHAPTER TWO ·

# THE ART OF PHOTOGRAPHY

The most fundamental qualities required to take a good photograph are an ability to see in a perceptive way, and to have a positive enjoyment of both creating and looking at pictures.

Many people underrate their ability to see and make pictures, believing that visual sense cannot be learned. In fact, anyone can develop and intensify the skill of seeing, as long as there is the will, time, and a real interest in the task.

One of the problems with many photographers is that the camera is just not used enough. Like any other skill, without constant practice, the ability to *see* and *realize* is no longer an automatic reflex. It is like learning to ride a bicycle or drive an automobile – once learned, the technique is best absorbed and used subconsciously. It may help to make strongly subject-orientated photographs, such as portraits, more powerful and direct, or it may help you to find pictures in things you might otherwise pass by.

**Choosing your subjects**
*Good photography is a matter of keeping an eye open for subjects, and learning to use elements such as light and color to create particular effects. This brightly painted horse captures the atmosphere of a fairground.*

# Looking for subjects

Everywhere you look, there are subjects for your camera. But you cannot make the best of them until you learn a little about how to actually look for subjects – and, having found them, how to look at them, seeing new angles and ways to make the most of each subject.

Picture building is not a matter of obeying rules or following artistic trends. You must learn to look afresh at the world around you, to become aware of shapes, forms, surprising visual juxtapositions, and the effects of light, which many people take for granted. Once you learn to see, you can select or reject, emphasize or suppress, to express your main subject in your own visual language.

A camera differs from your eyes in several ways. The scene your eyes see is limited only by your attention, as your eyes regularly scan and move across it, but looking through the camera viewfinder you see a picture framed by hard edges and corners. A photograph is taken from a fixed viewpoint, which determines what is included. The proportions of the frame affect how the different elements in your picture relate to each other.

There are endless ways of photographing a subject, so before you shoot, move around and examine it from different angles and heights. Notice how the image in your frame is affected.

Composition is just one of the tools that photographers can make use of. But it must be used in conjunction with a sound knowledge of the basic ways in which light behaves, and how it interreacts with the physical properties of the subject itself. The direction, quality, and timing of light, and the ways that it affects the surface textures, lines, shapes, patterns, forms, and colors offer infinite possibilities.

**The power of color** (above and left)
*Color is the single most powerful element in any picture, so you should control it carefully, harmonizing or contrasting hues the way the photographers have in these two pictures. Color results are affected by lighting quality. Dull light or cold weather will distort or weaken colors, often with disappointing results. You will achieve great impact with color if you shoot a subject that consists of bold areas of contrasting color, in bright but even light.*

**The camera cannot discriminate** (above)
*Pictures often appear cluttered, because your eyes showed you only the element you were concentrating on in a scene, whereas the camera recorded everything equally clearly. This photograph, for example, includes important and unimportant elements without discriminating between them. The subject could have been isolated by changing the viewpoint or using selective focus.*

**The camera must be focused** (above)
*Wherever you look, you see a sharply rendered scene. You are not aware of your eyes adjusting to focus at different distances, so it is easy to forget that the camera will only render the focused distance sharply. You must set your chosen subject distance on the camera lens, so that the subject you wish to emphasize is rendered sharply. Selective focus is a powerful tool for isolating a subject.*

**Film exaggerates contrast** (above)
*When viewing the scene shown in this picture the photographer saw detail in both the bright daylit balcony and the dark interior. But film exaggerates extremely light and dark tones. For a scene like this, you may have to decide whether to expose dark parts correctly, so that detail elsewhere is bleached by overexposure, or expose light areas correctly and accept dark areas as black through underexposure.*

**A photograph is two-dimensional** (above)
*A photograph is a flat image with height and width but no depth. You have to learn to suggest the third dimension, depth, experienced in human vision. This picture does so by using strong perspective lines, and lighting that exaggerates the three-dimensional form of the train. The part of the train on the right of the picture appears closer than the woman in the center, though both lie in a two-dimensional picture.*

**The offbeat approach** (above)
*Visualising in advance the way a subject will appear on film, as opposed to the way it appears in real life, will often give you a way of finding slightly offbeat subjects for your camera.*

# Using lines

Every picture is composed of lines – vertical, horizontal, straight, or curved. The way you visualise those lines and use them affects the mood and the composition of your picture.

The influence straight lines have on a scene depends on the angle they make with each other, and their relationship with the sides of the frame. Like all lines, they are also affected by their degree of dominance, tone and color in relation to their surroundings, and repetition. Scenes containing mostly vertical and horizontal lines suggest a formal sense of order and stability. (This particular use of line is evident in many kinds of institutional architecture.) Straight, horizontal lines, which occur particularly in landscapes, help to give an impression of calm, tranquillity, and space. A structure or a scene containing predominantly strong vertical lines tends to have a sense of height and grandeur. Tightly angled, irregular lines give a dynamic effect.

You will often find that you can alter the direction and effect of dominant subject lines by changing viewpoint. Coming down low and looking forward at vertical lines makes them seem to converge toward the top of the frame. If you look at horizontal, parallel lines from an angle, they converge toward a vanishing point on one side of the frame only.

**Vertical lines** (above)
*The lines in this composition of concrete structures help to give a feeling of stability and calm. Different material surfaces provide visual variety, without destroying the quiet atmosphere.*

**Curved line** (left)
*A pleasant visual sense of movement is induced by the curves of the road in this picture. The shape of the line is strongly brought out by the light reflecting off the surface of the road, set against the dark, underexposed surroundings.*

**Horizontal lines** (above)
*This picture is dominated by horizontal lines counterpointed by circles. In spite of the tractors' movement, the overall effect is static and ordered, with a sense of space. Viewpoint was carefully chosen so that the lines run exactly parallel to the top and bottom of the picture.*

**Leading the eye** (above)
*A mixture of curved and horizontal lines shows another example of traditional picture composition. The curved row of posts leads you gently into the picture, while the row of houses at the end of the curve brings you to a stop. Without the houses, the eye would have been led out of the top of the picture.*

**Lines and mood** (right)
*Soft lighting and gentle, horizontal lines give a peaceful effect that suits the mood of the subject.*

# Focusing

Regardless of the camera type, its lens must be set in the right position in relation to the film in order for it to form a clear, sharp image. This exact distance depends on the focal length of the lens and the distance of the main point of focus from the lens. The closer the subject, the greater the distance between lens and film.

### Fixed-focus lenses

Lenses on some inexpensive compact cameras, set in one focus position, are designed to render sharply subjects that are both far away and "reasonably close" to the camera. Usually the lens is set for a subject distance somewhere between these two limits, and relies on the smallness of the lens aperture (which must also be fixed or very limited in its adjustment) to extend the zone of sharp focus over the required range of subject distances.

A fixed-focus lens will rarely produce a photograph with an unsharp background, but there are distinct limitations to the nearest subject distance it can render sharply. The zone of sharp focus is greater with a small-format camera than with a fixed-lens 35mm type, as the smaller format has a shorter focal length lens.

When using fixed-focus lenses, therefore, the best pictures will be attained when subjects are in the middle and far distance, rather than close to the camera.

### Manual focus

The most obvious focusing aid is the focusing screen found on reflex cameras. On this, you can see the view through the lens, whether it is sharp or blurred. Manual focusing cameras also include a split-image rangefinder within this screen that splits the image when it is unsharp, bringing the two halves accurately together when the point of maximum sharpness has been achieved.

Another focusing aid is the rangefinder system used on some manual compacts. These are usually of the coincident image type: the viewfinder shows two images of the subject which are brought together as the focusing is adjusted. When they coincide, focus is sharp.

### The effect of focusing

*These two pictures differ only in the camera focus setting, and show how this control can be used to pick out parts of the subject. In the first (far left), the lens setting was about the same as for a fixed-focus lens – 30ft (9m). Almost all the picture, except for the foreground, is sharp.*
*In the second picture (left), the lens was focused for about 3ft (0.9m), so that the foreground appears sharp while detail in the background is unsharp. In this way you can use the focus to concentrate interest on areas of your subject, in the same way as you subconsciously focus your eyes on selected parts of your field of vision.*

**Fixed- and variable-focus lenses** (above)
*With a small-aperture, fixed-focus lens (above left),
sharp focus extends from infinity to a point a few feet
from the camera. You cannot choose which areas of the
picture you wish to be sharp or unsharp, as you can
with a variable-focus lens (above right). Having the
ability to focus selectively gives you the option of
creating different subject emphases within the frame.*

**Deep focus**
*Focusing on one aspect of a picture and allowing the
rest to fall out of focus can be effective in building
certain types of composition (above). In landscape
photography, however, it is usually more important to
juggle camera position, focusing, and aperture to
allow deep focus from the nearest foreground object all
the way out to infinity (below).*

## Autofocus

Some cameras have fully automatic lens focusing systems. There are three main ways in which a lens can "sense" a particular subject distance – by either comparing contrast, scanning with invisible infrared radiation, or measuring with sound waves.

The danger with all autofocus systems is that the unit may read the wrong part of the scene. Even with the most popular system – the contrast-comparing method – it is possible to photograph two people, for example, and unwittingly allow the sensor to measure the background area between them. Or you may often want your main subject off-center in the picture. The better autofocus cameras allow you to make the focus settings with the subject center frame, then lock the lens position while changing to a more off-center composition before shooting. These systems are becoming more sensitive and accurate all the time.

## Focus for emphasis

A major advantage of having a focusable lens, apart from the fact that it allows you to record the main subject sharply, is that you can determine emphasis. By separating items that you want to be detailed and clear from unimportant items at other distances, you emphasize the former creatively. This "differential focus" applies particularly to close-ups, because the lens must be so far forward that distant detail becomes very unsharp.

### Defocusing for effect
*Sometimes focus – or the lack of focus – can be made an integral part of the picture's purpose.*

**Problems with auto-focus systems** (left)
*In this picture the pronounced areas of light and shade would confuse contrast-comparing autofocus. An ultrasonic or infrared model would probably focus on the fence, as this is the nearest solid object to the camera. The off-center position of the sculpture would also cause problems, as most systems are set for centrally placed subjects.*

**Differential focus**
(above)
*By focusing sharply on the tribesman, and using a wide aperture setting, the photographer was able to isolate him from the background.*

**Focus and viewpoint**
(right)
*One of the difficulties in photographing personalities at crowded events is separating them from the confused surroundings. One solution is to move in close, but this often loses too much of the environment – the picture could have been taken anywhere. Here, the photographer thought ahead and carefully chose his point of focus.*

# Using the shutter

A camera with a range of shutter speeds helps you to give correct exposure under all kinds of lighting conditions and, just as importantly, it allows you to choose whether the camera records the subject's movement as fixed or blurred.

A stationary subject photographed with the camera supported on a tripod will appear the same at any shutter speed. But if your subject is moving, different shutter speeds will produce quite different results.

The slower the shutter speed, the greater the blur created by subject movement. The exact effect depends on how fast the subject is moving in relation to you, how near you are to the subject, and whether the movement is side-on or directly toward the camera. A fast shutter speed is most likely to record all subjects as if stationary.

Some photographers use the fastest speeds to avoid recording camera movement, but this can destroy any sense of action.

**Shutter speed and subject movement**
*The cyclists were moving at the same speed in each of these three pictures, but the exposures were 1/30 sec (left), 1/125 sec (below left), and 1/500 sec (below right). You can see how the fastest shutter setting freezes the action – the image remains on the film so briefly that no movement has time to record. At 1/125 sec there is still detail and only the fastest moving elements – the outer spokes of the wheels – show blur, although there is a sense of action present. The longest exposure, at 1/30 sec, has blurred the group of cyclists, separating them from their background and creating a strong impression of speed.*

**Freezing action**
(right)
*Selecting a fast shutter speed will freeze action so that fast-moving subjects appear static in the picture. While this technique might not give an artistic impression of action, it can be used for its own sense of drama. This shot was taken at a fast shutter speed of 1/500 second.*

**Blur and direction of movement** (above)
*Unlike the pictures of the cyclists opposite, all three pictures here were taken with the same shutter setting – 1/60 sec. The differences in blur are completely due to the differences in the direction of movement. Movement toward (right), or directly away from the camera* *always produces less blur than movement across the picture plane (left). The picture with the figure moving diagonally (center), shows an intermediate effect. If lighting conditions or other factors force you to use a slower than normal shutter speed, use a head-on rather than a side view of the action.*

# Using the aperture

The aperture has two important influences on picture results. First, it controls image brightness, allowing more or less light through to the film. A lens with a wide range of aperture settings can therefore be used in widely varying lighting conditions.

Second, the aperture controls the amount of a scene that is recorded sharply at any one focus setting. This means that a picture taken with a very wide aperture will show sharp detail only in that part of the subject where the lens is focused. The same scene taken with the lens "stopped down" to a smaller aperture will produce a picture with a wider zone of sharp subject detail. This zone of sharpness is referred to as "depth of field".

The choice of aperture is often determined by the requirements of producing the "correct" exposure – to compensate for shutter speed, for example. At other times, however, the photographer will want to manipulate depth of field artistically. A shallow zone of sharp focus will, for example, concentrate attention on a very specific area of a composition.

## Choosing depth of field
Whether to make all elements within the scene sharp, or to concentrate on more localized detail, depends on your particular subject and interpretative approach. Maximum depth of field gives maximum information, bringing out detail everywhere. This is valuable in scenes such as landscapes or interiors, where a wealth of interesting detail may contribute to the mood and atmosphere.

Shallow depth of field dictates to the viewer. It emphasizes objects at one distance and veils everything else, to a greater or lesser extent, in an unfocused blur. This "differential focus" is a useful device for implying depth and softening distracting detail that may clutter the background or foreground. It is possible to

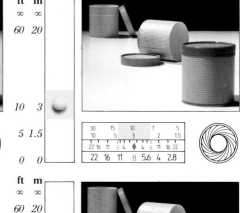

## Lens scale
*Many lenses have a fixed depth of field scale next to the distance markings on the focusing ring. The numbers on either side of a central mark on this scale correspond to apertures. Focusing the lens on the central mark allows you to read the nearest and furthest distances that will actually be in focus at a given aperture. This is the depth of field. At large apertures (above), depth of field is narrow. As you decrease, or stop down, the aperture (above right), the depth of field increases, until, at the smallest apertures, you achieve maximum depth of field (right).*

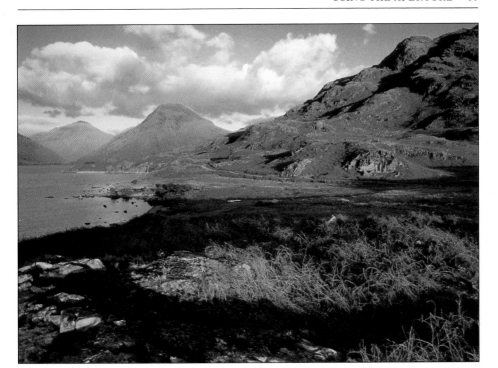

make unwanted areas unrecognizable, or remain as soft shapes, which still suggest the surroundings. You could use a shallow depth of field, for example, to draw attention to the eyes in a portrait, or to pick out a few people in a crowd, or to picture someone within a naturally occurring foreground frame, which is gently softened in outline.

Maximum depth of field is useful, not only for subjects that require sharpness throughout, but also for those times when focusing is difficult. When a subject is moving, for instance, there might not be the time to focus as accurately as you might with a static subject. On these occasions, using a greater depth of field will compensate for slight inaccuracies in both manual and auto–focusing.

**Wide depth of field** (above)
*A small aperture increases depth of field, producing image sharpness from foreground to background, and allowing you to capture a whole scene in detail.*

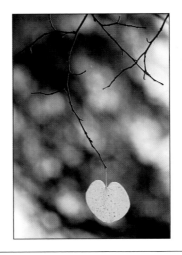

**Shallow depth of field** (right)
*A wide aperture was used to create a limited depth of field which isolated the sharply focused leaf against an out-of-focus background.*

# Setting exposure

Camera controls allow you to regulate the amount of light the film receives from the subject in two ways. First, the shutter speed controls the duration of the exposure. Second, the lens aperture controls the brightness of the image. For maximum exposure in very dim light, use a slow shutter speed and a wide aperture. In bright lighting conditions, though, use a fast shutter speed combined with a small aperture. The wider this range of exposure combinations, the greater the range of lighting conditions under which you can take pictures.

Low-cost cameras generally offer least flexibility. They may, for example, merely have a two-speed shutter (marked with symbols indicating sunny and cloudy) and a fixed aperture. With advanced models, you must balance the increased flexibility against the fact that they are more complicated to set and use.

Most 35mm cameras contain a light-sensitive cell facing the subject. This cell measures the level of illumination, and may control one or both of the exposure settings. Single lens reflex cameras usually contain an internal cell, and fully automatic models have their shutter speed and aperture setting programmed directly by its response. But for fuller control over the final appearance of your results, it is better to have a camera offering manual control – or at least one which you can switch between automatic and manual.

Modern cameras offer, among many different modes of automation, shutter- and/or aperture-priority modes. Give priority to either shutter speed or aperture, according to the effect required. When shooting action, the shutter speed will be your priority; for portraiture or landscapes, in which depth of field is important, give priority to apertures.

**Shutter priority** (right)
*This mode is most useful in action and sports photography, because a fast shutter speed allows you to freeze movement. You set the camera to the shutter speed mode and select the speed you require. You may also have to set the aperture ring to automatic. The shutter speed you select and the aperture set by the camera appear in the viewfinder. If the shutter speed you have chosen risks over- or under-exposure, a warning light flashes beside the frame on some models.*

**Aperture priority** (right)
*Aperture priority gives you control over depth of field. A wide aperture highlights a selected area of a picture, while a small aperture gives clear focus throughout a scene. This control is particularly useful for portraits, landscapes and close-ups. You turn the shutter setting ring to automatic and set the aperture you require. The camera will then select a shutter speed that gives accurate exposure, and the aperture and shutter speed will appear in the viewfinder as shown.*

## GETTING THE EXPOSURE RIGHT

In uneven lighting, with strong bright and dark areas, you have to be careful. Results will depend on where you direct the camera as it "reads" the subject. Learn to recognize different lighting, and when to choose a highlight reading, or a shadow reading, or an average between the two. If in doubt, err toward underexposure with slides, and overexposure with prints.

**Correct exposure** (right)
*A well-exposed shot should look crisp, with detail in main areas, depth of color and tone, and bright but not bleached highlights. Make sure that the displays are correct and read from the main subject.*

**Over exposure** (left)
*If the displays indicate overexposure your shot will be pale, with bleached highlights and indistinct detail. This happens when the aperture has been set too wide or the shutter speed is too slow. This shot is 2 stops over.*

**Under- exposure** (left)
*If the displays indicate underexposure, your shot will be dark, with deep colors, and lack detail in shadows. This happens when the aperture has been set too small or the shutter speed too fast. This shot is 2 stops under.*

**Bracketing**
*In uncertain lighting, or when you must be sure of a good result, it is wise to "bracket" exposure. This means taking extra shots at exposures close to the one your meter shows. Bracket by 1 stop each way. The meter showed correct exposure for this scene at f11 on 1/60 sec. (above center). At 1 stop over (1/30 sec) (above left), there is more detail, but highlights are burned out. Perhaps the best result is at 1 stop under (1/125 sec) (right).*

**Exposing to suit the subject**
(above)
*The exact exposure you use depends upon which parts of the picture you have selected as being important. In the first picture (above left) the exposure (1/60 sec at f11) was read mostly from the shadow area, so that the highlights are very overexposed, with a consequent loss of detail. The second picture (center) was given an average overall reading (1/250 sec at f11). For the third version, (above right), the exposure (1/500 sec at f16) was read from the highlights. The picture is underexposed, but is perhaps the most satisfying result.*

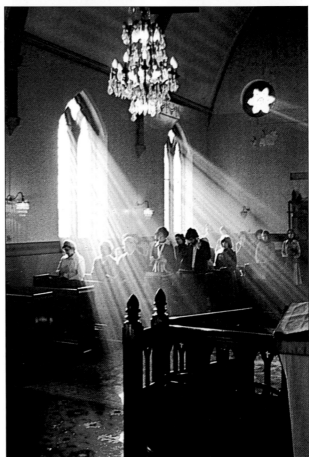

**Selective exposure** (right)
*Often, it is necessary to get exposure absolutely right for one area of the subject, allowing other areas to take care of themselves. In this picture the photographer exposed essentially for the area covered by the windows.*

## Where general readings are deceptive
*A general reading is misleading if the important element is quite small. When the background is bright (top far left), the reading underexposes the face so that it is too dark. A dark background (top left), produces the opposite effect – the face is now too pale (over-exposed). In the two larger prints (left and far left), the light readings were taken for the figure alone, so that the background lighting does not dominate the result.*

## METERING METHODS

### Using one overall reading
The exposure for a scene with the same overall tonal range can be accurately judged by taking one general meter reading from the camera position. Shadows and highlights in the subject will be about equal in area and the meter will average them both.

### Taking a selective reading
To overcome exposure reading difficulties when a scene has both bright highlights and deep shadows, you must make sure that the meter only reads from the most important area of the subject.

### Taking a spot reading (left)
*If your camera has a meter which takes a "spot" reading, align this marked area of the focusing screen with the subject. Since the meter ignores other parts of the picture, it gives correct exposure for the subject.*

### Moving closer (left)
*For built-in meters that give a general reading, move in until the subject fills the viewfinder. You can then take your meter reading without the back-ground affecting the over-all exposure. Move back again to take the photograph.*

### Local hand meter reading (left)
*If you use a hand-held meter you can bring it up close to the main subject to take your reading. In doing so, be careful not to inadvertently cast a shadow on the area being measured, as this will distort the reading.*

# Composition

The way you compose the image in the viewfinder – the way the various elements are arranged and relate with one another – can make or break the final picture. The format of the picture, the position of the principal subject or subjects, the viewpoint you choose, these all help to make better pictures.

## Format

Picture composition begins with the proportions of the picture format itself, whether it is square or rectangular. Formats have powerful physical associations.

### Horizontal format

Of the two options offered by a rectangular picture, horizontal proportions seem to look the most "natural". This is probably because our eyes are set horizontally and we naturally view the world approximately within this shape, rather than a vertical or square shape. We are conditioned, too, by the proportions of movie and television screens, both of which use horizontal formats. The majority of cameras are primarily designed so that they can be comfortably held this way round, and it may seem unnatural to turn them sideways.

We usually scan pictures from the left to the right, but much depends upon the content of

**Horizontal framing**
(left)
*Placing the subject in a horizontal format emphasizes its horizontal lines, and minimizes verticals. The man seems to be working his way along the wall, with still some way to go.*

**Extreme horizontal cropping** (below)
*This narrowly cropped picture exaggerates the horizontal "pull" between the man and his horse.*

the picture itself, too. A strong center of interest attracts the eye first. Probably because of these eye movements and the dominance of picture base in a horizontal format, horizontal lines and space itself are emphasized and expanded.

Horizontal format is a natural choice for portrait pairs or groups, and any subject where horizontal features and actions are to be emphasized. In landscapes it helps to increase the importance of the horizon. It is also much easier to communicate the idea of movement to the left or right in a horizontal frame – particularly if it is important to suggest that the subject is just entering or leaving the scene.

## Square format
The symmetry of a square format makes it the most neutral type of picture shape to employ. Neither horizontals nor verticals dominate; each corner tends to pull away from the central area. The format has an equal and balanced feel to it, but the picture can easily become dull and less stimulating than a more "committed" shape, with its potential to intensify the composition. This is one reason why many people find it difficult to compose pictures within a square. Although cameras which take square-shaped pictures do not have to be turned on their sides for different-shaped compositions, it is quite common for results to be cropped to a rectangular format in order to strengthen them.

## Vertical format
The composing space offered by a rectangle with vertical proportions is complementary in several ways to a horizontal rectangle. Its "pull" is mostly vertical. The eye tends to scan from top to bottom (or vice versa), comparing and relating objects it finds in these two areas, rather than in zones to the left and right. A feature of pictures with extreme vertical proportions is that separation between the two ends seems far greater than when the same shape is horizontal – you have to work your way up a tall, thin picture with a more conscious effort.

**Vertical cropping** (above)
*One of the biggest mistakes made by beginners to photography is to assume that the camera must always be held horizontally. Match the way the camera is held to the shape of the subject.*

**Square format** (left)
*If the subject's shape demands a square, rather than an oblong format, do not be afraid to crop accordingly.*

# Viewpoint

Viewpoint is the single most important means of selection and control in photographic composition. The exact position that the photographer chooses fixes a whole series of relationships. A shift in viewpoint to the left or right, upward or downward, immediately changes the position of near objects in relation to distant ones. Gaining height can change the predictable background of a scene, and emphasize or feature horizontal surfaces. Lowering viewpoint to ground level has the opposite effect – horizontal planes in the foreground become condensed. Moving nearer or farther away changes the apparent size of near objects much more drastically than distant ones, altering relative scale. Moving around the main subject can change the whole atmosphere of a picture. Often very minor shifts make a dramatic difference to the way subject shapes and elements "fall into place".

**Fill the frame** (above)
*Whichever viewpoint you decide on, always make sure that your subject fills the frame. The most obvious viewpoint of our subject was from the side, at normal height. The result is acceptable – a straightforward record; but it looks unimaginative and posed.*

**Moving around the subject** (left)
*A low viewpoint, close in, makes the horse appear larger and more powerful in relation to the child – the shot has a lively quality.*

**Close-ups** (below)
*You will sometimes find it hard to get an uncluttered background, even after you have moved around your subject and examined it from different angles. Instead of attempting to show the whole subject, try moving in close and concentrating on one part only. This will exclude distracting background elements.*

**High viewpoint** (right)
*The viewpoint used for this picture
eliminates the sky from the picture
and fills the whole frame with the
textured surface of the grass.
Because from this position the man
is not immediately recognizable, his
abstract shape becomes part of the
two-dimensional design.
Against a simple, flat
background the positioning of the
main subject is critical. Here the
man is placed off-center, but
moving parallel to the edges of the
picture frame, giving balance and
interest to the composition.*

**Low viewpoint** (above)
*The distorted scale created by the low viewpoint in the
picture, adds to the menace of the armed soldiers.
An eye-level viewpoint would have made each of the
soldiers recognizable characters, all on a normal scale.
This choice of framing and viewpoint also has the effect
of depersonalizing the soldiers and emphasizing boots
and rifle butts.*

# Placing the subject

The main controls in photographic composition are choice of distance, viewpoint, and angle. Tilting the line of sight up or down, for example, alters placement of the whole scene within the picture space. Ratios of one area to another change, and any item of interest can be moved around easily. It is possible to use the frame to discover how a composition would look with more or less sky, or to decide where a natural division should run.

## Using simple divisions

Using a line to break up the picture into divisions is a powerful and useful compositional device for many kinds of subject. Horizontal divisions such as horizon lines tend to be more natural and familiar in everyday scenes than vertical divisions, but there are many ways of creating and using vertical divisions, too. The tightly cropped side of a building, the vertical edge of a window or doorway, or a straight flight of steps when viewed from directly above, can all be used to create effective vertical dividing lines.

**Dividing the picture** (left)
*Dividing your subject area into nine equal parts, in the way shown here, will give you an idea of the best position for the various elements of the picture's composition. Where the horizontal and vertical lines cross, composition is at its strongest.*

**Placing the subject** (above)
*Placing the figure off-center, with the head on one of the thirds, gives the picture a stronger composition than if the figure had been placed centrally.*

Picture composition is usually improved if the principal subject is off-center. Imagine your picture has been overlaid with two equally spaced vertical lines and two equally spaced horizontal lines. Position your subject on one of those lines or at a point where any of them cross and you achieve better composition.

## PLACING THE HORIZON

Often the horizon is the main division of areas in open landscape. Other strong horizontal divisions occur between sea and sky or road and sidewalk. The flat top of a wall, or the junction between a floor and wall, has the same effect.

### Centered horizon
Framing the picture so that the horizon is central divides your picture into two equal halves, which have equal "pull", and there is a danger that this will detract from any single point of emphasis. A great deal depends on the variety of the values and shapes in each half. Sometimes a central division can create complete symmetry throughout the picture.

**Centering the horizon** (above)
*Framing the horizon halfway down the picture gives approximately equal divisions of sand and sky. Top and bottom halves seem to compete for attention.*

### Low horizon
Tilting the camera upward has the effect of shifting the horizon position down toward the bottom of the picture. Now the sky provides most of the environment, and the picture seems to have a more "open" feel. With fewer foreground objects, differences in scale within the picture are minimal, giving a more distant, detached impression. This is often a good way to simplify a picture. However, you should leave sufficient tonal weight at the bottom of the frame to give the composition stability and balance. It is important to judge the ratio carefully.

**Using a low horizon** (above)
*Composition is simplified, and there is a sense of endless, open sky. If you try cropping still more from the sand area, the sky becomes oppressive.*

### High horizon
Simply tilting the camera downward makes the horizon move toward the top of the picture format. The uneven division this produces immediately gives variety. Foreground is emphasized and provides most of the environmental clues for the main subject. Since you are now including additional elements that are relatively close to you, the scale difference between nearest and farthest parts of the picture is more marked, giving a great impression of depth. Cropping the sky can eliminate pattern which may compete with the main subject.

**Using a high horizon** (above)
*The high horizon allows the foreground to become an important feature in the picture. The angled shadow adds a sense of movement to the scene.*

# Framing

Often the simplest and most natural framing devices are the most successful. Architectural details, such as windows, or arched doorways, form obvious frames. A silhouetted arch, for example, could form a curved, black frame for a landscape instead of the usual picture rectangle. Make sure that the shape you use adds character to the shot – a store entrance flanked by pots and pans gives a much more interesting silhouetted frame than a bare doorway. It is possible to use upright framing shapes of this kind to allow vertical subjects to work within a horizontal-format picture.

You can find frames almost everywhere, and at any distance. A gap in trees on the horizon can frame a face aligned in front of it quite close to you. A hole in a fence or a space between two people a few inches away will form a foreground shape to frame a figure in the distance. Sometimes cast shadows provide internal frames – backlit arches or windows forming patches of light on the ground.

Frames do not necessarily have to be hard-edged. You can make them diffused and gradated, with the contained picture area fading away on all sides. You can do this by choosing a viewpoint that is so close to a frame that it is rendered completely out of focus, while your main subject remains sharp.

You can also use shapes, tonal or color contrast, or areas of defocused color as frames. Foreground frames add depth to a picture, background frames serve to isolate the subject. Take care with exposure – read for main subject brightness, not the frame area.

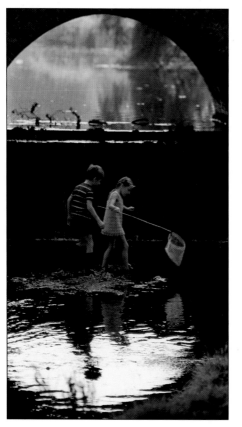

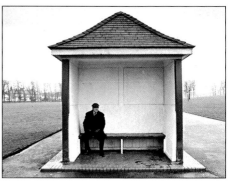

**Outdoor frames** (above)
*The bleak park shelter in this composition shows how a frame's individual character can help to make the point of a picture. It becomes a symbol of loneliness. The off-center figure relieves the picture's symmetry, emphasizing the man's isolation.*

**Powerful shapes** (left)
*The arch and its reflection in the picture, provide a strong frame to the center of interest – the two children. Because the two arch shapes are so powerful it was important to frame them symmetrically to balance the various elements of the composition.*

**Foreground frames** (above)
*Sometimes doorways and windows can be used as frames together. The photographer used an internal doorway as a long, silhouetted, foreground frame. A window out of sight adds some extra illumination.*

**Background frames** (above)
*The frame may not be in front of the subject; here, it is an out-of-focus arch behind. But it still has the effect of keeping the eye concentrated on the principal subject, and so aids composition.*

**Local frames** (left)
*This portrait of a share-cropper's daughter shows how well a hat can act as an eye-catching frame for a subject's face.*

# Contrast

Lighting contrast, and the way it affects objects which themselves possess relative brightness and darkness, gives the variations in tone we need to distinguish most of our surroundings. But our response to tonal differences is also subjective – the eye is easily deceived. A particular tone can look light when you see it next to a black background, but dark against another, lighter one – an effect that is known as "simultaneous contrast."

### Predominantly pale tones
In picture terms, a scene consisting mainly of pale tones is known as "high key". A person with fair hair, dressed in light-colored clothing, standing against a pale-toned background and lit with soft, frontal lighting would probably only show deep tone in the eyes and other tiny areas of shadow. The effect is delicate, open, and optimistic. Landscapes full of light-toned buildings, snowscapes, or scenes with large areas of pale sky, all lend themselves to high-key treatment.

It is advisable to leave a small area of dark tone to prevent the picture from looking flat, and to improve the relative luminosity of the rest. Use soft lighting if possible, plus any nearby reflective surfaces for extra light.

### Predominantly dark tones
The opposite effect – scenes in which most of the tones come from the dark end of the scale – is known as "low key". Results are more dramatic than high key, and may give an impression of enclosure and mystery. Sometimes you can create low-key effects simply by having some dark relevant object in the near foreground to fill large parts of the picture. If you can, choose a background which is as dark as possible, if not black. High-contrast lighting is also usually helpful.

### High-key landscape (below)
*This landscape is dominated by white and pale gray tones. Mist rising from the water scatters the light within the atmosphere, so that even dark objects appear only mid-gray. A few of the nearest elements appear almost black, but these are kept small. The whole mood of the picture is highly delicate and luminous.*

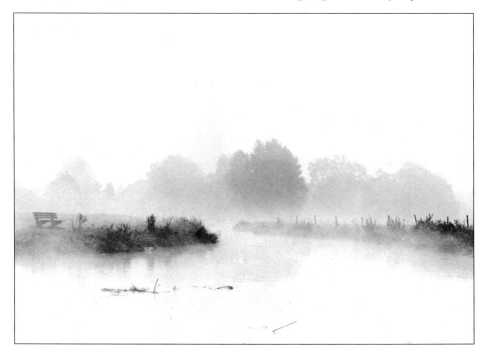

**Low-key scene** (left)
*The man and cat are illuminated by two "slots" of side-lighting coming through a door and window. Solid black, filling most of the picture, adds a note of mystery, and usefully eliminates superfluous detail. Lights emphasize relevant details.*

**Using tone to simplify** (below)
*Use contrast to bring out texture, to simplify lines and shapes, or to provide atmosphere. Frame your subject against a contrasting tone for additional impact.*

**Using contrasting tones** (right)
*In this riverside scene, a strong contrast between dark and light tones produces a strongly silhouetted main subject. Misty detail in the distance and the featureless sky provide a suitable high-key background.*

# Background

Sometimes, when your main item of interest is against an open landscape or plain studio backdrop, the exact relationship between one and the other is not particularly critical. More often, however, backgrounds contain detail and information which contribute a strong sense of environment. They can add to, rather than detract from, the subject of your composition.

Whatever your subject, try to adopt the habit of visually checking all the other details around the main element which are included in the frame. Often it is possible to make a last-minute viewpoint shift to one side, or to stand tall or crouch low, so that the background either contributes more relevant information, or forms a simpler, less cluttered setting.

The background, then, can be tied in with the main subject, or divorced from it. If the two are compatible, use depth of field techniques to keep them equally sharp. If, on the other hand, the background looks as though it might distract from the main subject of the picture, then shift the camera position, or use a wider aperture to throw it out of focus and so lessen the distraction.

You should also remember the effects of colors in the background. Strong colors might dominate a subject, when the background is supposed to be subdued. Once again, such clashes can be avoided by using focusing techniques and camera position.

**Changing your viewpoint** (left) *Both these pictures show the same subject, a man praying, but a change of background affects the pictures radically. The top version shows the bright figure perched high up in the walls of the temple. The background locates the subject in a recognizable and dramatic setting. Warm, frontal lighting pervades the scene. For the bottom version, the photographer altered the subject's apparent setting by climbing up behind him and looking down over his shoulder. From this viewpoint the background is now the river below, giving the subject quite a different setting. Shooting toward the sun now mutes most of the color, except for the man's brilliant-red robes and headdress. These two very different compositions demonstrate how, for most subjects, there is a wide variety of viewpoints to choose from. A location may offer several quite different viewpoints – any of which can produce good, individual images.*

# Balance

Pictures must offer variety as well as balance. It is possible to avoid rigid symmetry, yet create a sense of balance and completeness. Photographers tend to do this intuitively – shifting vantage point or distance to change the placing and spacing of objects until they look "right". When we analyse the resulting composition the various blocks of tone have their own individual "weight" – the whole scene pivots at its center, with everything equally balanced.

**Balance by position**
(above)
*Careful framing can create a striking, well-composed picture from a simple scene. The off-center position of the house is strong and dynamic, at the same time the low horizon emphasizes the sky.*

**Balance by contrast**
(right)
*A shot composed of objects of the same color, size or shape may look repetitive and dull. You create a livelier effect by balancing dissimilar objects. This shot balances horizontal against vertical.*

## Balancing tones and shapes

Think of the various elements in the picture, with their different areas and tonal values, as each possessing perceptual "weight" which can attract our attention in varying degrees, depending on the subject content as well as the picture structure. A particular figure, or a humorous or aggressive situation receives our sharpened attention even when it appears very small in the frame. Local contrast – the difference between a subject and its immediate surroundings in terms of tone, color, shape, and scale – boosts its importance. Lines which lead the eye into the picture can also give an emphasis to a particular element of the scene.

Weight, then, depends upon many factors, all of which have to be judged in the context of the picture as a whole. The challenge is to balance these factors within the proportions of the frame, so that they give a reasonable sense of order without a loss of variety and liveliness.

## Classical and dynamic balance

Composition that makes use of order and balance, conveyed by the frequent use of vertical and horizontal lines, and the simplicity of one center of interest, is usually considered to be "classical".

"Dynamic" balance in a picture means that the eye is actively encouraged to move from one object to another, yet without a sense of destructive division of interest. It is often possible to achieve this by using two elements – one clearly the center of interest, but the other counterbalancing and complementing it. Try to make use of differences in distance, and therefore scale. This kind of approach works much more successfully when the two objects relate to each other in some way – by content, structure, or symbolic relationship. You can present a meaning which goes far beyond the actual content of the scene.

**Classical symmetry**
(below)
*This picture shows
perfectly symmetrical
balance (as shown in the
diagram). Frontal
lighting helps to enhance
the effect.*

**Balance by size** (left)
*The boys in this picture are placed to provide balance. The largest, on the extreme left, balances the figures on the right (as shown below).*

**Balance by tone**
(below)
*In this landscape the smaller tree has equal weight to the larger, lighter group. The diagram (right) shows this relationship.*

**Dynamic composition** (right)
*The two figures in this picture are positioned asymmetrically in the frame. One boy fills a large area of the lower, left-hand corner of the frame, while another takes up a slightly more central but much smaller area in the top, right-hand corner. This makes the figures seem to pull away from each other, an effect that is enhanced by the fact that they face in opposite directions. Our eyes move from one figure to the other, giving the composition both dynamism and a feeling of balance.*

# Using color

Color is all around you and it can be all too easy to take it for granted. The creative photographer, however, learns to look at color in different ways, noting how some colors harmonize, while others clash, and generally using color to affect the mood of the picture.

Color relates to the emotions, and it can make sizable differences in the ways we react to objects and situations – we are far more critical of the color of some things than others (the color of food, for example).

The influence of subject color on mood works in two ways. There is the psychological effect of one particular hue that dominates the entire scene, and there is the way in which groupings of different colors form either acceptable or discordant color schemes. The use of colors creates fundamental changes of mood. Compare the usually somber color scheme of a waiting-room with the strident colors of a fashion store. For quiet effects, mix elements that have similar and fairly muted colors. Rich, contrasting colors gain vibrancy from each other, like the brilliant colors of a flower bed or a fairground.

Try to make use of color schemes to add coherence to your pictures, and to help you interpret scenes expressively. Often this means care over viewpoint choice, to exclude unwanted hues and emphasize wanted ones. Lighting is also important – the less colorful the subject is, the more its appearance changes in different kinds of lights.

**Using warm colors** (above)
*In this photograph of a Sardinian stairway, the photographer makes use of pink and orange hues to give a mood of enclosed sun and warmth. Light reflected from the wall helps to tint the shadowed areas of stone. The stairs lead the eye to a tiny square of blue sky, which is particularly powerful because of the unexpected color contrast.*

**Using cool colors** (left)
*The predominantly blue and green coloring in this interior creates an atmosphere of cool and shade. This is helped by soft, directional daylight from the single window, and reflection from the glossy paintwork, which adds an overall greenish hue to the whole scene.*

**Color and mood** (above)
*Color can profoundly affect the way the viewer's senses react to any given subject. Here, the low sun of early evening, providing a warm, golden color, has matched the tranquil setting, enhancing the peaceful mood of the subject.*

# The qualities of color

When describing or comparing colors it is helpful to use some basic technical terms. The first is "hue" – simply the name of the color, the band of wavelengths our eyes recognize as blue, or red, for example. Second, the word used to describe color purity is "saturation". You will find fully saturated colors in the spectrum refracted out of white light by a prism. If you add white, gray, or black, the color becomes diluted, or "desaturated" – just as it would on an artist's palette. Pastel colors are desaturated, and vivid colors saturated. If a pure red is desaturated it becomes pastel pink, and a green at the dark end of the saturation scale becomes olive. The third term, "brightness", means the amount of colored light actually reaching the eye. Colors tend to look stronger on bright days than on dull days, because the color sensitivity of the eye improves. Films, however, do not share this change – a photograph taken in dim light may reveal a surprising wealth of colors.

**Warm and cold hues**
*The color circle is taken from the white light spectrum. Blue, cyan, and green are all "cold" colors, and yellow, orange and red are "warm". If warm and cold colors appear together in the same picture, the cold ones will seem to recede, while the warm ones advance.*

*Cold*      *Warm*

In practice an object which carries a strong pigment may look pale because of the effect of its top surface. A dull surface can reflect sufficient diffuse, white light from the sky to dilute the color beneath, whereas a glossy surface gives a more saturated appearance. Color degradation happens, too, when your subject is illuminated by light reflected off a nearby surface of a different color. Misty or hazy weather conditions will often add a blue appearance to the light.

**Color harmony** (above)
*Harmonious colors are located close to each other on the color circle. They do not necessarily fall into the groupings of "warm" and "cold" colors. A single dominant color, used in a range of tones to give depth and form, will give a particularly strong, harmonious picture. Atmospheric conditions, such as haze, help to enhance color harmony. Mis-matching film and lighting, using pale filters, or under- or overexposing the shot are also ways of increasing the color harmony in an image.*

**Muted color** (above)
*Muted, or desaturated, color can either include a full range of tones (as here), or be restricted to pale tones (high key) or dark tones (low key). Under most conditions, overexposure gives a high-key effect. Underexposure gives a darker, low-key image with black shadows, and rich color in the highlights. High-key pictures are enhanced by using pastel-colored subjects, and diffused front lighting. Low-key pictures, on the other hand, often use rich-colored subjects and high-contrast lighting.*

**Strong colors** (above)
*Fully saturated colors – with almost no black, gray, or white – are the strongest, most intense colors. They have to be used carefully, as they easily detract from the main subject, and can confuse shapes and forms. Direct lighting and subjects with shiny surfaces help to give maximum color brilliance.*

**Distorted color** (above)
*Manipulating color, either locally or overall, can create interesting results; but if overdone the result can appear too contrived. The exact results are difficult to predict, but you can often make dramatic pictures from quite simple subjects. This picture was taken on infra-red film.*

**Saturated and desaturated color** (above)
*These two pictures of many-layered, torn advertising posters illustrate the different moods created by red and blue when they are fully saturated, and desaturated. The limited range of bold, saturated red and blue*

*(above left), gives the picture a lively, festive atmosphere. Desaturated, bleached pinks and pale blues on the other hand (above right), illuminated by warm lighting, create a much more harmonious, overall mood.*

**Mixed colors** (above)
*The plain white background in this picture has helped to balance the effect of so many different colors in the main subject.*

**Isolated color** (above)
*Even a relatively small area of strong color will dominate a picture when set against a neutral or monochromatic background color.*

**Contrasting colors** (above)
*Two contrasting, equally saturated colors can often detract from each other. But they are effective in this picture, because of their great difference in area. The tone variations within the green give just sufficient form to identify this as part of a car.*

**Harmony using one color** (right)
*Harmony in this landscape is created by the use of one main color – green. The wide range of subtly differing tones is made more apparent by the hard sidelighting, giving the picture a feeling of depth and separating the shapes and forms.*

**Muted color** (right)
*In this shaded street
scene, diffused lighting
has softened and merged
colors and shapes. Look
for muted colors when
light is scattered by haze,
rain or smoke.*

# Related and opposed colors

It is possible to "pull together" a picture containing a number of diverse shapes and forms, and to give it continuity by using color skillfully. In the same way that you might exploit any other kind of visual structure, it is often worth taking pictures for the color itself, making color combinations and themes, which can be appreciated for their own sakes, the main point of the photograph.

One approach is to explore harmonious, restricted colors, perhaps choosing subjects which have only two or three muted hues, similar in saturation. As an alternative, you can structure the picture around the interplay of only two colors, or, by careful selection and framing, show one color in various degrees of saturation, with the rest of the picture consisting of blacks, whites, and neutral grays. In landscape photography, the presence of water is very helpful for this technique. The surface of a lake or river reflects and takes on the color of the sky and surrounding landscape, increasing the area of variations in a single color scheme. On a smaller scale, puddles and pools can do the same job, and often separate the different areas of color far more efficiently than larger expanses of water can.

**Color interplay** (left)
*In this street scene, shadow cast by the low sun supresses the neutral tones of sidewalk and street. All the lit areas contain harmonious colors. Reflections from pools of water bring this same color scheme down to the bottom of the picture, but in a contrasting shape. This relates the different areas of the scene to each other.*

**Muted opposed colors** (left)
*This deceptively simple picture shows how well a composition can work when it is restricted to two opposing colors. In reality the bench, ground, and trees all differ in their muted hues, but the early evening sun has bathed all of them in pinky-orange light.*

**Dramatic color** (below)
*Opposing colors can add drama to a picture. Here, the yellow of the building contrasts strongly with the dark blue of the sky, with the black shadow on the building adding its own impact.*

# Using color for emphasis

Color offers a variety of ways in which you can control where emphasis falls in a picture. This does not mean that a composition has to be particularly colorful – if most of the hues in a scene are restrained, one element forming a single splash of color takes on great strength. Your main subject may itself be relatively free of color, but if it is backed up with an isolated patch of color, the same principle of color emphasis can dramatically help to make the picture work.

Some hues seem to seek attention more than others. Reds tend to come forward or "expand", while blues seem to "contract" and hold back. When many colors combine in one subject, the effect does not have to be a muddle. It depends what other hues are present, the context or mood of the subject, and the nature of the lighting.

**Warm and cold colors** (left)
*Generally, a restricted color range is more effective than a mass of unrelated colors. The shot of the bus is bright and colorful without being gaudy – strong colors are well balanced by more neutral tones. You will achieve the most dynamic color contrast by emphasizing warm colors against cold ones – reds and yellows against blues and greens.*

**Color in a supporting role** (right)
*The tree and the hooded figure are the main sources of balance in this picture. They balance each other out. But the background colors are important because they provide balance for the black and gray tones in the picture. The effect would be quite lost in a black and white picture. The colors also form a muted background wash which helps to link the elements with each other.*

**Color attraction** (above)
*A dramatic color contrast can give unexpected importance to a very small element of a scene. This landscape uses the contrast between the rust-red roof and the green fields behind it to emphasize the barn and its reflection as the main subject, although they* take up only a small area of the picture. This effect is enhanced by the tendency of reds to "come forward". In black and white, the red and green areas of the picture would merge as a single tone, and the lighter wall and foliage would form similar grays. The focus of the picture would be lost.

# Color contrast

Differing colors placed together in a composition create contrast, particularly if they are strongly saturated, far apart on the color circle, or offset by black or white. Saturated warm and cold colors together give bold contrast, the strongest effect being when a saturated color is adjacent to its "complementary", or opposite from the color circle.

To give greatest color contrast between the most important element in the picture and its immediate surroundings, use two colors which complement each other (such as yellow and blue). The conflict in hue will produce a dramatic effect, giving the main subject in the scene a definite emphasis.

The importance of color contrast can be seen if you consider how the pictures on this page would look if they were in black and white only. Subject colors would all become similar tones of gray, greatly reducing the points of emphasis created by the color contrasts.

Too many bright colors detract from each other and can confuse the image, and should be used only when you want to create a discordant effect. The greatest impact with bright colors can often be created by keeping the composition simple.

**Contrast using color**
*This picture uses a limited range of tones, and creates contrast through the use of color. The same scene in black and white would appear flat and uninteresting by comparison. Soft, even lighting brings out the pale colors of the leaves against the muted color of the wall.*

**Active and passive colors** (left)
*The contrast of active red and passive blue is supported by powerful composition in this picture of a boat swing. The blue recedes and the red advances, so that the swing appears almost to leap forward out of the picture. Diagonal lines add to the sense of movement. A fast shutter and head-on viewpoint helped to freeze motion.*

**Contrast using black and white** (below)
*The strong red color of the mountains in this picture is emphasized and made more luminous by its contrast with the black, underexposed foreground and the light-toned sky. The simple, dark silhouettes of the cacti and bushes form powerful shapes against the background color.*

# Isolated color

When a small, colorful object appears in a predominantly gray scene, it can have an influence out of all proportion to its size. This influence is much greater than that of the corresponding tone in a black and white picture. A quite small area of red, for example, may require balancing with a much larger area of gray to produce equilibrium. This effect, known as "isolated color", can therefore be a powerful way of emphasizing your main subject in a scene. It is especially effective in dull, overcast weather, or in drab locations which are muted in color. The eye is automatically attracted by the variety and sparkle that a distinct, bright hue can give to such conditions, so it is important to position and frame it in the viewfinder very carefully.

When learning to use isolated color in this way it is useful to seek out small patches of individual color and try framing them so that they dominate the picture. For example, in a garden, a backlit urn full of bright flowers appears strong and colorful when shown against a background of dark, shadowy hedge.

Compare this with the scene when it is seen from the sunlit side, where the flowers are just one of many competing areas of color. Sometimes a large block of color can be isolated by masking it with dark foreground objects. A child against a brightly colored garage door can be photographed from indoors, so that she is isolated – framed by the dark area around the window. In the same way, at night a patch of light reveals just part of a large, colored billboard. On a gray winter's evening in the city the scene is enlivened by a neon sign high up on a building. Small reflective surfaces are another good way of localizing color. A mirror hanging on a wall can introduce a reflected patch of sunlit color into a scene which is otherwise muted by shadow. Or a pool of water can show a brightly colored detail reflected off the paintwork of an automobile.

**Isolated red on gray** (below)
*Gray stormy skies and featureless gray water often provide an ideal setting for isolated color. For this picture, the photographer read the exposure from the sea. Then, he observed the movement of boats, until this group of red sails formed on the water. Notice how the red leaps out from the background.*

**Contrasts and colors**
(right)
*Capturing the bright
colors of the bird against
the muted tones of a dark
background has given
this picture impact. Had
the background also been
full of bright colors, that
quality would, without
doubt, have been lost.*

**A break in color**
(below right)
*This striking picture uses
a small break in a frame
filled with regular pattern
and strong color to
emphasize its main
feature. The isolated
purplish blue sky reflected
in the window seems to be
made stronger by the red
and yellow leaves filling
the rest of the photograph.*

# Subtle color

In color photography, you will often find that "less is more." In other words, that restricted color is usually more effective than a picture filled with a confusion of varied colors and tones. One means of creating harmony and strength is to limit yourself to the subtle effect of muted, or desaturated, colors. Pictures using muted colors can convey many different moods. They may use a full range of desaturated tones, or be restricted only to pale tones (high key) or dark tones (low key).

Even in subjects which might at first appear almost colorless, muted colors can be found – modern color films can record, and even slightly exaggerate, very pale colors. A composition with a predominance of white, gray, or other neutral tones makes the presence of muted color very significant. This is because neutral tones help to pick out every slight variation in tint.

Hazy lighting, rain or mist, can subdue the colors in your subject. When working indoors use diffused or bounced illumination to soften colors. The easiest method of toning down color is to use a simple glass diffuser on the lens. Diffusers can be bought in a variety of strengths but all have the effect of spreading the light and softening colors.

Slight overexposure of color slide film tends to desaturate colors, turning otherwise strong hues into pastels, and generally gives the impression of a high-key effect. Overexposure dilutes color in the brightest parts of the picture most, and so only the dark areas record color strongly. Underexposure gives a more low-key effect, with color recording most strongly in the highlights.

**Muted colors and black and white** (above)
*Taking a largely black and white subject, such as the sheep, with color film might seem pointless, yet the shades of black and white work to bring out the muted colors that blend and change with distance.*

**Subduing color** (left)
*Shooting through mist is a way of subduing colors and producing a subtle version of a subject which might otherwise have been much more colorful. The mood of this photograph would have been quite different in clear light.*

**Diffused light and muted color** (right)
*This fishing scene appeared almost monochromatic at the time of shooting. But through the slight mist, light from the dawn sky gives a pink flush to the water, adding greatly to the atmosphere.*

**Muting colors by exposure** (below)
*Overexposure gives a bleached effect. Normal exposure would have given a grayer sky which, together with the strong-colored laundry, would have detracted from the central figure. The muted effect is enhanced by the low camera viewpoint.*

# Manipulating color

You can create new and unusual images if you manipulate subject colors during exposure, by using filters, by over or underexposure, or by using inappropriate film for the lighting. You may do this to "warm up" or "cool down" a color scheme, or to create a particular interpretation of your choice.

## Filters

Extremely pale filters give a slight overall tint, most noticeable in delicate colors and highlight areas. Subjects of normal contrast are often spoiled by using a strong filter. However, backlit or similar high-contrast images can give you interesting results with strong filters, particularly if you also under- or overexpose them. The result is often the filter color plus either black or white.

Color negative film allows selective filtering during printing, so color changes can be made in the darkroom. If you use slide film, color manipulation will mostly have to be done in the camera, usually by adding lens filters. If you have your color negatives commercially processed, your manipulations may be "corrected" as errors, so you should include instructions together with the film to print as for normal negatives.

## Film

Another way of deliberately distorting image colors is through the film. One way of doing this is to use the wrong light source. It is worthwhile experimenting with the color casts created under different lighting to get the effects you want.

A simple way of doing this is to use the "wrong" film in different lighting. Normal daylight-balanced film will give a warm, yellow-brown cast when shot under artificial light. Film that has been balanced for artificial light, on the other hand, will give an overall blue cast to a picture shot in daylight.

**Graduated filters**
*Sometimes the colors in a scene can be given added interest and variety by using graduated filters. These filters have one color that diffuses into clear glass. The seascape was taken first without a filter (above left), and is almost monochromatic. The same scene (above right), taken using two graduated filters – blue and brown – has added color, especially in the highlights. A similar effect can be achieved by simply holding pieces of gelatin part-way across the lens and observing the effect in the viewfinder on a reflex camera with the lens stopped down to the appropriate aperture.*

**Blue filters** (left)
*This picture was taken against the light on daylight film through a dark-blue filter. Most of the brightly lit center of the picture was overexposed, resulting in little or no color. The darkest blues appear in what were originally dark mid-tones and shadows.*

**Red filters** (right)
*This high-contrast scene was photographed on daylight film through a strong red filter, and underexposed to restrict the main colors to red and black. The sun itself is just brilliant enough to overexpose and so bleach through the red cast created by the filter.*

# Using light

Without light there can be no photography. Yet many photographers fail to understand the importance of light or the way it affects the subject. To make the most of any picture, you must train yourself to really look at light, be it natural or artificial. The way the eye sees different lighting conditions and the way the film sees them can often be very different. The creative photographer must learn to understand those differences.

Lighting effects can range from the grand to the minute in scale. An aerial view of a vast city just after sunset is transformed by the evening light into abstract patterns of purple. Sunlight reflected from the inside rim of a cup forms a sparkling pattern of curves on the liquid's surface. The slanting light of dawn or late afternoon will tint the edges of fine seaweed, sand dunes, or huge cliffs alike. A reflection in a puddle, or in the gleam of an eye, can be as telling as a whole cityscape reflected in a lake.

Light has psychological significance, too – strange or unfamiliar forms of lighting suggest a disturbing mood, and command our attention. A face above a candle for example, or a room in a house surrounded by snow, or an airplane flying above over clouds, all receive unnatural, "up-turned" light, with a disquieting effect.

**Into the light** (above)
*When a translucent subject such as a leaf is shot against the light, it can be made to "glow" against a more subdued background.*

**Shadow and direction change** (left)
*Shadow lines falling across a pillar in this picture are cast by an unseen grid. Notice how they change direction and bend to follow the pillar's form. Straight lines falling on the pillar resemble fluting.*

# Lighting effects

Shadow – basically the absence of light in relation to surroundings – can have as important an influence on a photograph as light itself. Shadows appear attached to objects in two main ways; they are either cast or contained. Cast shadows fall on another surface, away from the object itself. Contained shadows remain inside the boundaries of the overall shape of the object. In most lighting though, both cast and contained shadows occur simultaneously around an object.

Always give shadow shapes the same attention as the lit areas of a scene. Sometimes you can exclude the object forming a cast shadow altogether. You can show the shadow of a huge tree behind you spread out over a field in front, its branch shapes reaching out in a pattern toward the horizon. If you keep the sun behind you, it is also possible to include your own shadow in every scene you photograph, forming strange associations and giving a kind of continuity.

**Repeating pattern** (above)
*High viewpoint, and the long shadows cast by late afternoon sun show this small group of figures as a double pattern. If you view the picture turned upside down, you will see how much shadow and subject shapes differ.*

**Low contrast** (above)
*Landscapes are usually thought of as colorful subjects. But shooting in low-contrast conditions, and matching* the mood of the picture to the light, sometimes subduing the colors, can be an equally effective technique, if used with care.

## Silhouettes

Silhouettes, with their stark, definite outlines, have an eye-catching simplicity. The subject communicates itself to the viewer by means of its shape alone – continuous shadow, for example, swallows up all form, color, and texture. Notice the visual strength of a tracery of tree branches, or the imposing shape of a building against an evening sky. The sun silhouettes any figures standing against it – a profiled face by a lighted window, or a figure standing on the brow of a hill obscuring the sun itself, becomes a strong, black shape. Be careful when choosing viewpoint, as minute shifts can have dramatic effects.

**Exposing for silhouettes**
(above)
*When a foreground subject is under-lit, compared to the background, expose for that background to make a strong silhouette of the subject.*

**Silhouette and environment**
(left)
*In this silhouette, enough detail is visible in the background to contribute a sense of environment. The picture was taken facing directly into the sun, which is hidden behind the foreground figure. Slight light-dispersal by haze over the sea separates the boat from the sky. These fishermen and their rods make strong repetitive shapes, which merge into the dark area of ground. Intense brilliance and contrast in this kind of picture may create problems when you are measuring exposure.*

## Sun and flare

Shooting directly into a bright light source, such as the sun, is often a direct and powerful way to add luminosity and radiant light to a picture. If the sun is just outside the frame, it may be possible to "spill" flare light into the picture to suggest glare. Sometimes you can add "flare spots" – colored, matched shapes of light – to the image itself. The size and shape of the spots depends upon the lens aperture setting you use; and quite small shifts in viewpoint affect them radically, too. Make sure that you notice these aperture flare spots if they occur and either compose them carefully as a constructive ingredient of the picture, or avoid them altogether by shading the lens. For greater overall flare, shoot through glass or use an old lens without anti-flare coating.

## Rim-lighting

Rim-lighting is a means by which a dark subject can be shown against a dark background without losing its outline. When the light source is mostly behind the subject, but also higher or to one side of it, a narrow strip of highlight will pick out the rim of the subject's top or side. If the background is also stark, it is possible to show up almost the entire outline of a subject.

**Flare spots** (above)
*In this picture, direct, bright sunlight has spilled into the camera lens from the top left-hand side of the frame. Each glass element of the lens forms a ghost reflection of the hexagon-shaped aperture.*

**Outlining shapes** (below)
*This picture of mannequins shows how rim-lighting can simplify a scene. The mannequins are in fact light-colored. They were lit by overcast daylight coming through wide windows, from above – each one reflecting a little light on its neighbor. Precise framing creates a highly structured picture.*

# Daylight

During the course of any day, light changes in both direction and in its actual color. These latter changes are not always apparent to the naked eye, but they are picked up by the film in the camera.

Direct sunlight at noon has an approximately even distribution of color wavelengths. Toward the beginning or end of the day, fewer short (blue) wavelengths are present. When the sun is low in the sky its light passes through the earth's atmosphere obliquely. Air molecules in the atmosphere always scatter a small proportion of light rays travelling through it, the most scattered being the short wavelengths (this is why the sky looks blue, not black). But sunlight reaching the atmosphere obliquely must pass through hundreds more miles of these molecules than at noon. They progressively filter out more short wavelengths, leaving only orange and red-colored radiations. This corresponds with the color of the sun at dawn and dusk which gives the sky its characteristic warm tints.

Changes in weather conditions throughout the day also influence color. When the air contains many water particles – haze, mist or cloud – these tend to absorb light, mostly in the blue regions of the spectrum again. The sky looks less blue and more white than at noon on a clear day. For the bluest lighting of all, look at the illumination from a clear sky as it affects shadows at midday.

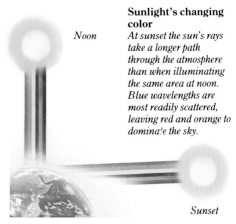

*Noon*

*Sunset*

**Sunlight's changing color**
*At sunset the sun's rays take a longer path through the atmosphere than when illuminating the same area at noon. Blue wavelengths are most readily scattered, leaving red and orange to dominate the sky.*

**The color of dawn** (above)
*Dawn produces a light that is all its own, suffusing the picture with a warm glow that can be seen at no other time of the day. Shooting at this time of day can cause its own problems. Low light leads to slow shutter speeds, so care must be taken to prevent camera shake.*

## TIMES OF DAY

Daylight is constantly changing, offering a range of colors and qualities between dawn and dusk, and in different kinds of weather. As it changes, it alters the appearance of everything you see, and different light can show the same subject in a variety of moods. Look at your subject at different times, waiting for exactly the light you want.

**Dawn** (left and below)
*Early sunlight contains few blue wavelengths, the whole scene is bathed in orange light. Similar effects can occur directly before dusk, depending on the weather.*

**Noon** (left and below)
*By late morning daylight contains a more even mixture of wavelengths. The widest variety of subject colors are seen, increased in brilliance by the strong lighting.*

**After sunset** (left and below)
*After the sun has set, blue-rich wavelengths dominate the light. These illuminate building and boats from parts of the sky behind the camera. The last direct light from the sun tints high clouds and sky. The still water reflects the clouds.*

**Storm light** (above)
*Sunlight before or after a storm, at any time of the day, creates dramatic lighting effects. Lit surfaces set against the dark sky seem to have a greater brilliance of tone and color. White objects stand out starkly. In changeable weather conditions, the whole mood of a scene can be transformed within minutes. Usually the most brilliant colors are seen in distant landscapes when sunshine follows directly after a heavy shower of rain. This is because of the exceptionally clear atmosphere – the air is literally "washed" clean.*

# Direction

The direction of lighting, together with its quality, affects the amount of contrast (difference between light and dark areas) in a subject. Contrast is closely related to the tonal range in a subject, and with shape it determines form. When light quality is hard, contrast is high, and the direction of the lighting can be used to emphasize or suppress the form of your subject.

If your subject is static you may have to alter your viewpoint to make the best use of available lighting. The strongest three-dimensional effects are usually produced by side-lighting; with the light behind the camera ("front-lighting"), subject detail is brought out with minimal texture and depth; shooting against the light ("back-lighting") creates high contrast, reduces detail, and simplifies form. (Never look directly into the midday sun through the viewfinder of your camera. You may permanently damage your eyes as well as your camera.)

Sometimes you may be able to select the ideal viewpoint and then return when the lighting direction and quality give the sort of effect you want.

## Viewpoint and lighting

Even though you can alter your own viewpoint in relation to almost any subject, this will not alter the way in which it is lit and shadowed. Altering your viewpoint will, however, affect how much of the lit and shadowed areas you can see, ranging from a view of the totally lit surfaces only, to a view where only the shadowed surfaces appear. Another factor to consider is the degree of glare from reflective surfaces when you view them from particular angles in relation to the light. This glare gives an increase in contrast between the brightest and darkest areas, which in photographic terms can either help to give dramatic effect, or destroy subject detail that you want to preserve. Equally, from some viewpoints there will be reflective surfaces which redirect some light back into the shadow areas. At other times, nearby grass and trees, for example, may cause problems by tinting shadows green, in which case you must choose a different viewpoint or time of day when these surfaces do not act as reflectors and produce these unwanted effects.

These are all subtle points to watch for, points which may be picked up by the film, if not by the eye. Being prepared will help you to take better pictures.

**Fixed lighting, changed viewpoint**
*Although the mill was lit from the same direction throughout, changing viewpoint has given a different lighting direction in each picture. From viewpoint 1 the sun sidelights the mill from the right. Moving around to viewpoint 2 and shooting into the sun, the now totally shadowed surfaces have a flattened, semi-silhouetted appearance. Viewpoint 3 results in a picture sidelit from the left. Compare these results with the series of two people in a boat.*

1

3

2

3

## DIRECTIONAL EFFECTS

### Side-lighting

Side-lighting strongly reveals the depth in three-dimensional subjects, but gives much less overall detail and information than front-lighting. This is because of the often harsh contrast between lit and unlit areas, and the long shadows. The more numerous and complicated the shapes present in a scene, the more harsh side-lighting will make it difficult to distinguish individual objects.

### Back-and-rim-lighting

When light comes mostly from the rear of the subject, shadows must form toward the photographer. If the whole background is brightly lit, an opaque object in the foreground is silhouetted. Objects reveal their complete outlines, giving a stark, black appearance. But moving around the subject in full daylight makes it possible to achieve a backlit effect.

**Different surfaces** (above)
*Side-lighting gives a confusing mixture of shadows and highlights across certain complicated surfaces.*

**Silhouette shapes** (above)
*Back-lighting from the sun directly ahead silhouettes foreground shapes – most detail merges into flat, simplified, dark tone.*

### Front-lighting

In a frontally lit scene, the light comes from directly behind the photographer. Shadows tend to fall behind the parts of the subject that formed them, and are mostly hidden. Lighting from this direction floods surfaces with illumination, revealing maximum detail in the subject, but minimizing texture. Three-dimensional objects lose most of their appearance of form and depth. Colors, however, are often rendered brilliantly when they are lit in this way. Front-lighting is also a good way of producing the maximum amount of glitter from a highly reflective surface such as glossy paint or glass.

**Flat detail** (above)
*Lighting from the front gives detail, yet has a flattening effect. Shadows are hidden behind the objects that produced them.*

# Quality of light

Quality of light combined with light direction is only one of several lighting factors influencing a scene. Shadows are not always hard-edged; often they are soft outlines, and give little contrast between shadowed and lit areas.

The "hardness" or "softness" of shadow areas is an indication of light quality. Hard-quality light tends to give stark, dramatic effects. Shadows contribute strong lines and parts of subjects are often well defined. With soft-quality light we are less conscious of shadows, and the form of the subject itself dominates over shadow lines.

By careful choice of lighting it is possible to create shadow of a quality that suits the mood, subject, and structure of a picture. Hard lighting might suit a portrait of a man hard at work, but it could destroy a romanticized portrait of a mother and child.

**Hard-light abstraction** (left)
*In this simple composition hard noonday sun projects sharp, downward shadows, which are exactly the right length and angle to duplicate the design of the tiles. Notice, too, how the harsh light reflected from angled louvers in the window shutters makes the paintwork glisten. This helps to break the picture's otherwise severe symmetry. The clothes line, some distance in front of the wall, has cast its shadow outside the picture frame.*

**Soft-light detail** (right)
*This picture of the interior of an Indian temple shows how totally diffused light can reveal minute detail in a complicated structure. Reflections from ceiling and walls outside the picture area have scattered most of the daylight, giving an even luminosity to the carved pillars and polished stone floor. Hard lighting would have produced a complicated grid of shadows, which would have confused this subject even further.*

### Hard light

*Hard lighting results when you have a relatively compact light source. Areas behind objects are blocked off from light, and form hard shadows. Hard light sources include the sun (which is comparatively small in the sky), flash bulbs, and bare light bulbs.*

### Soft light

*Lighting is softened when the illumination is scattered, perhaps as a result of sunlight passing through cloud, or the light being reflected from a light-toned surface. The result is a generalized lighting, which creates shadow areas that are diluted and soft-edged.*

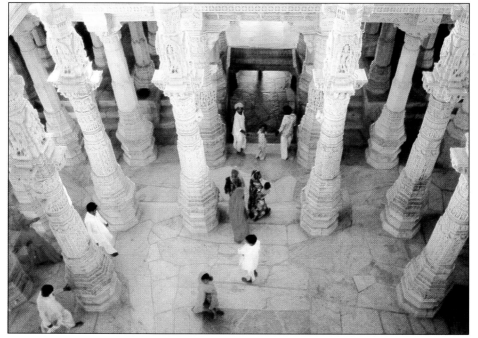

# High-key and low-key lighting

Most subjects contain many gradations of tone between black and white. The tonal range is affected by the lighting, the reflective properties of materials, and the colors in the subject. Subject tones may change sharply, or gradate gently. These attributes mark the differences between high-key and low-key.

Creating these effects relies on subject, lighting and exposure. For a high-key picture, for instance, a light-toned subject against a light-toned background needs to be lit mostly by frontal, diffused lighting. A low-key picture, on the other hand, should exclude light-toned subjects and needs more directional light.

This theory can be applied to still lifes and portraiture, where the tones in the picture can be carefully controlled by the photographer, using artificial light in the studio. Some types of subject may benefit from a low-key approach, using lighting to convey dark, moody effects with high-contrast lighting. Using light colors and flat lighting will produce a less contrasty, shadowless light, which, in turn, gives a more delicate effect that might be better suited to other subjects.

These techniques first came into being when photography was essentially a black and white medium, and today the use of high- or low-key lighting in a picture tends to work best in monochrome. There is, however, nothing to stop the creative photographer using similar techniques to impart different moods to color pictures, using light, pastel colors for high-key and darker, more sombre colors when a low-key effect is required.

**Low-key** (above)
*This low-key picture has a moody, forbidding air created by predominant dark tones and few highlights.*

**High-key** (above)
*This high-key landscape uses pale tones from the high end of the tonal range to create a sense of space.*

**Low-key portrait**
(above)
*The somber, slightly
mysterious atmosphere in
the portrait is largely
conveyed by the
predominantly dark
tones of the image. The
choice and arrangement
of clothing, the underlit
background, and the
exposure – which was
measured only for the
flesh tones – all help to
limit detail to the face
and hands. In these flesh
areas, form is strongly
conveyed, giving the
portrait character and
individuality.*

**High-key portrait**
(right)
*The lightness and
delicacy of this high-key
portrait come from its use
of values at the pale end
of the tone scale.*

# Light and surfaces

The surface qualities of a subject are conveyed by texture. Texture can be used to give realism and character, and may itself form the subject of a photograph. It can be brought out either by working very close-up or by working at a distance where large areas of the subject merge to create texture. Used as a subsidiary element, it can add strength to the subject.

Lighting quality and direction are of the first importance in revealing the texture of a subject – they must give a rich tonal range (which can be further enhanced through the processes of exposure and printing).

For showing up texture across horizontal surfaces, such as waves, cobble stones, or wooden floorboards, oblique sunlight is excellent. Try to pick a slanting light that comes mostly from behind the subject, so that the surface textures produce short, hard-edged shadows which come forward, and each raised part of the subject is then outlined by a rim of highlight. For extreme emphasis, use a light that is almost parallel to the surface.

**Combining textures** (above)
*In this picture two quite different textures are combined. The textures of the pebbles and the smooth wet rock are enhanced by direct, hard sunlight from behind the subject.*

**Side-lighting a surface** (below)
*Harsh, angled sunlight emphasizes the aged, weather-beaten texture of the door. Textured surfaces that are mostly on one plane are often accentuated by hard, oblique lighting. Close-up shots often need a point of reference like the latch in this picture.*

**Glossy surfaces** (left)
*Any material which has a smooth, glossy surface tends not to disperse the light, but to reflect it in one direction only. This means that from one vantage point you see a glaring "hot spot" of light, if the light source is hard, or a larger patch of reflective sheen if it is soft and diffused. From all other viewpoints the object is free of surface finish reflections.*

**Skin texture** (below)
*The wrinkled texture of the man's face in this picture gives the portrait a strong and interesting character. The man was positioned in the shade so that soft, reflected light illuminated his skin evenly without dense shadows.*

# Using existing light

The term "existing light" is a confusing one: surely all light is "existing" in some way? In photography, however, the term has come to refer to natural or man-made light sources which might not always be thought suitable for, or specifically designed for, photography.

Whenever possible, use existing light for its infinite variations and subtleties. The reason for this is that flash used on the camera, although a technical convenience, often destroys these natural lighting qualities by giving a harsh burst of frontal illumination. Ordinary, everyday lighting can be both atmospheric and symbolic, too – often possessing nostalgic qualities. The flickering light from a camp fire, and the solitary, lit window of an isolated house at dusk, become symbols of invitation. The glare of a fiery sun, or the softness of overcast weather, form a reminder of particular seasons, or different parts of the world. Bobbing lines of flame torches at night, and strings of colored lights, are reminders of special processions and festivals. The soft, moody light of banks of candles in a dark cathedral is evocative of a hushed atmosphere of worship.

For the most part, it is the simple visual incidents created by light which are the most rewarding. We often notice them, but tend to underrate them as photographic subject matter. The way morning light spills around drawn curtains, or forms a brilliant pool of light when it is refracted through a glass bottle, can be just as exciting as the most elaborate floodlit building at night.

**Light spill** (left)
*This composition creates an arresting subject out of something that we see all the time – light spilling into a room from a barely opened door. It shows that even the simplest light formations are worth observing carefully and using.*

**A curtain of light** (right)
*In this market scene, rays of sunlight, "sliced" by a grid, and travelling through a dusty atmosphere, form a "curtain" across the bazaar. It separates the boys in the center from other figures behind. The projected pattern of bars and the spots of light on the ground add a sense of luminosity and depth.*

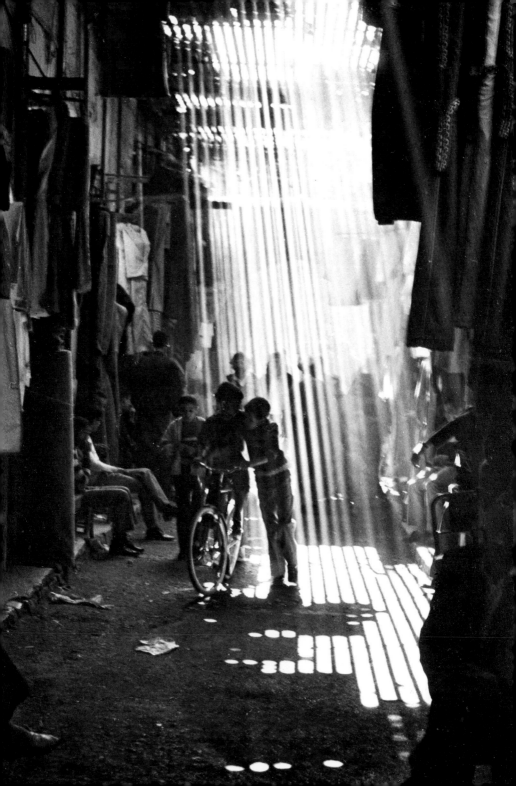

# Using lenses creatively

A standard lens, the type that is most often supplied with the camera, is designated as one whose focal length is approximately equivalent to the diagonal of the format it serves. On 35mm that gives a standard lens of around 50mm; on medium format the standard is more like 80mm; larger and smaller formats require longer and shorter standard focal lengths respectively. The angle of view of a standard 50mm lens on a 35mm camera is 46°, and for many straightforward pictures this proves perfectly adequate for the majority of subjects. Either side of the standard lens are shorter and longer focal lengths, which give wider and narrower angles of view and differing degrees of subject magnification.

On SLR cameras the lens barrel can be detached from the camera body. This enables you to change to lenses of other focal lengths. An SLR camera is ideally suited for a range of lenses. Its through-the-lens focusing system shows you the altered amount of the subject that the lens includes.

On many compact cameras, focal lengths can also be changed by means of a dual lens control or a built in zoom lens. In both instances, the viewfinder image changes to correspond with the focal length set.

A range of lenses allows you to record images that cannot be caught with a standard lens. The characteristics of each lens also give different impressions of the same subject. A range of lenses will give you more creative options as a photographer by allowing you to photograph distant objects, include a wider scene, or capture the smallest details of the subject. As well as these more immediate characteristics, each lens will also have more subtle effects on the appearance of an image. Changes of focal length or lens design will slightly alter elements such as perspective and depth of field.

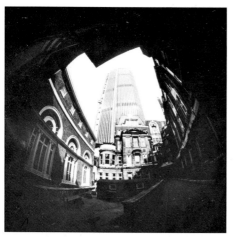

**Fisheye for framing** (above)
*An 8mm fisheye lens was used for this picture. The photographer took advantage of the lens' circular image field to frame the modern skyscraper with the older buildings near by.*

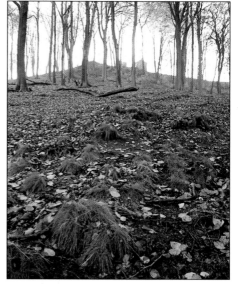

**Extended perspective** (above)
*A wide-angle lens has the effect of "stretching" perspective to give a strong sense of distance. It will also extend the depth of field to keep the image sharp from foreground to background.*

## Focal length and angle of view

*From ultra-telephoto lenses capable of bringing distant subjects into close-up, to the 180° (or greater) panorama of a fisheye lens, the diagram shows how angle of view narrows as focal length increases. Depth of field is also reduced with an increase in focal length, and apparent perspective is altered. All of the focal lengths and angles of view shown relate to the 35mm format.*

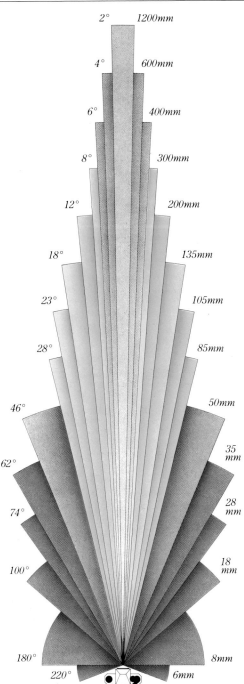

2° 1200mm
4° 600mm
6° 400mm
8° 300mm
12° 200mm
18° 135mm
23° 105mm
28° 85mm
46° 50mm
62° 35mm
74° 28mm
100° 18mm
180° 8mm
220° 6mm

### 400mm to 1200mm
*Useful when the inaccessibility of a subject precludes the use of a lens with lower magnifying powers. Size and weight, risk of camera shake, a small maximum aperture, and limited depth of field are their disadvantages.*

### 85mm to 300mm
*These lenses are portable, relatively light, and have sufficiently wide maximum apertures to permit hand-holding with fast shutter speeds in favorable light. The longer the focal length, the shallower the depth of field, and the stronger the compression of perspective becomes.*

### 50mm
*Regarded as the "normal" or "standard" lens for the 35mm format. The image size in the viewfinder is roughly equal to the eye's view of the scene. These lenses offer the widest maximum apertures.*

### 18mm to 35mm
*Wide-angle lenses have a large depth of field. They are ideal for use in confined spaces, or when close contact with the subject is needed. The shorter the focal length, the more distortion there is toward the edge.*

### 6mm to 8mm
*"Fisheye" lenses have a far wider angle of view than the human eye. Horizontal and vertical lines, except in the center of the view, are quite dramatically distorted.*

# The effects of different lenses

On a 35mm camera the basic lenses are typically a standard 50mm lens, a short focal length, or "wide-angle," lens of 28 or 35mm and a long-focus, or "telephoto," lens of 100 or 135mm. These three form a useful set for most work, but for more specialized needs there are many intermediate lenses to choose from, as well as the more extreme wide-angle and telephoto types, and close-up and perspective control lenses.

Having interchangeable lenses means that picture making can be extended in three important ways. First, you can change the amount of the subject included from the same camera position. Second, you can control the perspective in your pictures. Third, you can reduce or increase the depth of field.

The focal length of any lens affects its angle of view – the area that it takes in. Lenses of a short focal length have a wide angle of view, taking in a large area of a scene, so that each individual element of the picture is relatively small in the whole frame area. At the other end of the scale are the longer focal length lenses which take in a far smaller angle of view, which has the effect of making the central element of the image relatively large in the frame.

A short focal length used from a close viewpoint gives your pictures a greater feeling of depth than a standard lens. Elements in the background recede and appear much smaller in size. Lines and planes converge strongly within the picture to add to the depth. Long focal length lenses used from a more distant camera viewpoint have the opposite effect making the background elements appear larger and generally "flattening" perspective, lessening the sense of depth in the picture.

Changing to a shorter focal length lens always increases the depth of field in your pictures, even at the same aperture. This is because foreground and background elements are brought into sharp focus much closer together within the camera. As a result, at any one aperture a larger area of the image is acceptably sharp than would be the case with a lens of longer focal length.

## Wide-angle lenses

*A lens of 28mm focal length is wider than standard on the 35mm format. It opens up the picture area, allowing you to record more detail on each side, top and bottom of the picture area. It is useful for landscape photography and for indoor work where conditions are too cramped to use a standard lens.*

*28mm lens*

## Standard lenses

*A standard lens on a 35mm SLR has a focal length of 50mm. This gives an angle of view that approximates what the human eye sees in terms of magnification and perspective.*

*50mm lens*

## Telephoto lenses

*Short telephoto lenses on the 35mm format start at around 100mm. A 135mm lens like this, or a zoom lens that takes in a similar focal length, gives a larger than normal magnification of image, bringing far subjects closer in the viewfinder. The longer the focal length, the greater the degree of magnification.*

*135mm lens*

## Controlling the picture area

*The angle of view is the amount of the subject that is included within the picture at any camera position. The three pictures were all taken from the same camera position, but with 28mm, 50mm, and 135mm lenses. The sequence of pictures shows the dramatic effect that changing lenses has on the amount of the subject you can include in the picture. With a 28mm short focal length lens (top), a large area of the scene is included, but everything is reduced in size. With a 50mm lens (center), the angle of view is about the same as normal human vision. A long focal length lens of 135mm (bottom), magnifies the main subject, limiting your picture to a smaller area of the scene.*

## Controlling the perspective

*These pictures were taken with three different lenses – 28mm, 50mm, and 135mm. In each case the camera distance has been changed, greatly altering the perspective, but the different focal lengths of the lenses have kept the statue the same size. With the wide-angle lens (top), there is a strong feeling of depth in the picture and objects in the background appear small and distant. Some of this depth is lost with a more distant viewpoint and 50mm lens (center), and the background objects are brought much closer. Using a 135mm lens (bottom), the background appears almost on the same plane as the foreground.*

## Controlling the depth of field

*The depth of field scale on a lens shows the amount of the subject that is sharp at any given focus and aperture setting. This varies according to the focal length of the lens. These pictures show the extent of the depth of field in front of and behind the subject on different lenses, with the focus and aperture constant. The 28mm lens (top), renders objects sharp from about 6ft (1.8m) to infinity at f5.6. On a standard 50mm lens (center), the depth of field is reduced. Less of the foreground, and much less of the background, is sharp – from 8ft (2.4m) to 13ft (3.9m). The bottom picture shows the narrow depth of field produced by a 135mm lens, at f5.6 – from 9½ft (2.9m) to 10½ft (3.2m). Because of the extended depth of field, a short focal length lens is useful when the focus settings have to be estimated or made very rapidly. A long focus lens restricts the detail to the main area of interest. Because of this shallow depth of field, there is little latitude for any focusing errors.*

# Using lenses with more pronounced effects

One of the advantages of using an SLR camera is the way that you can interchange lenses for different effects. Sometimes, a change of focal length is necessary to get a certain type of picture; at other times, you might change focal length just for the sake of creativity.

**Telephoto lenses**
Telephoto lenses have relatively long focal lengths for the size of the picture format that they fill. They use an optional system that reduces overall length, and have an effect like a telescope – making the subject appear closer.

With a telephoto lens the photographer can fill the frame even with a distant subject. This is very useful in portraiture, natural history, sports, and candid photography, and for situations where working close-up could disturb or obscure the subject. Telephotos also have more subtle effects on photographic

composition. They effectively compress a picture's perspective, just as wide-angle lenses help to expand depth and space.

The widest range of telephotos is available for 35mm SLR cameras. There is also a reasonable range (from 100mm to 500mm) for rollfilm formats. A few are made for sheet film cameras. These seldom have focal lengths longer than 300mm.

Lenses with focal lengths beyond about 250mm (for 35mm cameras) offer all the characteristics of long lenses in an extreme form. Compared with standard 50mm lenses they have a narrower angle, a smaller maximum aperture, give extremely shallow depth of field, and are more bulky.

Extremely long focus lenses should be used on a tripod. Camera shake with such bulky lenses is particularly visible because they magnify a small area of the subject, so you should always use a fast shutter speed to reduce the possibility of visible camera shake. This, combined with the fairly small maximum aperture on long focus lenses, means that you

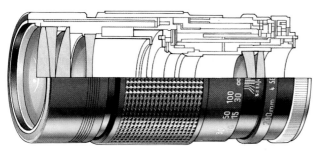

**Telephoto lens** (left)
*Long lenses give a closer view of a limited area of distant subject. They flatten perspective, making subjects in different planes seem closer together. The longer the focal length of a lens, the shallower will be depth of field through its range of apertures. Modern telephoto design allows lenses of long focal length to be more compact, though they are still fairly bulky.*

**Zoom lens** (right)
*This zoom lens has an infinitely variable focal length between 35mm and 70mm. To change the focal length you operate the zooming mechanism, sliding the lens elements apart or together. Once you have focused on a particular subject distance, it remains in focus throughout the zoom.*

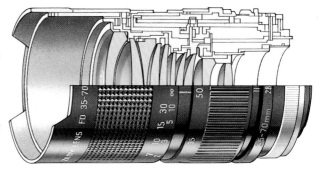

will have to use a fast film, or "uprate" the film speed and "push" during processing (see *Manipulating film*, pp. 184–7).

The longer the lens, the flatter the image contrast tends to be. This is partly due to the amount of light dispersed by the atmosphere between you and the subject. Extra development of the negative will help to compensate for this, and using a lens hood and an ultra-violet filter will assist by reducing unwanted light in the image.

## Zoom lenses

Of the large range of zooms, there is greatest choice among focal lengths around 80–200mm. These offer the best image quality of all zoom lenses. With a zoom of this type, the shortest end of the range makes a good portrait lens, while the other end of the range can be used by the non-specialist photographer for natural history and sport. Typical closest focusing distance is about 5ft (1.5m). A 24–35mm or 28–50mm is the most useful wide-angle zoom.

85mm

105mm

135mm

200mm

300mm

400mm

600mm

1200mm

**Telephoto effects**
*The group of images of neon signs shows the effects that are possible with the range of telephoto lenses available in a comprehensive camera system. At the shorter focal lengths, between 85mm and 135mm, there is only a slight narrowing of the angle of view. These short telephotos also start to bring the subject closer to the camera. The medium telephotos, from 200mm to 400mm, continue this process. (When used for photographs that include objects at different distances, these lenses also compress perspective dramatically.) The longest telephoto lenses (from 600mm to 1200mm) exaggerate these effects so much that only a minute area of the subject is visible – in this case only an abstract pattern of colored lines. Few photographers use every lens in the range. Most make a selection of short and medium telephotos, renting the longer ones if needed.*

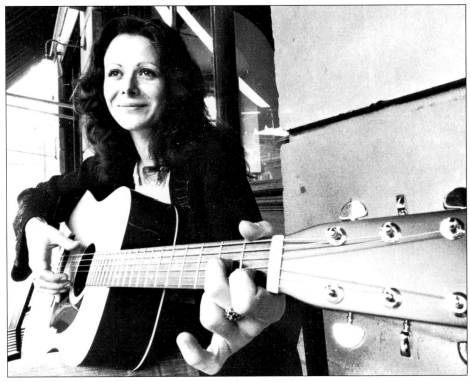

## Wide-angle lenses

A wide-angle lens has a relatively short focal length for the size of the picture format that it fills. Wide-angles for 35mm cameras range in focal length from 45mm to 13mm. While an extensive range of wide-angles is available for this format, there are far fewer for others.

With a wide-angle lens, foreground detail is increased, and this part of the image becomes much more important and dominant. Wide-angle lenses are useful for architectural subjects, especially in enclosed areas, or for any subject where dramatic angles and a steeper-than-normal perspective are needed.

Another feature of this type of lens is its generous depth of field. Sometimes this makes the lens difficult to focus, due to the problems of seeing which part of the subject is most sharp. Using a wide-angle means that quite small changes in viewpoint make appreciable differences in both the structure and the content of a picture.

**Using distortion** (above)
*With a wide-angle lens, subjects that are close to the camera look unnaturally large in relation to the background, but this distortion can be used for emphasis, as in this picture.*

**Avoiding distortion** (below)
*Used from a distance, so that the foreground is not distorted, a wide-angle lens can help to extend the picture, fitting more of the subject into the frame.*

## Fisheye lenses

A regular lens produces a circular field of light. A camera normally uses only part of this field – a rectangle of light in the center of the circle that forms the image on the film. To produce the widest possible angle of view it is necessary to use the whole of this circular field, but on a regular wide-angle this poses certain problems. Lens aberrations cause image distortions at the edge of the field, and the image vignettes rapidly into black. In addition, the tube-like shape of the lens limits its angle of view.

One way around the vignetting effect is to incorporate a very large front lens element, which collects light over 180° or more. This also increases the angle of view dramatically. The designer then has to decide how best to present such a vast amount of subject information as an image on the flat plane of film.

If maintaining the rectilinear projection of a regular lens is paramount, it becomes necessary to squeeze edge detail wildly out of shape. An alternative solution is to make detail progressively smaller toward the edges of the circle producing an effect like a convex mirror. This automatically makes straight lines appear curved (unless they pass through the precise center of the image).

The result is an unnatural, but very dramatic image, featuring a form of curvilinear image geometry known to lens designers as "equidistant" projection. This means that image magnification varies across the picture according to its distance from the center. Objects which are in reality flat and square-on to the camera bulge out of the frame. Scenes which in actuality "wrap around" the camera on all sides seem almost flat. Close objects near the picture edge are warped.

*16mm*  *8mm*  *6mm*

### Comparative wide-angles
(above)
*Wide-angle lenses of very short focal length are primarily used for special effects. The 16mm fisheye has an angle of view of 170°. The 8mm lens, with its 180° angle of view, is about the shortest focal length you can hand hold. The 6mm fisheye's angle of view (220°) actually sees slightly behind itself.*

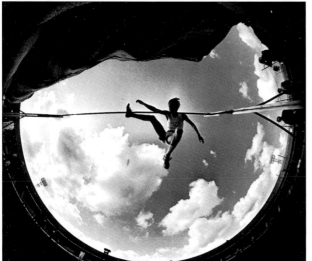

### Extreme distortion (left)
*An extreme fisheye lens gives the ultimate in distortion, producing a circular image on a standard film frame. This type of lens is really only useful for special effects.*

# Using specialist lenses

The variety of lens types available is not limited to a range of focal lengths. Some lenses, designed for particular applications such as close-up work, have special characteristics, which go beyond the usual variations of magnification and angle of view.

## Close-up lenses

Most standard lenses have a minimum focusing distance of about 18in (45cm). This is adequate for most situations, but to produce true close-up pictures, with life-size (or larger) images of the subject, the camera must move in much nearer. Working very close can reveal with greater clarity the patterns, textures, and colors of ordinary objects. It is also possible to photograph things that are too small for the naked eye to see clearly, either for aesthetic reasons, or to provide a technical record.

There are two ways of expressing image magnification in close-up work. The reproduction ratio shows the relationship between the subject's dimensions and its size when recorded on film, and magnification is image size divided by object size.

A life-size image has a reproduction ratio of 1:1 (or a magnification of × 1). A piece of a leaf ¾in × 1½in (22mm × 36mm) will then fill up the entire 35mm format. Working even closer will give an image larger than life size. At a magnification of × 3 (reproduction ratio 3:1) a mark on the leaf ½in (12mm) long would be magnified to 1½in (36mm) in length.

The simplest method of testing the limits of your close-up equipment is to take a picture of a ruler and then measure the result on the film.

Using a weak converging element that fits over the standard lens is a simple way to produce close-up results. This presents light from relatively close objects as if coming from infinity. You can still use the focusing ring on the main lens, though the distance scale is no longer accurate. Supplementary lenses come in a range of focal lengths. Most manufacturers calibrate them in diopters, a rating calculated by dividing 3ft (1m) by the lens's focal length. A 1m lens is rated +1, while a 25cm lens is rated +4. This system is helpful when combining supplementaries, since using two +1 diopter lenses together gives the same focal length as one +2 lens.

The main advantages of supplementaries are their low cost and the fact that they have no effect on exposure. On an SLR camera they do not interfere with the automatic diaphragm. The longer the focal length of the main lens, the greater the supplementary's magnification. It is best to work with the main lens stopped down, to improve the shallow depth of field.

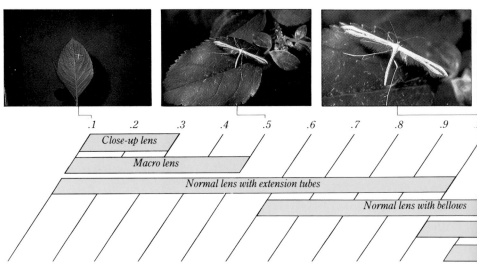

.1      .2      .3      .4      .5      .6      .7      .8      .9

Close-up lens

Macro lens

Normal lens with extension tubes

Normal lens with bellows

## Macro lenses

Macro lenses are designed to produce fine quality close-up pictures. You can use them for normal photography, but they give their best results at very close focusing distances. A 50mm macro attached directly to the camera gives magnifications of up to almost life size. With shorter focal lengths you can work much closer, achieving greater magnification. Focal lengths over 50mm give less magnification, but allow space between the lens and the subject for lighting, filters, and other accessories. With all lenses, extension tubes and bellows increase magnification. Bellows permit fine focusing. Macro lenses offer much better image quality than supplementary close-up or reversed standard lenses. They are corrected for edge-of-field distortion and give good color rendition. As in all close-up photography, the depth of field is shallow, allowing little latitude for focusing errors.

**Close-up focus** (right)
*To capture a subject this small, use a macro lens in place of the camera's standard lens. The depth of field is very shallow, so focus carefully.*

**Close-up options** (below)
*Different close-up attachments make varying degrees of magnification possible. The most extreme types of magnification are used for specialist work in natural history photography.*

|  3× | 4× | 5× | 6× | 7× | 8× | 9× | 10× | 20× |
|---|---|---|---|---|---|---|---|---|

*Macro lens with bellows*

*Normal lens with microscope*

## Mirror lenses

One way to reduce the bulk and weight of extreme telephotos is to "fold up" the optics, by means of a design that uses curved mirrors as well as lens elements. Light is converged by a mixture of reflection ("catoptric") and refraction ("dioptric") effects, so these lenses are known as catadioptric lenses. You can always identify a mirror lens by its drumlike shape and the opaque central area of the front element, marking the position of one of the two mirrors in the lens.

The mirror system of a catadioptric lens enables the lens designer to accommodate an extreme telephoto focal length within a comparatively short barrel. The distance from the back of the lens to the film can be only about one-tenth of the focal length. A typical 500mm mirror lens is about 5½in (14cm) in length, and weighs about one-half of an equivalent focal length lens using regular optics. Their lightness and compactness help to create better camera balance, and you can comfortably hand-hold lenses up to 500mm. Mirror lenses are also cheaper, since image

forming by reflection completely eliminates aberrations that occur due to dispersion, making fewer correcting elements necessary. An additional advantage of mirror optics is that close focusing distances are much shorter.

The main disadvantage of mirror lenses is that the aperture is unchangeable. It is impossible to fit a variable diaphragm to this type of lens, because it causes vignetting. Most mirror lenses therefore have a fixed aperture of f8 or f11, and you have no control over depth of field. You regulate light intensity by selecting from a series of neutral density filters built into the back of the lens, and control exposure by adjusting the shutter speed setting.

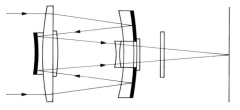

**Mirror optics** (above)
*A mirror lens can accommodate long focal lengths within the physical dimensions of a short lens. This is achieved by using two mirrors, incorporated in the lens barrel, as well as glass elements, to converge the light rays.*

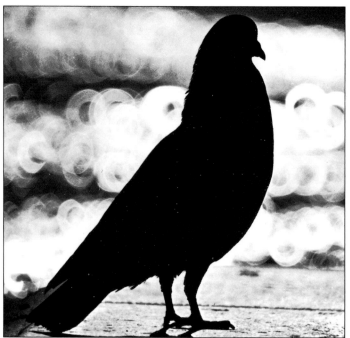

**Mirror lens effects** (left)
*A mirror lens, like a telephoto, appears to bring distant subjects closer to the camera, allowing you to photograph subjects that might be difficult to approach. It also turns out-of-focus highlights into circles of light.*

## Perspective control lenses

The most common lens movement – focusing backward and forward – is practically universal. A few lens and camera designs offer additional movements. One of these is a sliding movement of the lens, either up, down, or sideways from its normal location.

Several lenses for 35mm SLR cameras offer this special shift device. Turning a control knob on the lens moves it fractionally sideways so that is off-center on its mount. You can convert this to an upward or downward movement by rotating the whole lens through 90°. Perspective control lenses are much more expensive than normal types of lens.

A few of these lenses also have the facility to pivot slightly, so that the lens is no longer parallel to the film. This is a useful device for improving depth of field. Pivoting is only found on lenses designed for shifting too. You can see the effects of shift and pivoting movements on the SLR focusing screen and decide on the exact effect before shooting.

Normally, when photographing tall subjects, you have to tilt the camera upward to fit them into the picture frame. This makes vertical lines appear to converge. With a shift device you can correct this by keeping the camera vertical. Instead you displace the lens to take in the subject, so that parallel vertical lines appear normally in the image.

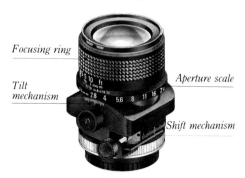

*Focusing ring*

*Tilt mechanism*

*Aperture scale*

*Shift mechanism*

**Perspective control lens** (above)
*This perspective control (PC) design has a swing movement in addition to upward and downward shifts. (These become sideways shifts by rotating the mount through 90°.) There are very few of these lenses made for 35mm format.*

**Straightening verticals**
(above and right)
*A perspective control lens moves parallel to the film plane (above). Tall subjects, distorted when photographed from below with a standard lens (right), can be recorded accurately (far right).*

**Avoiding reflections** (right)
*The photographer needed a square-on viewpoint, but using a conventional lens he included his own reflection. Moving the camera to one side, and recentering the image with a shift lens, has preserved the viewpoint but cut out the unwanted reflection.*

*Without perspective control*

*With perspective control*

# Using filters

The use of filters can both enhance and change the look of your pictures, whether you are shooting color or black and white. Filters, however, should never be used purely for their effects. They should be used with subtlety, not to make a bad picture good, but to make a good picture even better.

## Neutral density filters

Gray neutral density (ND) filters have no effect on image color. They simply reduce the intensity of the light entering the lens. ND filters enable you to shoot at a wide aperture in brilliant lighting or when the camera contains fast film. This facility is particularly useful if you want to produce differential focus effects in these situations, where, even when selecting the fastest shutter speeds, you would have to stop down to avoid overexposure.

Another use is to allow prolonged exposure, to increase the blur of moving subjects. Even at the smallest aperture, you may not be able to use a shutter speed as low as 1/30 sec for panning a moving object, or 1/8 sec for zooming unless you use an ND filter. For architectural photography in a busy street, you can make long exposures with a deep ND filter in place, so that figures and traffic become so blurred that they disappear. At night you can record longer light trails from moving vehicles. ND filters are also essential for exposure control with a mirror lens, which has a fixed aperture. This type of filter comes in a range of strengths, for flexibility of exposure control.

| NEUTRAL DENSITY FILTER FACTORS | | |
|---|---|---|
| Type and density | Effect on exposure | |
| | Multiply exposure by | Increase aperture by |
| ND 0.1 | 1¼ | ⅓ |
| ND 0.2 | 1½ | ⅔ |
| ND 0.3 | 2 | 1 |
| ND 0.4 | 2½ | 1⅓ |
| ND 0.5 | 3 | 1⅔ |
| ND 0.6 | 4 | 2 |
| ND 0.7 | 5 | 2⅓ |
| ND 0.8 | 6 | 2⅔ |
| ND 0.9 | 8 | 3 |
| ND 1.0 | 10 | 3⅓ |
| ND 2.0 | 100 | 6⅔ |

**Neutral density filters** (above and right)
*Neutral density filters reduce the intensity of light but do not affect tonal range. The picture above was taken with a small aperture and fast shutter speed. With a neutral density filter added (right), the aperture could be increased so that the depth of field is reduced.*

## Polarizing filters

Regular light rays from any source (both natural and artificial) vibrate in all the planes at right-angles to their direction of travel. When they are reflected from a smooth, non-metallic surface, such as plastic, glass, or water, they vibrate in only a single plane. This reflected light is known as polarized light. The naked human eye cannot detect the difference between polarized and unpolarized light, but a polarizing filter can.

A polarizing filter on the front of the lens allows light to pass in only one plane, so that you can make the filter remove the single-plane vibrations of polarized light. You can do this by rotating the filter while observing the effect this has on the image. This is especially useful for photographing subjects behind glass. You simply turn the filter until the reflection disappears. You can use polarizing filters with both black and white and color film. With color film, a polarizing filter will darken a blue sky without altering colors in other areas.

**Polarization** (right)
*Light waves normally vibrate in many planes. When reflected from a smooth, non-metallic surface, only a single plane remains.*

**Removing reflections** (above)
*Without a polarizing filter, reflections in glass can spoil a picture (above left). When taking photographs at an angle of around 45° to the reflecting glass, use a*

*polarizer. This filters out the polarized light, and the reflections disappear (above right), allowing the objects behind the glass of the window to appear clearly in the final photograph.*

**Darkening skies** (above)
*Blue skies can sometimes appear pale in a photograph when they were, in reality, a strong blue. A polarizing filter will darken the skies. It can also be used to make*

*an ordinary blue sky (above left) appear dramatically dark (above right). This effect works only on blue skies, and is strongest when you are shooting at right angles to the sun.*

## Filters for black and white

You can manipulate the way black and white film reproduces subject colors by using colored filters over the camera lens. Filters consist of dyed glass, plastic, or thin, colored sheets of gelatin. These are most often used to create contrast between colors that would otherwise reproduce as similar tones of gray, or to improve tonal separation between pale colors and white. If you want to darken a particular color you should photograph through a filter complementary to that color. To lighten a color, shoot through a filter that matches it.

You can see this for yourself by looking at bright colors through different filters and noticing the changes. Looking through a red filter you cannot distinguish red from white, while rich greens and blues appear very dark. In the same way, a deep red filter will darken blue sky and so make the contrast between sky and clouds much stronger. It will also absorb ultraviolet wavelengths. These invisible radiations have an effect on all photographic films, making distant parts of scenes paler. You can achieve the same correction without affecting other wavelengths, by using a colorless ultraviolet (UV) filter.

Other useful filters include various shades of green (to lighten green foliage) and yellow (to darken blue skies slightly). Typical film differs from the eye's response to color brightnesses, especially in the blue and yellow-green bands. Film is more sensitive to blue, so blue appears pale on the final print. Using a pale yellow "correcting" filter both darkens blues and lightens colors in the middle of the spectrum.

Each filter is marked to denote the factor by which you must multiply unfiltered exposure time, or make adjustments to the aperture, to compensate for the light that the filter absorbs. Do not rely on a TTL meter when you are using a deep-colored filter. When particularly accurate results are necessary, it is best to bracket (see *Getting the exposure right*, p. 57). UV filters do not require exposure changes.

**Increasing contrast** (below)
*The filters used in black and white photography lighten their own colors and darken their complementaries. The first picture, (below left), was taken without any filtration. In the second picture, (below center), a red filter has lightened the tomato and darkened the blue of the sky. In the third picture, (below right), a green filter has lightened the green-colored fruits.*

**Darkening the sky** (above)
*To create this landscape picture the photographer used an orange filter to darken the sky, making the cloud formations stand out clearly.*

| FILTER EFFECTS | | | | | | | |
|---|---|---|---|---|---|---|---|
| **Effect required** | **Filter** | | | | | | |
| | Yellow (8) | Yellow-green (11) | Orange (16) | Red (25) | Deep red (29) | Blue (47) | Green (58) |
| Natural sky | • | | | | | | |
| Increased cloud/sky contrast | | | • | | | | |
| Strong cloud/sky contrast | | | | • | | | |
| Dramatic cloud/sky contrast | | | | | • | | |
| Simulated moonlight | | (underexposed) | | | • | | |
| Natural sunset | • | | | | | | |
| Dramatic sunset | | | • | | | | |
| Natural haze effect | • | | | | | | |
| Enhanced haze effect | | | | | | | • |
| Reduced haze/increased contrast in distant subjects | | | • | | | | |
| Stronger haze reduction/increased contrast in distant subjects | | | • | | | | |
| Natural foliage/flowers | • | • | | | | | |
| Lighter foliage | | | | | | | • |
| Increased texture in sunlit materials | | | | • | | | |
| Natural skin tones (tungsten light) | | | | | | | • |
| Natural skin tones (daylight) | | • | | | | | |
| Lighter red/orange tones | • | | | • | • | | |
| Darker red/orange tones | | | | | | • | |
| Dark red/orange tones | | | | | | | • |
| Lighter blue/purple tones | | | | | | • | |
| Darker blue/purple tones | • | | | | | | • |
| Dark blue/purple tones | | | • | • | • | | |
| Lighter green tones | • | • | | | | | • |
| Darker green tones | | | | • | | | |
| Dark green tones | | | | | • | | |
| Very light yellow tones | • | | | | | | |
| Lighter yellow tones | | | | • | • | | • |
| Darker yellow tones | | | | | | • | |
| Typical filter factor | 2 | 4 | 2.5 | 8 | 14 | 8 | 4 |

## Filters for color

Color filters used for color films are generally divided into conversion, or balancing, filters and paler color-compensating filters. A color conversion filter such as Kodak 80A (blue) allows you to take pictures in tungsten lighting with a daylight film. Conversely, if you must shoot a few frames of tungsten-light film in daylight, you can use an 85B (strong orange) filter. Other conversion filters help you to match film to most types of fluorescent tubes. In all cases, try to use the correct film, because these filters absorb some light. They all have exposure factors, which means that the film requires increased exposure. Kodak filters with even numbers shift colors toward blue, while filters with odd numbers have a reddening effect.

Compensating filters are much paler than conversion filters, and they are made to "warm up" or "cool down" slightly the colors present in the image, particularly when you are using slides or instant film. Often the reason for using these filters is subjective, such as gently enhancing the mood of a scene. Sometimes, though, you may have to use a compensating filter to help to correct the color distortion produced by overlong exposure of the film. Color-compensating filters are made in the three primary and three secondary colors, and in various strengths.

Color-compensating filters are very helpful if you want your slides or instant pictures to be strictly objective records. This is important with subjects such as food, silverware, and glassware, or when copying paintings. If test shots indicate a color cast in any direction, view through a color-compensating filter of the complementary color. Decide which strength filter makes mid-tone areas of the slide or print appear correct in terms of color, then use a filter of half this strength when reshooting.

## FILTERS FOR USE WITH COLOR FILM

| Filter | Filter factor* | Effect | Film type | Conditions in which film and filter are used |
|---|---|---|---|---|
| **Color balancing filters** | | | | |
| 80A | ×3 | Cooler | Daylight | In tungsten lighting. |
| 80B | ×2 | Cooler | Daylight | With photolamps, or in tungsten light. |
| 80C | ×1.7 | Cooler | Daylight | With clear flash bulbs. |
| 85B | ×1.7 | Warmer | Tungsten | Daylight, or daylight-balanced flash. |
| 85C | ×1.3 | Warmer | Tungsten | As above. Paler than 85B, cooler effect. |
| **Filters for fluorescent light** | | | | |
| 40M+30Y or FL-D | ×2 ×2 | Natural | Daylight | With "daylight" fluorescent light. |
| 30M+10Y +85B | ×2.5 | Natural | Tungsten | With "daylight" fluorescent light. |
| 40C+40M or FL-W | ×2.3 ×2 | Natural | Daylight | With "warm white" fluorescent light. |
| 30M+20Y | ×2 | Natural | Tungsten | With "warm white" fluorescent light. |
| **Color compensating filters** | | | | |
| 1A/B | | Warmer | Daylight | To reduce bluish cast in strong sunlight. |
| 81 series | ×1.2–1.7 | Warmer | Daylight | To reduce bluish cast caused by shade, overcast lighting or strong sunlight. Each gives increasing warmth to color tones. |
| 82 series | ×1.1–1.5 | Cooler | Daylight | To cool down marked reddish tones in daylight, according to degree. Cancels out effect of 81 series. |
| 86B | ×1.8 | Warmer | Daylight | To correct heavy blue light or strong shade. |

*These factors are approximate, varying slightly with different makes of filter. Check the manufacturer's recommendations before using.

## FILTERING DIFFERENT LIGHT SOURCES

You must decide whether or not to filter an image so that it matches the color balance of your film. The blueness of overcast conditions, or orange light late in the day, can often be unacceptable. Filters can be useful to correct this, especially with slides.

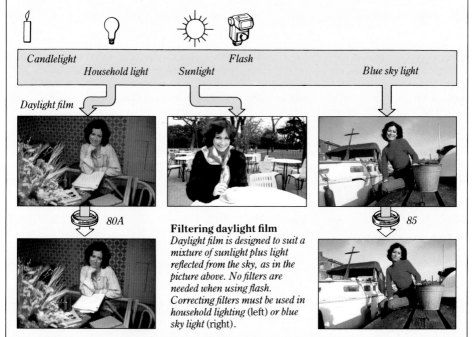

**Filtering daylight film**
*Daylight film is designed to suit a mixture of sunlight plus light reflected from the sky, as in the picture above. No filters are needed when using flash. Correcting filters must be used in household lighting (left) or blue sky light (right).*

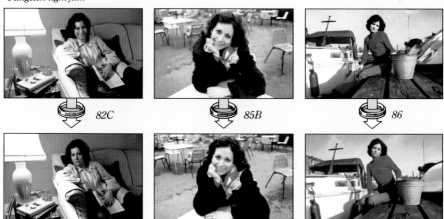

**Filtering tungsten film** (above)
*Tungsten film is balanced for scenes that are lit by photographic lamps, and must therefore to be used*

*with filters when taking photographs in subdued household lighting (above left), in daylight (above center), or under a blue sky (above right).*

# Lighting your shots

When you move away from natural light, to shoot indoors or in the studio, you have to begin thinking about how you are going to light your subject to its best advantage. The easiest way is with a flash unit built into the camera or mounted directly on top, but this does not always give the best effect.

## Using flash

Many of the principles and practical problems of using flash are the same as for continuous light sources. It is important to pay the same attention to the quality, direction, and evenness of the light.

Several features are unique to flash. One of these is the tradition of mounting a flash on the camera, pointing directly at the subject. This is a great limitation to creative lighting. It is convenient to carry a flash unit around in this way, but a photographer would not always choose to have a tungsten lamp mounted next to the lens, or always use the sun directly behind the camera. The result when flash is used in this way is frequently monotonous and regular, with flat, form-destroying frontal light, near objects lighter than distant objects, and backgrounds dark.

Experienced photographers know that, when used imaginatively, flash can produce excellent, naturalistic lighting, while several flash units allow a very flexible approach. Additional advantages include freedom from camera shake (so that the photographer can use a hand-held camera, for flexiblity of viewpoint), low operating heat, and a color which matches daylight. Most flash units are also independent of electricity supplies.

**Flash for bright color** (above and right) *Toward the end of the day, or when the sky is overcast, there is not enough light to do justice to the colors and details of a small object, like this plaque. Use flash to simulate sunlight and brighten colors.*

**Flash and existing light** (above) *The photographer used a mixture of available light from high windows and diffused flash from the camera position to photograph this gold-robed monk. Flash adds a little extra detail and subject modeling, without destroying the subdued, peaceful mood of the picture.*

## Freezing action with flash

The action-freezing effect of flash varies according to the type of flash source. Most studio electronic flash units deliver flashes of a consistent speed of between 1/1000 and 1/5000 sec, according to design. With some units, this time is reduced still further when you switch the power pack to half light output. Flash exposures of this duration will freeze all human movement, together with all normal forms of camera shake. They may not, however, prevent blurred detail in a fast-moving spray of water, for example, if you photograph it close up, instead exaggerating its movement.

Still greater action-freezing capacity is possible if you use a battery-operated electronic flash incorporating a light sensor. Since these units are designed to reduce flash duration as a means of regulating exposure, the closer the subject, the briefer the flash. Using such a unit singly, or in conjunction with other heads, flashes may last 1/5000sec with distant or dark-toned subjects, or 1/20,000sec if used close up. The briefest flash time will freeze breaking glass, and fast-moving machinery such as an electric fan or parts of an engine. For ultra-high-speed subjects, such as a bullet in flight, scientific-quality micro-flash units are necessary, but extremely costly.

**Blurring movement** (above)
*Used together with other light sources, and with a slow shutter speed, flash can give an unusual combination of blurred and sharp areas.*

**Freezing movement** (above)
*Used as the only light source, flash dictates a fast shutter speed and so freezes subject movement for dramatic results such as this.*

## Altering flash quality

Flash is a fairly hard, directional light source that can cast ugly shadows. You can create softer, more even lighting by diffusing it. Cover the flash with one layer of white tissue, or use a ready-made diffuser.

Working indoors, you can make use of techniques that involve "bouncing" flash illumination. Use a camera-mounted flash that tilts upward, reflecting light off the ceiling between camera and subject. Do not use too steep an angle, as the subject may be unattractively top-lit. You can also turn the unit to bounce the light off a wall, or a reflector of white cardboard. Avoid bouncing light off colored surfaces if you are shooting with color film as this will create a color cast.

If you have a clip-on flash unit, you can increase its versatility by using an extension cord. You can then detach the light source from the camera and position it with the same freedom as you would a lamp. To make best use of off-camera flash, practice with a still-life or portrait subject indoors.

You can also try using two flash units, a large one for bouncing, and a smaller one pointing directly at the subject. Problems occur, however, if you move toward the subject, or the ceiling is very high or not sufficiently reflective. Unless you can adjust the balance of the two units, the fill-in light will become relatively more powerful, and illumination will resemble that from a single flash unit pointed straight at the subject.

*Bounced*

*Diffused*

*Bounced and filled-in*

### Bounced flash
*Bouncing the flash off a white wall or ceiling to light the subject indirectly gives a soft modeling effect. Increase exposure 2 stops, or set it to automatic.*

### Using a diffuser
*Adding a diffuser in front of the flash head softens the light. You can also use tissue or tracing paper. Increase the exposure 2 stops, or set it to automatic.*

### Using two flash heads
*With advanced units you can use two flash sources to give good modeling – one as key light, the other as fill-in. A slave unit triggers the second flash.*

# PROBLEMS WITH FLASH

Many amateur photographers are uneasy about using flash, because it all too often produces harsh and unnatural results. The basic problems associated with flash can, however, be avoided by being careful when setting up your shots, and following a few simple guidelines.

## Flash fall-off

Flash illumination falls off sharply, so subjects farther away get less light than those close to the camera. Subjects twice as far from the camera receive only a quarter as much light. You can exploit fall-off to darken ugly backgrounds.

**Avoiding fall-off**
*The group is all within flash range, but the rear figure looks too dark.*

*When taking group shots, be sure that everyone is roughly the same distance from the camera.*

## Red eye

This fault occurs when a small, hard, direct light source is positioned very close to the camera lens. If the camera is then aimed directly at the subject's face, the light passes through the pupil and illuminates a patch of the pink retina at the back of the eye. This is what the film records. There is a similar effect when an automobile's headlights illuminate the eyes of an animal. You can prevent the problem of red eye by using any accessory which places the flash unit a little farther away from the lens. Many compact cameras with built-in flash avoid the problem by having the flash designed to be pulled up before use. Bouncing the light off a wall or ceiling also solves the problem. If these solutions are not possible, ask the subject to look at a light before you take the picture. The pupils will contract, reducing the effect.

### Creative use of red eye
*Red eye can be created deliberately, by mounting the flash on the lens barrel, and taking the photograph at the subject's eye level.*

# Using studio lighting

The value of studio lighting is that it is completely under the photographer's control. The direction and nature of the light from each lamp can be altered one step at a time, and the photographer can monitor these changes and observe their effect on the set as a whole. In addition, experience with studio lighting helps greatly when using and adapting available light.

Most photographers use studio lighting to create a natural appearance, using one dominant light source above camera level (simulating the sun) and adding diffused illumination to lighten the shadow areas (to imitate general skylight). It is essential to avoid "over-lighting" – using lighting units too close to the subject, and from too many directions.

It is best to explore thoroughly all the possibilities of a single light source at a time, using it from different heights and positions, and discovering how to use it in conjunction with reflectors. By adding lights one by one, it will be possible to build up the lighting while being aware of the precise function that each unit fulfils. One lamp might illuminate only the background, another an edge or surface.

When first exploring lighting techniques it is best to photograph still-life subjects, though you may eventually use a studio mainly for portraits. Working with inanimate objects gives you plenty of time to watch and consider the effect of each light, and to take a number of pictures with small lighting variations. Viewing and photographing as you proceed also helps to make clear the differences between the way your eye sees things, and the way the camera records them on film.

Choose your subject carefully. Often very simple shapes and materials offer the greatest scope. Natural forms in materials such as stone or wood, eggs, onions, a ball of string, or a roll of corrugated cardboard can all form interesting lighting subjects. You can either use a sheet of paper to give a continuous neutral background, or pick a material with a textured surface on which to position your subject. This material should be chosen to form an effective contrast with the subject's texture.

## Home studios

For simple studio work, a desk lamp, table, uncreased blotting paper, and a few clamps will be sufficient. For color work, a studio photographic lamp for tungsten-balanced film,

**Directional effects** (right)
*Studio lights can be used in an almost infinite number of ways. The angle of the lights used can be critical, so it is necessary to start with a clear understanding of what effect each angle will have on a given subject. A single light source, placed in a variety of different positions relative to the subject, can produce drastically different results. Each angle will highlight some areas of the subject and throw others into deep shadow. At the same time, it will either exaggerate or reduce both texture and form. The effects that are created by using just one studio light in five different positions around a single subject are shown here.*

**1  Front lighting** (above)
*Front lighting reveals detail, but also flattens subject form and texture. The effect on the bust is uninteresting – the picture appears all on one plane.*

**2  High side-lighting** (above)
*Side-lighting gives a much bolder, three-dimensional effect. Deep shadow eliminates detail, however, in the areas that are furthest from the light.*

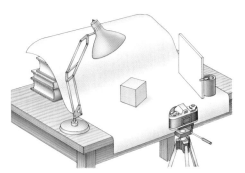

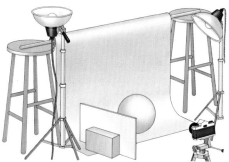

**Single light source** (above)
*1 Desk lamp. 2 White reflector board. 3 Background paper. 4 Books used as support. 5 Camera mounted on tripod.*

**Two lights sources** (above)
*1 Photofloods mounted on stands. 2 White reflector board. 3 Roll of paper. 4 Stools used as support. 5 Camera mounted on tripod.*

or flash for daylight-balanced film, will provide the correct color content. Avoid using rooms decorated in vibrant color schemes, as color casts may result.

For more space, use a 6ft (2m) wide roll of background paper supported by poles, and attach lamps to stands or clamps. Sheets of stiff white cardboard, plastic, or plywood can act as reflectors. One hard and one soft lighting unit provide a working minimum. If you can use

an entire room for studio work, try to use one with generous dimensions. Height is important, since you will require space for high and low viewpoints. To calculate floor space, work out the typical lens-to-subject distance you will require, and then allow an extra 3–6ft (1–2m) for working behind the camera and for separating the subject from its background. To accommodate lights, a room with a width of 12ft (4m) is best.

**3 Top-lighting** (above)
*With the lamp placed above the bust, all top-facing surfaces are highlit. The eyes and neck are in shadow, but the forehead, nose, and cheekbone are emphasized.*

**4 Low side-lighting** (above)
*Low side-lighting gives a "footlight" effect. Since the head is facing the lamp, both sides of the face are lit, but an ugly shadow is cast upward by the nose.*

**5 Back-lighting** (above)
*The lamp is just above the bust facing the camera. Matte white paper beside the camera dispersed some illumination on to the bust to give an even, low illumination.*

# Lighting set ups

While taking pictures in a studio gives the photographer complete control over lighting and subject arrangement, studio illumination can provide a highly artificial environment, or produce an excessively austere effect. The mass of photographic equipment can often be intimidating.

Lighting balance and contrast pose particular problems. Even with effectively placed lights, some dimming, or limiting of the area that each illuminates, is often necessary. The amount of adjustment will depend on whether the image is color or black and white. On color film, color contrast may separate the different elements and planes of the subject, without it being necessary to improve lighting contrast as it would be with black and white.

Every subject, and each camera viewpoint, creates a fresh lighting challenge: portraits, in general, call for a more flexible approach to lighting than still lifes. In all areas of photography it is vital to solve each lighting problem according to the demands of the particular subject.

**High-key lighting**
*Light a pale background evenly with two floods. Illuminate the subject by floods bounced from reflector boards to give soft, frontal lighting, and surround the subject with reflected light. Use a lens hood to stop stray side-light from entering the camera lens and diffusing the image.*

**Low-key lighting**
*Direct a spot with barn doors on to a reflector board (left), and use a matte black background. In the picture (below), direct spill from the spot sidelights the front of the locomotive without affecting the background.*

Set up your chosen subject on a table with free space all around it, so that you can place lights in any position. It is important to leave sufficient space between the subject and background, as you may want to illuminate the background separately from the subject. Then adjust the camera on its tripod to give the most pleasing framing and composition. This is the point from which your eye must judge each lighting effect.

Sometimes the lighting of a studio set works well in a general sense, but you also want to give special emphasis to a particular part of the subject. A mirror can often be useful for introducing light into a small area. Another method is to use direct light from a lamp masked with a long conical snoot of black paper. The hole at the end of the snoot should be about 1in (2.5cm) in diameter and you should position the lamp as closely as possible to the subject, without including it in the camera's frame of view, in order to concentrate the light on the detail.

### Lighting glass

*These glasses were backlit by reflecting light off a white background. Black cardboard behind and to the sides of the subject darkened edges. A reflector gave soft frontal illumination to the glasses.*

### Lighting polished surfaces (below)

*Polished silver, chrome, and other reflective surfaces impose special lighting difficulties. Sometimes you may want to emphasize the reflective qualities of the subject, rather than suppress them. You can avoid unwanted reflections by shooting through a gap between two white reflectors. You can also make a "light tent." Surround the subject with translucent white material on a frame. Use floods outside the screen for diffused illumination, and shoot through a hole in the material. Use strips of black cardboard to induce reflections that will bring out the subject's form. If shooting in color, use extra reflectors of the same hue as the subject to restore color that is lost in the highlights.*

· CHAPTER THREE ·

# PHOTOGRAPHING DIFFERENT SUBJECTS

This chapter demonstrates how the equipment and techniques that have been outlined in the previous two chapters may be put into practice on a range of subjects. Everything that you choose to photograph has its own individual features, and will present unique challenges, requiring a range of approaches and treatments. For some subject areas certain equipment may be almost indispensable, such as wide-angle lenses for panoramic landscapes, or telephotos for capturing action in a sporting event. It would be a mistake, however, to imagine that equipment is the overriding factor. In many cases it may be that your manner is of the greatest importance to the result, as in the case of portraits, where the subject must be at ease. In other areas, such as wildlife photography, the degree of patience that you possess can be the deciding factor in capturing the perfect shot.

**Making the most of a subject**
*Every subject requires a different technique. For a scene like this you might observe lighting effects at different times, and take a variety of shots – an approach that would be inappropriate for other subjects.*

# The natural world

Some types of nature photography, such as close-ups of plants, are set up by the photographer. In other areas, the subject is a whole environment, and it is then up to the photographer to find the best way of recording it. This is when a sound knowledge of lighting and composition comes into its own.

**Landscapes**

To take strong landscapes, you must develop an eye for the effects of light, weather, and season, and a skill in conveying distance through viewpoint and composition. Mist and haze will mute colors and create a sense of

mystery. Storms produce dramatic light changes – low clouds sweep across the sky, dappling the land with dense shadows and brilliant highlights. It is advisable to examine scenes in varying weather, and at different times of the day (see *Times of day*, p. 97). It is also necessary, however, to work fast when conditions are changing.

In many parts of the world, landscape appearance changes radically according to the season of the year. Sometimes a particular lighting effect may only occur a few times in the year, such as around the longest or shortest day. Tone and color also depend on lighting.

## LENSES FOR LANDSCAPES

*Some types of scenery demand the special qualities of a wide-angle or telephoto lens. A 28mm or 35mm lens is ideal for a panoramic view (left). It includes more foreground, makes distant elements appear farther away, and steepens the perspective. Its extreme depth of field also gives sharp focus from fore- to background. Conversely, a 135mm or 200mm lens enlarges distant elements. It makes a far-off mountain look high and close, and by picking out distant scenes, appears to compress subject planes (below left). Its narrow depth of field puts fore- and background out of focus, (below right), and softens colors.*

Viewpoint is another essential element in composing landscape pictures. Looking at a scene from different viewpoints can make it change dramatically in shape, color, or lighting direction, or emphasize either the foreground or the far distance.

The presence of water in the foreground of a landscape allows the pattern and color of distant mountains and sky to be repeated. Change of viewpoint and irregularities in the water surface offer a variety of possible effects, ranging from a symmetrical mirror image to a generalized mass of tone or color. Haze is also frequently found near water.

**Panoramas**
You can build up a panorama as a mosaic with a series of images. When exposing component images in this way, it is essential to keep the camera horizontal, to preserve a straight horizon. A tripod is ideal for this. A standard or short telephoto lens is more likely to give images that join up in foreground and background than a wide-angle. After each exposure you turn the camera on a vertical axis sufficiently to give a 30–40 per cent overlap with the subject area previously recorded. It is vital to match the prints in size, tone, and color balance. When joined as one long print, you can view the panorama bowed into a concave shape.

**Foreground interest** (above)
*A common problem with landscape photography is the way an impressive scene in real life can look flat and two-dimensional on the print. One of the ways to get around this is to introduce some kind of foreground interest to add a third dimension.*

**Points of interest** (below)
*To be successful, a landscape picture must have a point of interest to draw the eye. In this picture, the eye goes automatically to the area around the house and tree, then balances that against other buildings and the hills. The absence of a light-toned sky prevents the eye from being drawn out of the picture area.*

# Flowers and gardens

Many people have a garden of some kind, yet how many really look at it in terms of picture possibilities? Gardens offer a wealth of opportunities not only for plant and flower photography, but also for wildlife portraits. Undoubtedly, however, flowers are one of the most popular garden subjects.

**Photographing plants close-up**
The main technical challenges when working on close-ups of plants are magnifying the image sufficiently, obtaining enough depth of field, avoiding wind movement, and removing confusing background detail.

With an SLR, the photographer can use a reversed lens, close-up attachment, extension tubes, or bellows, but a focusing macro lens is most convenient for close-ups. With non-reflex cameras, a spacing bracket used with a close-up lens is effective and quick.

It is advisable to photograph most plants and flowers in their natural habitat, since they cannot be moved without damage. This also gives a genuine sense of environment. A studio, on the other hand, allows total control of lighting and background, and there is no problem with movement due to wind.

**Simple composition**
*Looked at from different angles, a garden can reveal some surprising possibilities for photographs. Sometimes a strong color contrast can provide drama. Red and green work particularly well in this shot, creating a semi-abstract composition.*

**Color harmony** (right)
*Bright, even daylight will bring out the colors in a garden best. For a harmonious composition, choose flowers of one kind, and use a shallow depth of field to eliminate distracting detail in the rest of the garden.*

**Knowing your subject** (left)
*Successful nature photography depends on being in the right place at the right time. You must be up early to capture the morning dew on a spider's web. Find a viewpoint that catches the light in the dewdrops and sets the web against a dark background.*

**Close-ups and movement**
*To achieve perfect clarity (right), always use a tripod. If there is the slightest breeze, position a shield of heavy cardboard in its path (above).*

# Animals

One of the essentials in animal photography is a great deal of patience. Unlike people, most animals – especially wildlife – cannot be made to pose and, unless they are well-trained pets, it may be impossible to direct them at all.

It is necessary to know something of the subject's nature. How an animal moves, how it reacts to different circumstances, and – in the case of wildlife – where it can be found, are important factors. Good animal photography is usually the result of study and observation and, based on this, a careful choice of position and equipment. In all cases, be prepared to use a large amount of film.

**Photographing wildlife**
It is possible to photograph wildlife around your area – although one should always obtain a landowner's permission, and *never* intrude on, or disturb, wild animals – in national parks or zoos, or on organized photo-safaris.

A medium to long telephoto lens is needed, since it is usually impossible to get near to the subjects. A focal length of 200mm is the minimum that will be useful. Having decided on

**Pattern pictures** (above)
*Pictures of animals do not always have to be of a single subject. In this picture the reflective surface of the water, plus strong side lighting, has made an intriguing pattern from the birds, their shadows and their reflections. Distant groups of animals will often form a pattern of some kind.*

**Zoo photography** (left)
*Not all wild animal pictures have to be taken in exotic places. A picture like this is just as easily shot in a zoo, using a long lens to fill the frame and to eliminate unwanted detail.*

**Filling the frame**
(left)
*Family pets are popular subjects. For good results, move in close to fill the frame, and use a viewpoint at the level of the subject.*

**Pets at play** (below)
*Rather than trying to pose pets, try taking photographs of them at play. You will often capture the character of an animal far better in this way.*

your vantage point, it is a matter of waiting for the animal, framing it in the viewfinder, and then carefully following its actions and adjusting focus until composition, lighting, and position are to your liking.

If photographing wildlife from a car in a safari park, be careful not to support the camera on any part of the car while the engine is running. The vibrations can easily blur the shot, particularly when using a telephoto lens.

## Photographing pets

Most people wish to take pictures of their family pets at some time, and since there is plenty of opportunity for practice, it is not too difficult to produce good pictures. Pets can be photographed with a standard lens, or even a wide-angle.

When photographing pets, it is usually a good idea to work with an assistant. He or she can attract the animal's attention in whatever direction you wish, by either calling its name or offering morsels of food. It is also a good idea to photograph your pet while their attention is absorbed by some other activity such as running, or playing. Shots taken at these times often show the most character.

**Anticipating action** (above)
*Anticipate your subject's movements, and preset focus and exposure to catch the right moment. In this way you can capture the energy of the action.*

# Buildings

The subjects of architectural photography range from new developments to archaeological sites, taking in both interiors and exteriors. This wide variety of subject matter poses a number of problems. The most important is the challenge of emphasizing the subject's essential features. Aspects that stand out in the camera viewfinder frequently become insignificant or dull in the final photograph. It is easy to distort perspective. Those photographs that do overcome these problems can convey a scene's essential elements and form strong creative images.

Successful architectural photography must also bring the subject to life, conveying its form, texture, setting, and relationship to people.

## Exteriors

The main visual influences on architecture are lighting and viewpoint. Lighting can completely alter the appearance of a scene. A cityscape that appears cluttered and dirty in the revealing light of day can become transformed at dusk,

**Found reflectors**
*Heat-reflecting glass, used in many modern buildings, can form spectacular mirror surfaces. In this photograph, twin towers reflect each other and the sunlit block across the street. The formal pattern of windows contrasts well with the mirrored distortions. Even a small change of viewpoint would give these reflected structures a totally different look.*

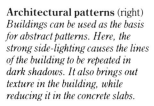

**Dramatic silhouette** (above)
*Strong architectural shapes can often be shown to their best advantage by shooting into the evening sun and underexposing slightly. The technique works particularly well on this ruin, because all of the windows are lit by the sky behind them.*

**Architectural patterns** (right)
*Buildings can be used as the basis for abstract patterns. Here, the strong side-lighting causes the lines of the building to be repeated in dark shadows. It also brings out texture in the building, while reducing it in the concrete slabs.*

its roads illuminated by neon signs and the lights of vehicles. Bridges turn into delicate silhouettes, their angles and curves standing out clearly against the evening sky.

Careful use of viewpoint and focal length can often allow you to combine architectural details, juxtaposing colors, textures, and patterns in the same frame. They can divide the picture into contrasting areas, forming a semi-abstract design. Often a change of viewpoint entirely alters a subject's appearance, simply because of the foreground and background elements included. It is frequently best to photograph a complete

building "straight," examining all its features closely. You can then come in closer and move around the subject for more effective views. It will also be useful to return at different times and under different weather conditions to observe lighting changes.

**Architectural details**
Well-chosen details can epitomize a building's character as well as a whole view. It is even possible to show a whole town in this way. The severe lines of a concrete structure, or a cluttered pattern of shadows on an older building, can sum up an entire locality.

# Interiors

A tripod is essential for both general architectural interiors and details. The most useful lens is a wide-angle, but care is necessary when using this lens. The photographer must keep the camera back upright. If the image includes features well above the camera, a perspective control lens will be necessary.

The main technical problems with interiors concern lighting, especially between window and wall detail. If possible, it is best to shoot with the light, keeping windows behind you so that the whole room is illuminated evenly. Otherwise it is necessary to average exposure readings taken from both windows and walls, or to slightly overexpose the window detail and light the interior with multihead flash. For the best effect, bounce flash illumination off a wall behind the camera.

Details can be particularly revealing. Fan vaulting, staircases, or glimpses of rooms through doorways are all elements that show an interior's character. When showing a whole room, you can often stress its best, or most important, features by rearranging the furnishings so that they fit better within the picture area. Interiors often look better if some of the furniture is removed.

**Emphasizing structure** (above)
*Emphasize structures with different techniques. Here a wide-angle lens has distorted and exaggerated the line of the staircase.*

**Lenses for interiors** (left and below)
*Choose lenses carefully to make the most of the subject. Here the larger picture was taken with a wide-angle lens, and the smaller shot with a standard lens. Wide-angle lenses are necessary if you wish to get a whole room into the picture.*

**Preserving atmosphere** (left)
*Using light from a window will produce a more pleasing effect when photographing an interior than would be achieved by bringing in studio lighting or flash. Here, artificial lighting would destroy the atmosphere, giving the appearance of a studio set.*

**Lighting limitations** (right)
*Natural light levels indoors are surprisingly low, making either a long exposure or a large aperture necessary. For this photograph, the small aperture, needed for the large depth of field, meant a long exposure, and required the use of a tripod to avoid camera shake.*

# People

People are one of the most popular subjects for the camera, from the formality of portraiture in the studio to the more informal approach in the home.

## Portraits

In all portraiture, the photographer must decide what the sitter's strongest characteristics are. The photographer must concentrate on these characteristics – which can range from vivacity and self-confidence to reserve and contemplation – and find the best ways of expressing them photographically. A relaxed atmosphere and the ability to put subjects at their ease are essential.

Short telephoto lenses are generally more useful for portraits than standard or wide-angle types. With 35mm equipment, for example, a 100mm or 135mm lens allows you to take full-frame head-and-shoulders portraits from a sufficient distance.

Using a tripod, although it is not always technically necessary, means that the photographer does not have to look through the viewfinder continuously. This allows more natural communication with the subject.

Whether the picture is taken outdoors, inside a room, or in the studio, an environment that is directly relevant to the sitter will be most revealing. This can involve showing the subject at home or at work.

Camera angle is also critical. You can use it to emphasize important features and suppress others. Often an eye-level viewpoint is best, because the eyes are the most dominant and influential facial features. But a full-face view of the subject may be too symmetrical – often a three-quarter portrait is more interesting.

The other major influence on the appearance of a portrait is lighting. Most photographers prefer to keep the arrangement simple, using existing light as much as possible. This can be modified slightly to control contrast and composition. Fill-in flash and reflector boards are especially useful for reducing shadows.

**Relaxing the subject**
*A subject's character will communicate best when he or she is relaxed in front of the camera. To achieve this, try to have your subject in a familiar and informal setting, or keep a conversation going in order to avoid awkwardness.*

**Portraying action** (above)
*The power of the subject's expression here is intensified by the contrast with the calm appearance of the background figure.*

**Using surroundings** (above)
*Including surroundings can help to convey character. Here, both the background and the pose suggest anticipation of action.*

**Arranging groups** (left)
*People in groups work better when they are naturally involved with each other, rather than assembled solely for the photograph. When posing groups of people, remember that odd numbers, such as the three in this picture, work better than even ones, which tend to create difficult symmetrical compositions.*

## PHOTOGRAPHING SOMEONE AT WORK

A friend who has an interesting hobby or job makes a good subject for informal shots. Your main aim should be to link the person closely with the activity so as to show them as an integrated whole.

If they have an intricate hobby such as model-making, you will want to bring out as much color and detail as possible. This means using flash to supplement daylight, so that you can stop down and increase depth of field. Move in close to show exactly what your subject is doing. (Diffuse flash close up.) Exclude anything not closely related to the activity – a neutral background is best. Above all, try to convey the skill and concentration demanded by the hobby.

**Choosing viewpoint**
*Before shooting, study your subject from various angles. An eye-level viewpoint (top), gives a good overall view of both man and boat. But you must get down low to show the subject's expression (far left), as people tend to lower their heads when working with their hands. Shooting from above (left), emphasizes the precise skills that are involved in the hobby.*

# Candid and unusual shots

The secret of expressive candid portraiture is to remain as unobtrusive as possible, either by concealing the camera or yourself, or by shooting when the subject is occupied in some activity. A wide-aperture, or a 100mm or 135mm telephoto lens allows you to take pictures from a distance without too much flattening of perspective. By taking advantage of limited depth of field you can also isolate the subject from distracting surroundings. If it is impossible to remain unobserved, shoot frequently so that your presence begins to be taken for granted.

Smooth camera handling and a good sense of timing will help to capture the climax in a verbal exchange, or the momentary gesture or expression that sums up the subject's whole character. Set exposure in advance. You may also be able to prefocus, using the figures on the focusing ring or focusing on something that is about the same distance away in another direction.

You can often get closer to your subject, without being intrusive, by using an unusual viewpoint. Photographs which do not include the face will often help to avoid self-consciousness in your subject, and they can also be surprisingly revealing.

**Capturing the moment**
*For a dramatic shot, watch for the moment when a crowd reacts to an event, and is therefore unlikely to notice you.*

**Character shots** (above)
*What the subject is doing can be as interesting and revealing as what he or she looks like, especially if it is something creative. People are often less self-conscious when photographed in this way.*

**Using details** (above)
*Sometimes an unusual detail can be just as informative as a full portrait would be.*

## Glamorous portraits

At the other end of the scale from straight portrait photography is the field of glamorous portraiture, where the object is to create a particular look or quality, quite distinct from the character of the subject. Make-up, clothes, and incidental props are very important: entirely different approaches would be appropriate for a futuristic, a romantic, or an exotic shot. The lighting should also be chosen to complement these moods.

A good rapport with the model is important. Amateur models can be inhibited, so using a professional, who is comfortable in front of a camera, can be a good idea. On the other hand, friends may be willing to be adventurous, and curious about seeing themselves in a new way, so do not overlook this possibility.

**Graphic patterns**
*This studio portrait shot has been carefully set up so that the bold outlines of the model's hair and face are mirrored by the shape of the fan. The three arcs form a strong repeating pattern. Look for unusual viewpoints and build up a collection of simple props, and use them to help to create stylized and imaginative portraits such as this.*

**Creating mood** (above)
*The clothes and the use of chicken wire as a prop determine the stark effect of this shot.*

**Using lighting** (above)
*Try to think of the body as a landscape, and use lighting to bring out form.*

# Nudes

Most people find that nudes are the most difficult of all subjects to photograph well.

A wide range of interpretative approaches is possible, from harshly objective to abstract, innocent to erotic, romantic to stark. The subject may be distorted into new forms, or translated into visual fantasy. Try isolating small areas of the body and treating these like landscapes or abstracts. Backs, shoulders, hands, and sides work well this way.

The serious photographer goes to great lengths to find a relaxed model and create a good working relationship. All models feel vulnerable, even for simple facial studies. A nude model is especially vulnerable, and needs to have confidence in the photographer's ability to create worthwhile results. Soft, directional daylight often suits the body's rounded forms, unless it is important to emphasize silhouette shape or skin texture.

**Sculptural approach** (above)
*Using an angle like this may be helpful in putting a more inexperienced and self-conscious model at ease.*

# Parties and celebrations

Quick candid shooting is best for photographing parties and celebrations, to capture once-in-a-lifetime moments and fleeting expressions. Plan a sequence of shots to show the whole occasion. At Christmas, for example, your pictures might include unwrapping presents, the dinner table, and the tree, as well as family groups. Wherever possible, preserve the spirit of the occasion by shooting in existing light (daylight, household tungsten lamps, or candlelight). Even if you use daylight film in tungsten light, the orange cast often adds a pleasant, warm appearance to the shots. Alternatively, use compatible tungsten slide film or a color-balancing filter. Flash may kill the mood of a party shot unless it is skillfully controlled. Use it bounced, or off camera, or combine it with daylight from a window to fill in shadow areas. When shooting by available light you will need your widest aperture lens, and you must focus carefully or use an autofocus camera. (Remember, also, the advantages of an instant picture camera for these occasions.) The wider angle of view and depth of field of a 28mm or 24mm lens are

**Informal atmosphere** (above)
*Informal photographs will often convey the atmosphere of an event best. A viewpoint along the table, at the level of those sitting around it, will capture most of the people present at a natural height, and show some of the surroundings. A wide-angle lens can be useful for these shots, but be careful to avoid distortion.*

**Formal posing** (left)
*For a more formal record of an event, wait until everyone is gathered together naturally, as here, and then take your picture. It is best to limit the number of such shots, as people become bored and self-conscious when asked to pose repeatedly, and this will show.*

useful for incorporating a group seated around a table. Make sure that faces are not too close to the camera, or at sides or corners of the picture, or they will be distorted. Use a low viewpoint, at table height, to pick out individual faces, or use a high viewpoint to give a more general view showing everyone. Remember that it is always effective to use features such as a mirror, an archway, a window, or a doorway to act as a frame for a scene. Shooting from a distance means that you are less likely to be noticed by your subjects.

Plan your shots to cover the event – overall pictures of the setting, candids, group shots, and humorous action. Frame tightly to exclude distracting elements, and arrange people in a pleasing pattern or around a center of interest. If you cannot arrange a shot, look for viewpoints that avoid muddled composition – high to contain a large group, low to clear intrusive backgrounds.

**Finding patterns** (above)
*From a distance, this crowd becomes abstract bands of color. The rally's atmosphere is conveyed, although its subject, the line of flags, is almost obscured in the colors of the scene.*

**Informal moments** (right)
*A wedding is the ultimate celebration, but it is usually best to leave the traditional pictures to the professionals. Photographs taken by available light, either in the bride's home (above right), or in an unguarded moment at the church (below right), can capture the atmosphere better than any posed picture.*

# Sport

I n order to photograph any sport
successfully, a knowledge of both the rules
and the procedures of play is necessary. Only by
being able to anticipate what is going to happen
next can one watch for the peak of the action, and
time shots to the best advantage – at the highest
point of a jump, or the moment when either
triumph or dismay shows on an athlete's face.

The ideal lens for sports photography is a
medium to long telephoto or zoom, as the
subject is often some distance away. A long
focal length will give the impression that the
picture has been taken in the thick of the
action, rather than from the sidelines. Since
these lenses usually have a small maximum

**Character shots** (right)
*Try to photograph athletes in training, as well as
involved in competitive events, in order to capture the
character of both the sport and its participants.*

**Panning with the action** (below)
*Following the action as you use a slow shutter speed
will keep the principal subject sharp, while blurring the
background to convey an impression of speed.*

aperture, a short exposure will be necessary to freeze action, and it may be advisable to use a fast film. On the other hand, a sense of excitement and the atmosphere of the event can be conveyed by allowing subject movement to blur slightly, or panning with the subject to blur the background.

For track and athletic events, it is possible to set up a camera on a tripod in anticipation of a peak of action or the finish of a race. Most team sports, and games such as tennis, however, will need to be photographed with a hand-held camera, as the action is continually shifting from one area to another. Keep both eyes open when photographing fast-moving sports, so that you can watch what is happening outside the viewfinder.

**Using a different approach** (right)
*Here, a high viewpoint has isolated the subject against the water, and a slow shutter speed has blurred the movement. A picture taken at ground level on fast film would lack the sense of speed apparent in this shot.*

**Waiting for the right moment** (below)
*For this picture, the camera was positioned as close as possible to the subject beforehand. A fast shutter speed has frozen the action at the most dramatic moment.*

# Babies and children

When photographing babies, try to fill the frame with the subject – either by using an 85mm or 135mm lens, or by getting in close with a standard lens. At close range depth of field is minimal, so focus accurately. It will be necessary to prop up a very young baby with cushions, or hold him or her looking over someone's shoulder (or the back of an armchair) unless you want to photograph the baby lying down. Show the baby occupied – playing, or being fed or bathed. Avoid cluttered, distracting backgrounds, and try to shoot in soft lighting. Indoors, natural light from a window or bounced flash is best; outside, hazy or overcast conditions provide the most pleasing lighting. Use medium-speed (ISO 125) film, and preset exposure at 1/125sec or flashspeed setting. Babies are unpredictable subjects and tire easily, so you must be ready to shoot whenever an opportunity arises. Be prepared to use a large amount of film in order to obtain good shots.

**Straight portrait** (above)
*Young children tend to be much less self-conscious in front of a camera than are older children and adults, so this kind of straight shot can work well.*

Children become bored and restless very easily, although they are otherwise excellent photographic subjects. A low viewpoint is essential, since a picture taken from adult height looking down will distort the subject. Unless you are taking formal portraits, use a hand-held camera and follow movements and expressions through the viewfinder at all times in order to capture your subject's most expressive moments.

Older children can be self-conscious about having their photograph taken. Try making the whole procedure of taking the photograph into a game, or shoot while the child's attention is occupied elsewhere.

**Unusual viewpoints** (left)
*A picture like this looks like a candid shot, but is easy and simple to set up. Unusual angles are useful in photographing more self-conscious children.*

**Using surroundings** (above)
*Try to take shots which show children in their surroundings to convey a particular atmosphere. The dreamy, slightly wistful mood of the little boy at the window is enhanced by diffused lighting and harmonious tones.*

**Expressive moments** (above)
*Babies make delightfully unselfconscious subjects, but their emotions and expressions change rapidly. Have your camera ready at all times and be prepared to work fast. A quick reaction was necessary in order to catch this yawn.*

**Spectator events** (left)
*When photographing events that include performers and spectators, do not forget the potential of the audience as subjects. The attention of these children was entirely absorbed, allowing the photographer to shoot without being observed.*

# Night photography

Apart from an obvious lack of light, extreme contrast is one of the main characteristics of night photography. You may be able to see the details inside a lit building, along with its dark exterior, but this is usually beyond the range of photographic film. Where possible, shoot at dusk, when some sky light is still present to illuminate shadows. Results often look more realistic than genuine night pictures. Another way of handling contrast problems at night in towns and cities is to work after rain has wet roads and sidewalks, and use the bright reflections of the surrounding lighting (from shopping centers, store windows, and cinema and theater entrances – all of which can provide a bright, even spill of light) to add extra illumination to the picture. With a mobile subject, such as a person, you have maximum flexibility, and can move him or her at will to make use of these light sources. Try to avoid top-lighting from nearby streetlights. Although it may be tempting to use their available light, their direction and harshness combined may cast deep and unattractive shadows over the subject's eyes and nose.

**Using available light** (above)
*A fast film allowed this picture to be taken without flash, which would have destroyed the atmosphere.*

**Light trails** (above)
*The characteristics of night photography, often regarded as problems, can be used for their own effect.*

*This picture was taken on a normal speed film, using a slow shutter speed to transform the lights of moving traffic into colored trails.*

**Photographing light sources** (above)
*When lights are bright, and fill the frame, a camera can be hand-held, using even a moderately fast film, without camera shake being a problem.*

**Night portraits** (above)
*Try using available light from windows. Calculate exposure carefully, and bracket shots to be safe. Using existing light conveys atmosphere well.*

**Using twilight** (left)
*Fairgrounds are good subjects for night photography, as this is when they are brightly lit and full of people. This picture was taken at dusk, and the last of the light in the sky has preserved detail in the foreground of the scene.*

For moonlit landscapes, it is best to shoot at late dusk with an early-risen moon in the sky, perhaps also showing some distant, half-hidden artificial light sources. When working by the light of the moon alone, you may have to exclude the moon itself because of its movement during very long exposure. In the absence of any artificial lights, landscapes under a full moon can photograph almost as if they are sunlit, provided that the exposure given is long enough.

Whatever approach you take to night photography, shooting at dusk or after dark can add another dimension to even the most mundane of subjects.

**Fireworks**
*When shooting a fireworks display, stop down and use a time exposure to keep the shutter open for several bursts. Cover the lens between bursts, so that you don't overexpose the rest of your image.*

# Still life

In still-life photography, everything from the choice of the subject through to the final adjustments of lighting is completely under the control of the photographer. The best still-life pictures are the result of careful advance planning of three elements: the background, the composition, and the lighting.

The background is the first thing to consider in any still life. If the objects are to be shown in their usual setting, it must not be confusing in pattern, or likely to give a color cast if you are using color film. Often it is better to set up a plain light or dark neutral background. Use a large sheet of matte paper, such as seamless paper, or even an ironed sheet or tablecloth. Attach this to the background wall, and drape it down and over the surface on which you are setting up the shot in a smooth, gentle curve.

This will avoid the sharp dividing line across the background that is given by a tabletop against a wall.

Study the composition of the objects before photographing them. Arrange them in different ways until they make a harmonious pattern. Remember that objects of different sizes,

**Composition and lighting** (left and below)
*The composition of this picture looks fairly simple, but it has been carefully thought out. The lighting consists of one lamp close to the camera and another behind the set-up.*

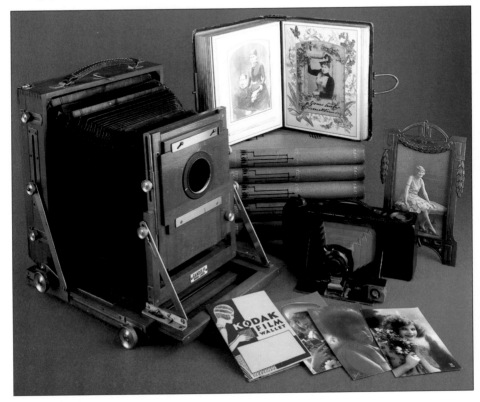

colors, and tones have different visual weights (see pp. 71-3). Bear in mind, also, that odd numbers are easier to arrange than even ones. Try to have some theme linking the objects in a still life. Similar shapes, textures, styles, or a common purpose will all serve to give the composition some meaning.

When arranging the lighting, experiment with a range of angles (see pp. 132-3), and with different kinds of light. Pay careful attention to shadows that may be cast on to one object in the arrangement by another. If working with flash, use a diffuser, bounce the light off a reflector, or separate the flash unit from the camera. In general it is best to keep the lighting soft, and use fill-in lights to minimize shadows, but each composition will require different lighting techniques, and in some circumstances it may be appropriate to use harsh, shadowy lighting.

**Subject choice** (left)
*Always watch out for suitable still-life subjects. The most ordinary objects can make impressive pictures, if they are arranged and lit imaginatively.*

## SETTING UP A STILL LIFE

1 *The objects have potential as a group, but colors and textures have been clumsily combined. Some of the objects are half-hidden and the centrally placed lamp dominates the composition.*

2 *The still life is beginning to take shape. The tray is well displayed at the back, with the lamp in front of it. But the small objects are scattered, and some lead the eye out of the frame.*

3 *The final version shows most unity. Smaller objects are well related at the front, while the bowl and blue pot now balance the tray. Moving the lamp off-center has strengthened the composition.*

· CHAPTER FOUR ·

# PROCESSING
# AND
# PRINTING

The exposure that the light-sensitive film receives inside the camera creates a "latent" image. The ability to amplify this invisible image into a permanent, stable picture is the keystone of the photographic process.

The processing and printing aspects of photography have their own, traditional, mystique. They do, after all, take place in the dark and involve the use of potentially dangerous chemicals and unfamiliar equipment. This attitude is largely based on imagery coming to us from the turn of the century when darkroom work called for a knowledge of chemistry and carried an element of risk. Today, it is a far more streamlined routine involving relatively little time in the dark, and no more knowledge of chemistry than is required for cooking.

**Choosing your prints**
*One of the advantages of using your own darkroom is that you have complete control over all of the results. You can make contact sheets – same-size prints – of all of your negatives, and then decide which of them are worth enlarging into full-size prints.*

# The darkroom

As film and paper processing becomes more streamlined in terms of equipment, time, and chemical procedures, it is becoming easier to set up a home darkroom. Being self-sufficient may not save money, but it gives complete creative control.

The basic requirements for any darkroom are an area where you can keep out all light, an electricity supply, a water supply, and a ventilation system. If necessary you can use an area that does not have running water, storing processed materials in a bucket of water until the end of the session, and then transferring them to a convenient water supply for washing. Always group similar aspects of the processing sequence together for convenience.

The first consideration when setting up a darkroom is adequate ventilation. Some chemicals can produce noxious fumes, so an exhaust fan and light-tight slatted blinds should

be installed. Whenever handling chemicals there is also the possibility of an allergic reaction, so wear rubber gloves as a precaution. All chemicals must be stored in tightly capped bottles, away from children. It is important to be aware of the safety aspects of working with liquid chemicals and an electricity supply in a blacked out area. Separate dry from wet areas, and keep all electrical cables away from liquids. Use cord-operated switches for all of the lights.

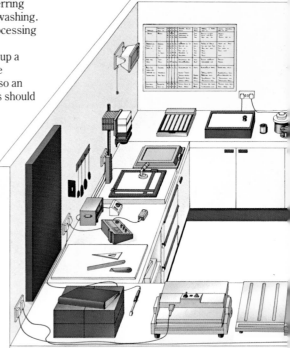

**Permanent darkroom**
*A permanent darkroom is convenient because you can leave it blacked out with everything in position between sessions. With a large room at your disposal, you can build up a darkroom where you can tackle any aspect of processing and printing. The wet bench should be large enough to accommodate all the processing trays for black and white work, a tempering box for your chemical solutions, and a motorized unit for a color print processing drum. The dry side should accommodate an enlarger, timer, color analyzer, mounting press, and trimmer. There should also be room for sorting film. The best floor covering is a material such as seamless PVC, and all work surfaces should be covered with sheets of laminate, as bare wood will absorb chemicals and may be a source of contamination. Black out any windows with opaque blinds secured at the edges with black masking tape. Ensure that you have adequate safe lighting. If the room is large, this may mean using two or three lights.*

**Dry side**
*This half of the room is reserved for activities that do not involve chemicals or liquids. This helps to avoid damage to films, negatives, and paper.*

THE DARKROOM · 167

## Temporary darkroom

*A bathroom is an ideal location for a temporary darkroom, because of its ready supply of running water. Most home bathrooms also have only one window, and are easy to make light tight. To make a work surface, use a fitted board to convert the bathtub into a bench. Arrange the processing trays on an absorbent material, such as newspaper, to soak up spills. Put the enlarger at a level above the trays, so that any spills from the trays do not reach the baseboard and contaminate it.*

| | |
|---|---|
| 1 Extension cord | 4 Processing trays |
| 2 Paper box | 5 Rubber hose |
| 3 Enlarger | 6 Safelight |

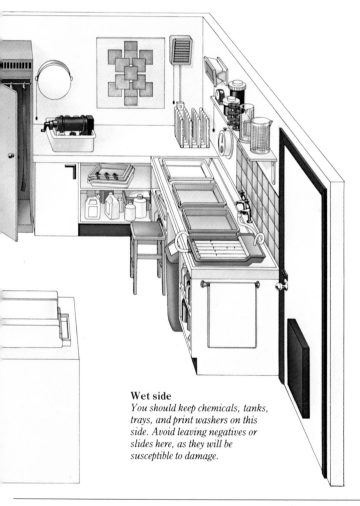

1 Safelight
2 Wallchart
3 Contact printing frame
4 Light box and magnifier
5 Daylight tank and reel
6 Film drying cabinet
7 Color-corrected light
8 Tempering box
9 Refrigerator
10 Exposure and filtration tests
11 Exhaust fan
12 Print drying rack
13 Safelight
14 Timer
15 Darkroom graduates
16 Wall clock
17 Processing trays
18 Flat-bottomed sink
19 Print washer
20 Resin-coated paper drier
21 Rotary trimmer
22 Dry mounter
23 Negative and slide files
24 Trimming board
25 Color analyzer
26 Blacked-out window
27 Enlarger timer
28 Voltage stabilizer
29 Masks and dodgers
30 Enlarger
31 Masking frame
32 Focus magnifier
33 Paper safe

### Wet side

*You should keep chemicals, tanks, trays, and print washers on this side. Avoid leaving negatives or slides here, as they will be susceptible to damage.*

# Processing films

Processing film may be your first step toward photographic self sufficiency. It puts you in control in two ways. First, you can ensure consistency. Second, you can give controlled modifications of results.

## Film processing tanks

The most popular tanks are the plastic type (easier for beginners and adjustable to accept most film sizes) and metal type (easier to keep dry and clean). Plastic tanks come in different sizes, to accommodate one or several rolls of film. You can adjust the central reel to suit different films. With plastic tanks, you must cut the film leader square. Metal tank reels are not adjustable, so you have to buy them for each size of film. With some metal reels, it helps to shape the film end.

## Loading a plastic tank

*Plastic tank design*

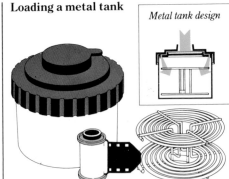

## Loading a metal tank

*Metal tank design*

**1** *Set the reel to the correct width, then lock it in position.*

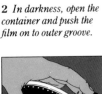

**2** *In darkness, open the container and push the film on to outer groove.*

**1** *Position the core of the reel to accept the leader end of the film.*

**2** *In darkness, open the film container and clip the end to the core.*

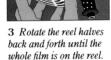

**3** *Rotate the reel halves back and forth until the whole film is on the reel.*

**4** *Cut the end of the film and tuck it into the outer reel groove.*

**3** *Gently press the sides of the film so that it bows slightly as it feeds in.*

**4** *Detach the film from its core and tuck the end into the groove.*

# Black and white film

Development time varies, so be sure to read the leaflet that accompanies the developer. It is important to agitate the film properly during development (see right). Too much agitation causes overdevelopment and surge marks, too little forms uneven density. Always avoid chemical contamination – particularly stop or fixer in the developer – as this can ruin the entire film. Be careful to keep all solutions at the recommended temperature.

**Agitating the film tank**
*After you have poured the developer into the tank (see below), fit the cap, and agitate the solution by inverting the tank. Be sure that you keep your finger over the cap to avoid solution spillage.*

## Processing black and white negatives

**1** *Mix a tankful of developer and bring it to the correct temperature.*

**2** *Tilt the tank slightly. Add the developer, taking about 10 sec. Start timer.*

**3** *Tap the tank to dislodge any air bubbles. Agitate as shown above.*

**4** *10 sec before the end of the development period start to drain the tank.*

**5** *Quickly pour in a pre-measured tankful of stop bath. Agitate as before.*

**6** *After the stop period has been completed, drain the tank again.*

**7** *Pour in the fixer, and agitate initially as before, then as recommended.*

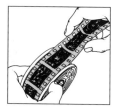

**8** *After half the fixing time you can remove the lid and check results.*

**9** *Complete fixing, drain tank. Push a hose into the tank and wash film.*

**10** *At the end of washing, add a few drops of wetting agent.*

**11** *Attach a film clip, pull film from reel, and attach the second clip.*

**12** *Wipe with squeegee tongs dipped in wetting agent, and hang to dry.*

# Color film

Before you start to process color film or paper, remember that it consists of at least three different emulsion layers, carefully balanced in their sensitivity to light and their contrast. If your processing is in any way inaccurate, the resulting images could show a shift in color away from that of the original scene, as well as having the wrong density or contrast. The factors that could cause problems in color processing are solution temperature and strength, agitation, and the timing of each processing stage. You must pay close attention to all of these at all times to ensure consistent results from each film.

Unlike black and white processing, where chemical solutions are chosen and bought separately, color processing chemicals are nearly always purchased as complete kits. Always follow the accompanying instructions carefully with reference to time and temperature. With most color processing, you cannot compensate for a variation in the temperature of the chemicals by altering the development time. Stand solutions in water of the right temperature, or use a tempering box.

## Color negatives
It takes about 25 minutes to process a color negative film (see below). The first step, color development, forms a black silver image plus

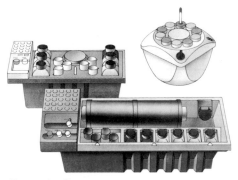

**Tempering boxes**
*These units contain a heater, and circulate either water or air around the bottles. A thermostat built into the box will hold all of the solutions at the required working temperature. This is typically 68°F (20°C) for black and white, and 80°F (27°C) for color.*

colored dye negatives in each layer. You must then bleach and fix away the silver image (sometimes combined in a single step, called a "blix" solution). After processing, you have an image with reversed colors and a pale orange mask overall.

Most of the equipment is the same as for black and white. You must, though, have extra containers and graduates, and a thermometer marked in 0.5°F (0.3°C) divisions. A metal tank is best for the higher temperatures. Most color negative films use type A chemistry, and require process C-41, but check your film container before you start.

## Processing color negatives

**1** *Have all chemicals ready in the correct order and at the correct temperature. Fill the loaded film tank with color developer. Start the timer. Agitate solution as recommended.*

**2** *10 sec before the development is complete, start to drain developer and return it to its container. Pour in the next solution, and begin timing and agitating the tank as before.*

**3** *Follow the same procedure for fixing. Use a rubber hose and filter for all wash steps. With most processes, you can remove the tank lid for all stages after bleaching is complete.*

**4** *After washing time is complete, you may have to soak the film in a stabilizer solution (see kit instructions). After the required period, hang the film up to dry in a dust-free area.*

## Color slides

Color slide film is more complicated than color negative material, and so slide film processing has more steps than color negative processing. Once you have mastered the techniques of processing slide film, however, it is easier to manipulate successfully than negative material.

You can process most slide film yourself, using chemical kits that are made either by the film manufacturer or by independent manufacturers. It is especially important when processing color slide film to follow instructions to the letter, as there is no printing stage where you can correct any processing faults. The first step is black and white development, although with some of the older kits you have to give the film an initial pre-hardening. You then wash the film and add color developer. Finally, you must bleach and fix, leaving only the positive dye images. The critical processing stages are the first development, because it controls the amount of halides left, and color development itself.

**Processing kits**
*Most kits contain bottles of concentrated liquids, but some use powdered chemicals. Both give good results. Usually, the film processing capacity of the first developer and color developer is half that of the other chemicals, so kits will often contain double amounts of both developers.*

As with color negative film, the temperature of the solutions that you use when processing slides is of critical importance. Even less variation in temperature is allowed in slide processing, so it is advisable to invest in a tempering box.

There are some slide films that are described as non-substantive. These must be sent back to the manufacturer for processing.

## Processing color slides

1 *Using Kodak E-6, pour the first developer into the tank, taking about 10 sec, then start the timer.*

2 *Agitate as recommended for the kit. 10 sec before the end of this stage begin to pour the developer out.*

3 *Wash the film in running water for 2 min, or fill the tank with water, agitate, and drain twice over.*

4 *Pour in the reversal bath. Check the temperature of the color developer. Rebottle the reversal bath.*

5 *Pour in the color developer. After given time pour developer out and conditioner in.*

6 *Pour out conditioner. Then bleach the film for the given period of time, and fix it.*

7 *Next, wash and soak the film in stabilizer, before removing the reel from the developing tank.*

8 *Remove the film from the reel, and hang it up to dry without washing. Rebottle your stabilizer.*

# Assessing your films

Your negatives may, at first sight, seem successful, but reveal problems when you enlarge them. Check dry, processed film through a magnifier if there are signs of spots or slight variations in density. Look at any large areas of even tone; these will show up faults more clearly than areas of complex detail.

Processing errors can result from inexperience, attempts at short cuts, or failure to concentrate on what are often boring but important routines. Sometimes the film itself is faulty, particularly if it is out-dated stock, or has been badly stored.

## Assessing black and white negatives

When film is dry, cut it into convenient, easy-to-view strips of five or six negatives, and examine the results. First check that your negative is free from extreme errors, then look for more subtle mistakes.

### Overexposure
*When overexposed by 1½ stops, the resulting negative looks generally dense. Highlight tones, such as the subject's cheeks, tend to merge, becoming flat. Shadows retain good detail.*

### Correct exposure
*Subject highlights contain more detail information, but shadow areas are not excessively dense. The whole image shows subject detail clearly, and should yield a good print.*

### Underexposure
*This negative was underexposed by 1½ stops. This results in pale (or "thin") shadow areas, as with the girl's hair. These zones will print as flat, continuous black. Highlight areas still show detail.*

### Overdevelopment
*A contrasty, bright-looking negative results from overdeveloping. Highlights are dense, but the image lacks the excessive shadow detail given by overexposure. Development here was 50 per cent too much.*

### Correct development
*With the correct development time, highlights are less dense and shadow areas are improved. The image has correct contrast and density, and, like the correctly exposed image, should print well.*

### Underdevelopment
*Like underexposure, underdevelopment gives a thin negative, but highlights look weaker, and shadows have slightly more detail. The result is low in contrast. Development was 25 per cent too little.*

### Completely clear
*This processed silver image negative film is without edge lettering or frame numbers. Placing the film in fixer or stop bath before developer can produce this result. Chromogenic processing can also cause this.*

### Black
*If the processed film is completely black, with the manufacturer's edge lettering obscured, it has probably been fogged by light, chemicals, or even fumes. This can happen in the camera, or before or during processing.*

### Clear, with edge numbers

*If the film is clear except for the manufacturer's edge lettering, it is probably unexposed. The edge data is printed on the film with light and its presence shows that processing was correct.*

### Uneven density

*Bands of uneven density (but not fog) along the entire film are due to insufficient developer. The right-hand half of this image was only intermittently covered during the film processing sequence.*

### Fogged before development

*Fogging the film outside the camera causes a gray veil of fog along most of the film's length. It may be due to loading the processing spiral in a room that is insufficiently blacked out.*

### Camera fog

*A dark bar across the film is a typical result of fogging caused by briefly opening the camera back. The black scratches also shown here were probably due to dirt in the camera body, or on the rubber squeegee tongs.*

### Fogged during development

*This film has an overall gray veil, together with pale lines around the frame edge, lettering, and other contrasty detail. It was caused by accidental fogging during development.*

### Surge marks

*The bands of paler density extending from the perforations are due to excessive agitation. Developer flowed continuously through the holes, giving extra development to the adjacent areas.*

### Exhausted developer

*Processing a film in either exhausted or contaminated developer gives an underdeveloped result that also has a veil of fog. The lines of uneven density are typical, and there may be a yellow stain.*

### Insufficient fixing

*If the film appears fogged or opalescent by transmitted light, or milky gray by reflected light, it has not been fixed properly. Clear the film by refixing in fresh solution, then wash and dry it again.*

### Clear patch

*A clear or milky-looking patch on the negative is caused by careless loading of the processing spiral. One loop of film pressed against another, preventing chemicals from reaching the emulsion surface.*

### Drying marks

*The circular marks on this negative were caused by drying the film while water droplets were still attached. You can rub these marks off the base, but not off the emulsion. They can also be caused by splashing dry film.*

## Assessing color negatives

Color negatives look more fully exposed than they really are, and all colors appear as their complementaries. Start by comparing any new negatives against a negative you know to give a good print. The yellow or orange that covers all color negatives can make it difficult to detect faults. To reduce the effects of this mask, view the negatives through a filter of the same color. This will help you to see how much shadow and highlight detail is present, although it is still difficult to detect color casts. Faults will show more clearly in prints.

### Contaminated tank

*It is important to clean and dry the processing tank thoroughly before use. Traces of fixer have produced this pale, patchy cyan staining. The negative has an overall color cast, and is too thin to print.*

### Underdevelopment

*This negative was correctly exposed, but underdeveloped. Highlight areas are weak, and will probably print yellowish. Shadow areas are better than the underexposed version, but contrast is flat.*

### Underexposure

*Shadow areas look empty – lacking contrast, detail, and color. Midtones and highlights record well and show good detail. These areas may print well, but shadows will look flat.*

### Correct exposure

*This negative is darker, with stronger tone and color information in the shadows. Details in the highlights are still distinct, and colors can be picked out easily.*

### Overexposure

*Subject highlights are now beginning to look dense and solid, and the colors too dark to separate clearly. They will print bleached and featureless. Color and tone in the shadows are, however, excellent.*

### Correct development

*Correct exposure and development times have improved the overall contrast. Highlight areas are darker and details· look more contrasty and distinct. The negative is well balanced and should produce a good print.*

### Overdevelopment

*Overdevelopment has formed a brighter, more contrasty negative. Highlights are dense, but shadows are less detailed than in the overexposed version. Grain is more pronounced, and the print will be harsh.*

### Fogged in tank

*This color negative was fogged by a small amount of light while in the processing tank. Perhaps this was due to an insecure lid. Notice how the perforations have printed from the next loop in the spiral.*

### Fogged by safelight

*This negative was slightly fogged by an amber safelight during tank loading. The negative has a cyan cast. Fogging by colored light gives a complementary tint, which you cannot correct during printing.*

## Assessing color slides

You will find that it is much easier to identify color and tone errors on slides than it is on color negatives. Try to judge all your films against the same light source. First look for exposure problems, then try to identify any color errors that are due to lighting conditions. Color casts show up most clearly in images that contain neutral grays and off-whites.

Errors made during the many stages of processing result in a wide range of faults, and these will vary according to the film and chemicals that you are using.

### Underexposure
*In the shadow areas, colors have become dense and heavy. Highlight details are good. Underexposed slides will require extra development time.*

### Correct exposure
*This correctly exposed image is not as dark and has more shadow detail. Highlights are lighter, but still show good color. The harsher the lighting the more accurate exposure must be.*

### Overexposure
*Overexposed slides have bleached highlights. Only shadow areas have accurate color. This will result in slides appearing weak, and prints will have flat white or gray areas, instead of highlight detail.*

### Overdevelopment
*"Pushing" a slide will make a correctly exposed image pale. Highlights will appear bleached, especially if the subject was contrasty. The slide will be difficult to print on positive/positive material.*

### Bleach omitted
*If the bleach is omitted (or it becomes exhausted) silver remains in the film along with the dye image. The slide is almost black, or shows patchy gray central areas. You can correct this by treating with fresh bleacher.*

### Fogged by light
*Slight fogging of film by white light before, or possibly just after, first development, will produce a weak looking image, with flat gray shadows. The film rebates are also less than fully black.*

### Underdevelopment
*Less than normal development (holding back) makes a correctly exposed slide image look dark. Highlights are veiled and shadows may be featureless, producing a flat result. This slide had half the usual time.*

### Bleacher in developer
*Contamination of one color slide solution with another gives various degraded image effects. Here, bleacher reached the color developer, producing a blue cast in mid-tones and shadows.*

### Fixer in developer
*The magenta cast affecting most dark tones in this slide was due to contamination. A few drops of fixer were allowed to spill into the color developer when the solutions were in adjacent graduates.*

# Making prints

The advantage of doing your own printing is the control you have over the results. Instead of accepting standardized, full-frame prints produced by automatic machines, you decide the cropping, contrast, and density best suited to each individual picture. You do not have to enlarge every picture: it is generally a mistake to make prints from every frame of a roll of film.

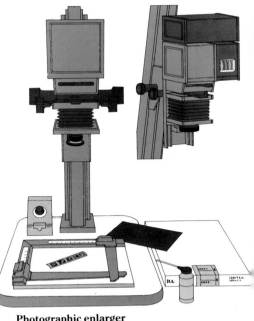

## Black and white film

For black and white printing, the materials are insensitive to red or orange light, and are processed in open trays where you can see the gradual appearance of the image as it develops. Negatives themselves tell you whether the image is correctly exposed, accurately focused, and generally sharp. But it takes a print to tell you if the expression in a portrait is relaxed, or if the lighting is exactly right.

### MAKING A CONTACT SHEET
For every newly processed film, your first task will be to make a set of contact prints – a sheet consisting of rows of miniature prints. These contact sheets are important, and worth doing well. Spend time looking at them, to decide which prints you want to enlarge.

**Photographic enlarger**
*This is the basic equipment that you will need in order to make prints. It works like a vertically mounted slide projector, forming an image on paper on the baseboard below. For color prints, the enlarger must accept colored filters. Most use a tri-filter color head with scaled controls. An enlarger must give even illumination. Any darkening of the light towards the edges will produce an uneven print.*

### Exposing the contact sheet test strip

*When you make a contact sheet you are dealing with a large number of separate negatives. It is impossible, of course, to make exposure allowances for each individual negative, but it is a good idea to make a test strip first, using two different exposures (see right). Use soft-grade paper, as this will produce reasonable results from a wide range of negatives.*

**1** *With the safelight on, place the paper emulsion (glossy) side up on the baseboard. Cover the lens with the red filter, switch on, and check that the paper is fully lit.*

**2** *Position the negatives emulsion (dull) side down on top of the paper. Lay a clean piece of glass on top of the negatives and paper. Remove the red filter and expose.*

**3** *After 5 sec, cover half the paper with opaque cardboard and continue the exposure for a further 5 sec. Switch off the enlarger, remove the paper, and process it.*

Once you have exposed your contact sheet test strip, you must process it. After allowing it to dry completely, assess the results. The techniques here are the same as those that you will use to process the entire contact sheet and your final prints. Just as in black and white film processing, there are four stages in black and white print processing: developing, stopping, fixing, and washing. You will need separate trays for each solution.

## Processing the contact sheet test strip

**1** *Tilt the developer tray forward slightly, and lay the exposed paper face down in the tray. Start the timer.*

**2** *Lay the tray down so that the developer washes back over the print. Turn the print over and gently agitate the tray.*

**3** *At the end of the correct development time, use the developer tongs to remove the print carefully from the tray.*

**4** *Drain the print, and drop it face down into the stop bath. Do not allow the developer tongs to enter this solution.*

**5** *Use the fixer tongs to agitate the print gently for the complete stop period. Remove the print and allow it to drain.*

**6** *Place face down in fixer. Agitate for the first 15–20 sec. After 1 min switch on white light and turn the print over.*

**7** *You can view the print before fixing is complete, on the back of a spare tray. Return the print to the fixer for its full time.*

**8** *After fixing is complete, wash the print in a constantly changing source of water, then allow it to dry.*

### Assessing the test strip

*The test strip now shows two very clearly divided zones. The lighter half received the shorter exposure time of 5 sec. Of course, individual negatives will vary in contrast, some printing better at one exposure and some at the other. But you must decide the best compromise exposure and then expose a whole contact sheet for this length of time.*

## MAKING A PRINT

A contact sheet helps you to select your best pictures, but enlargement really brings them to life. For each printing, the best exposure time depends on the density of the particular negative, the size of enlargement, the lens aperture, the enlarger bulb wattage, and the paper type and grade. The best way of determining exposure is to make a test strip similar to the one described for a contact sheet. Position the strip so that each zone will contain dark and light image areas.

### Exposing the print

**1** *Select the pictures that you want to enlarge from your contact sheet, and mark them up for cropping. Note the negative numbers.*

**2** *Mix and set out all of your processing solutions in advance, in the same way as you did when making your set of contact prints.*

**3** *Adjust the empty masking frame to accommodate your size of paper. Allow for a suitable border all the way around.*

**4** *Pick out the negative you want and blow away any dust on both of the surfaces. Place it in the carrier, emulsion (dull) side down.*

**5** *Change to darkroom safelighting. Switch on the enlarger at full aperture. Adjust the height until the image size is correct.*

**6** *Focus the image on the baseboard. Adjust the frame to compose the best picture. Alter the enlarger head height if necessary and refocus.*

**7** *Stop down the lens to about f 5.6. If the negative is very thin and likely to give a dark print, stop down the lens to f 8 or f 11.*

**8** *Swing the red filter over the lens and switch off the enlarger. You are now ready to make a test strip of the image, as for the contact sheet.*

### Projection print scale

*You can use this to make a test strip, instead of covering parts of your print. It produces 10 exposure segments through varying densities of black printed on film. Place it over the paper and expose the negative for 60 seconds. Each segment shows the result that would be obtained by exposing for the length of time printed at its edge.*

## The first print

Assess your test strip, as for the contact sheet, for the correct exposure for making the enlargement. You will discover far more from the first full print. Unevenness, dust and hair marks, wrong contrast grade, and poor framing are far more obvious on an enlargement. The print below shows a wide range of defects, and the print corrections at the foot of the page show how you can correct them. In general, a good print should show a rich range of tones between deep black and clean white. Much, however, depends on the subject and your interpretation of it. It should be your aim at first to master the techniques, and produce a clear and objectively correct print, free from errors and defects. Once you have accomplished this, you can begin to manipulate the various procedures involved in order to produce more subjective results.

**Unwanted edge detail**
*This element in the picture is distracting and best removed. You can crop it off by increasing the degree of enlargement or by shifting the edges of the masking frame inward slightly.*

**Uneven density**
*Although exposure time was correct for most of the print, you could improve these areas with slightly more exposure, and the darker areas with slightly less.*

**Unequal white border**
*The width of the border here is unequal, and the picture is slightly crooked on the paper.*

**Obstruction**
*This vignetted corner does not appear on the negative, so something has blocked the light. The soft edge suggests that the obstruction was some distance from the paper.*

**Hairs and dirt**
*White shapes with sharp outlines are generally caused by dirt on the negative, the glass of the negative carrier, or the paper itself.*

**Flare from rebate**
*This darkened area has been caused by light passing through the film rebate. It means that you did not place the negative correctly in the carrier.*

## Correcting the first print

**Hairs and dirt**
*Remove the negative carrier. Hold it under the light beam and dust off both film surfaces.*

**Flare from rebate**
*Re-align the negative accurately in the carrier so that all four negative rebates are masked off.*

**Borders and edges**
*Alter the paper stops to equalize the print borders. Move the frame to crop out edge detail.*

**Obstruction and uneven density**
*Check that nothing blocks light. Burn in the window (see p. 183).*

# Color prints

The materials used for making color prints are sensitive to all light, so you must become accustomed to working in total darkness. Make a contact sheet of each film that you process, and test exposures to determine exposure and filtration for each print. Allow these tests to dry before assessing the results.

## Printing from color negatives

**1** *Clean your negative. Place it in the carrier, emulsion side down.*

**2** *Adjust frame. Switch on enlarger. Compose and focus.*

**3** *Examine your notes and the recommended filtration and exposure.*

**4** *Set chosen test exposure on enlarger timer. Select filters.*

**5** *Angle the frame to test a typical section of the enlarged image.*

**6** *In darkness, place paper in the frame, emulsion side up.*

**7** *Expose the sheet. Re-expose with one-third, then two-thirds covered.*

**8** *Put the exposed paper in the processing drum, close the lid, and process.*

*20 sec      15 sec      10 sec*      *50Y 30M      55Y 30M      65Y 40M*      *22 sec      20 sec      18 sec*

**Exposure test**
*When the print is dry, assess results. Density appears correct in the central band (15 sec).*

**Filtration test**
*Mask off each area and expose it separately. The central one has the best density.*

**Exposure adjustment**
*Make another test for density, using the best filtration settings. The center area has the best density.*

# Prints from slides

Printing from a slide is simpler than printing from a color negative, as you can compare the colors of the print with those of the original. The papers used are also very tolerant of inaccuracies in color filtration. Slightly dense and flatly lit slides, rather than contrasty ones, usually produce better prints.

## Printing from slides

**1** *Place slide in negative carrier, emulsion (dull) side down.*

**2** *Clean the slide. Dust will appear as black specks on the print.*

**3** *Switch off the room lights, focus and compose the image.*

**4** *Set the filtration suggested on the pack, or refer to your notes.*

**5** *Set the enlarger timer for the necessary exposure time.*

**6** *Place paper in the frame. Expose part of it for the set time at f 5.6.*

**7** *Expose separate parts of the paper at f 8, at f 11, and at f 16.*

**8** *Load the paper into the print drum. Close the drum and process.*

*f 16    f 11    f 8    f 5.6*

**Exposure test**
*In this example, all strips received 15 sec exposure. At f 11 density looks correct.*

*70Y15C 60Y15C 50Y15C 40Y15C*

**Filtration test**
*The strip filtered 60Y 15C has the best color and density, but could still be a little "warmer".*

**Final print**
*For this the exposure was 15 sec at the half-stop between f 8 and f 11, and filtration was 80Y 05C.*

# Manipulating film

I deally, the image on a film should be an exact representation of the subject, but this is not always the case. One advantage of processing and printing for yourself is that you can manipulate the image.

## Black and white film

In manipulating black and white film the basic concern is the density of the image. If the film has been uprated or downrated, the density of the whole image will be affected, while on photographs that were taken in contrasty lighting, different areas of the image will have varying densities.

**Pushing and holding back**
There may be times when you need to uprate the film in the camera, and then compensate by pushing (extending) development time. This is a useful technique when illumination or lighting

conditions are flat and gray. When light levels are too bright, or lighting contrast is bright, you may have to use the opposite technique.

Uprating the film speed means treating an ISO 400 film as if it were ISO 800, for example. Pushing the development time to compensate for this underexposure will produce an image of fairly normal density, although detail may be decreased in the shadow areas, and grain more noticeable. The more exposure and development are pushed, the more apparent these tendencies will become.

The opposite technique of downrating a film – by using an ISO 400 film with the camera set for ISO 200, for instance – and then pulling (shortening) development time to compensate for the overexposure, is not as common as pushing. You are most likely to use it when photographing a brightly lit subject with a very fast film loaded, which would be overexposed by even the fastest shutter speed and smallest aperture. While negatives have almost normal density, image contrast is reduced.

**Pushing**
*Uprating film speed alone gives a thin negative (right). With extended development time (center right) the negative of this flatly lit subject is greatly improved. Excessive uprating and pushing (far right) gives harsh contrast and a grainy image.*

*ISO × 2/normal development*

*ISO × 2/pushed development*

*ISO × 8/extreme development*

**Holding back**
*Downrating film with normal development produces a dense negative (right). Reducing development time creates a low-contrast result (center), useful in harsh lighting conditions. Overdone, downrating and holding back give very flat negatives (far right).*

*½ ISO/normal development*

*½ ISO/development reduced (held back)*

*¼ ISO/development held back (minimal)*

## CONTROLLING PRINT DENSITY IN SMALL AREAS

Photographers can improve most prints by lightening or darkening selected areas during enlargement. To lighten a particular area, it must be shaded from light during part of the exposure. This technique is called shading or dodging. For the opposite effect, a selected area of the paper must receive additional exposure, and the technique is known as burning in or printing in.

First, make a test print to decide the area (or areas) affected. Tools for dodging are very simple – appropriately shaped pieces of cardboard attached to thin, but stiff, non-reflective wire. For certain shapes you can use the side of your hand, or fingers. The most versatile implements to use for burning in are your own hands. Cup them together to shade most of the picture.

**Dodger**
*Use a dodger for an isolated area. Keep the wire moving to avoid line shadow.*

**Shape on glass**
*Using opaque dye, you can paint any shape you require on a piece of clean, thin glass.*

**Cupped hands**
*To burn in a small area, cup both your hands together, leaving a small gap.*

**Modified flashlight**
*Use a flashlight with a cone over it close to the paper to fog small areas of light.*

**Shading an accurate shape**
*The window in the print is a precise shape, so you must tailor the cardboard to the outline. When printing in this area, be careful to hold the cardboard still to avoid darkening areas around the window.*

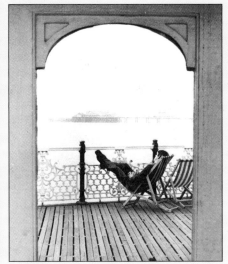

1 *Hold a sheet of opaque cardboard a few inches above the masking frame. Turn the enlarger on and trace the outline of the window.*

2 *Cut the window area out. Expose the main print, then print in the window detail, holding the card at the same height as before.*

3 *The results of doubling window area exposure.*

# Color film

You may underexpose a film by uprating it to a higher ISO number when photographing in poor light, or overexpose it by downrating it to a lower number when taking pictures in very bright light. You must then make adjustments during the processing to compensate for this, and produce a normal image. This is done by extending the development time for a film that has been underexposed, and reducing it for one that has been overexposed. Adjustments for slides are made at the first development stage. Try to limit this sort of manipulation of color film, however, as incorrect exposure of a film can introduce casts that cannot be corrected – and may even be compounded – by altering the development time.

*Normal*                                    *Pushed*

**Pushing color negative film**
*If you have underexposed a color negative film, you can push-process it to partially correct the image. As this comparison shows, however, the push-processed result will have harsh contrasts and noticeably more grain, so try to limit use of this technique.*

**Pushing slide film**
*Uprating the ISO speed of slide film when photographing, and then pushing the first development time to compensate, gives increased contrast, which may be helpful with flatly lit subjects. If it is overdone, however, the technique can result in featureless and unnaturally gray shadows. Pushing also helps to compensate for unavoidable underexposure. Most slide films will allow for a greater degree of pushing than of holding back.*

*Correct exposure and processing*   *Underexposed × 4, pushed*   *Underexposed × 8, pushed*

**Holding back slide film**
*Slides that have been downrated during photography, and then held back in processing, show reduced image contrast. This can improve an overly contrasty subject. Holding back can also help to compensate for overexposure. Results have less rich blacks, and highlights may show warmer tones. If this processing technique is taken to extremes, the resulting image is likely to be muddy in appearance, and have a strong color cast.*

*Correct exposure and processing*   *Overexposed × 4, held back*   *Overexposed × 2, held back*

## BOOSTING AND CORRECTING AREAS OF COLOR

When you make a color print, you can lighten or darken selected areas, and adjust areas of color to rectify any cast or introduce richer tones. Bright areas may reproduce as bleached in color prints, or shadow areas take on a cast. You can boost color in an area by burning in (or shading it, if printing from slides), as with black and white film (see p. 183). Local casts can be corrected by adjusting filtration in the area. If using filters below the enlarger lens, use optically suitable color correcting (CC) gelatin types: acetate color printing (CP) filters will spoil the image definition.

**Boosting color**
*In this print the sky had bleached out. Printing from a negative, increase the sky area's exposure by 50 per cent, and burn in through a 30Y filter. Printing from a slide, shade the sky throughout exposure using a 40B (or 40M 40C) filter.*

**1** *On negative/ positive paper, expose the whole sheet to give the best overall color and density.*

**Correcting color**
*Here the snow has taken on a cast from the sky. Printing from a negative, shade the foreground with a blue CC filter, or extra magenta and cyan filters, and give extra exposure. Printing from a slide use a yellow filter.*

**1** *On negative/ positive paper, shade the blue cast with a blue filter throughout the exposure.*

**2** *Hold a yellow CC gelatin filter below the lens, or dial in extra yellow in the enlarger filter head.*

**3** *Now, burn in the sky area for the extra period. Shade the rest of the print with opaque cardboard.*

**2** *Reset the enlarger timer to give extra exposure (to correct any possible local change in density).*

**3** *Mask off all but the shadow area of the print. Burn in for the extra time, again using the blue filter.*

# Preserving your pictures

The more film you process, the more important it becomes to have some sort of system of protecting and filing your results. Make it a routine to cut up and protect negatives or slides as soon as the film is dry. One of the main purposes of any filing system is being to enable you to find a particular image quickly and easily. With negatives, give each film a sequential number, and then identify individual negatives by their edge numbers, which should also be written on the back of every print.

**Filing film**
*You can file strips of film in clear plastic or paper sleeves (left), or store them in sleeved pages held in a binder. These hold an entire roll of film, and you can file the corresponding contact sheet alongside (below). Give each film a number, then use rebate numbers to identify frames.*

## Storing film
Negatives should always be stored in special sleeves of acid-free plastic or paper. Plastic has the advantage of allowing you to view the film without having to remove it from the protection of the sleeve. These film sleeves can be bought either singly, or as sheets to be clipped into a binder.

## Storing slides
Successful slides can be kept in mounts and stored in a variety of ways. Mounts for 35mm slides are made of either cardboard or plastic and glass. Larger format mounts are available to take slides from all sizes of rollfilm. Once mounted, slides can be kept either in boxes or in suspension files.

**Filing slides**
*First, you must decide how you want to sort your slides. Once sorted out, you can store them in suspension files (below), which hold 20–25 slides each, or keep them in boxes (left). A diagonal line drawn across the mounts tells you instantly if slides are out of the correct order.*

**Cardboard mounts**
*The cheapest, simplest slide mounts are those made from cardboard. These are completely safe, but the film does tend to heat up and bow slightly when projected.*

**Glass mounts**
*Glass-faced plastic mounts protect your slides from finger marks and dust, and hold them perfectly flat during projection. You can easily reopen the mount if you want to remove the slide for printing.*

## FINISHING PRINTS

No matter how careful you are, some of your prints may have small defects, which will require some simple retouching before you can display them.

### Black and white

To remove white spots, use a sable brush (size 0 or 1), a tube of black water color or a retouching dye, and a plastic palette or saucer. You can spot most matte-surface papers using a soft lead pencil. Use white pigment or the point of a scalpel blade to remove any small black specks on the print.

**White spots**
*Stipple in the spots with a lead pencil, or dye on the tip of a very fine, almost dry sable brush, until they disappear.*

**Black specks**
*Use white pigment, or scratch them from the surface of a fiber-based paper using the point of a scalpel.*

### Color prints

To treat color prints you will require fine brushes, cotton balls, and wet and dry retouching dyes. If your print has any small white specks, use a brush and diluted water color. For large light-colored areas, such as skies, you can use either water color or dye designed for your type of paper. Apply the color in light coats, building up to the right strength. Treat any black specks with a chemical reducer. To "tone down" color, use dyes: cyan for red, magenta for green, orange for blue, and yellow for blue and magenta.

**1** *Breathe on a cake of dry color. Use cotton balls to apply the color to the print with small, circular movements.*

**2** *To make the retouching permanent and remove surface marks, hold print over steam for 10 sec.*

### Mounting prints

Mount color prints on thick board with a cardboard overlay. You will require a sharp knife, baseboard, cardboard, acid-free adhesive tape, a ruler, and a pencil. Use a set square to check that all of the corners are at right angles.

**1** *Mark out an area on the cardboard overlay that is slightly smaller than the image area of the picture.*

**2** *Use a metal ruler and a sharp knife to cut out the center area of the cardboard along the marked lines.*

**3** *Position the print on the baseboard. Check that it is straight and centered, and secure it with adhesive tape.*

**4** *Attach the cardboard overlay to the baseboard, using double-sided tape to secure it in position over the print.*

· CHAPTER FIVE ·

# SPECIAL
# EFFECTS

Special effects photography is concerned
with manipulating reality – to form an
eye-catching image, or to create a dream-
like, even nightmarish visual situation.
To become a good special effects
photographer you must experiment – be
prepared to waste some materials, and in
the process you will discover new kinds of
image. You need to be a good technician in
order to get the most out of tools and
processes, and you must be flexible and
inquisitive – before you throw away a
"spoiled" image, consider how you could
take that type of image further or turn it in a
different direction for an interesting result.
If your main aim is to experiment and
explore in order to discover what
variations are possible, make sure you
adopt a methodical approach and take
notes. You should record details of
exposure, as well as of technique.
Finally, the best way to learn about special
effects photography is to go out and
practice it. Most people find that it is far
easier than they expected. You should
be adventurous, and follow your own
visual preferences.

**Surreal color**
*The colors in an image can be distorted by using
different types of film, filtration, and processing. This
landscape was photographed on infra-red sensitive film
and then filtered magenta and yellow during printing.*

# Studio effects

There are a number of special effects and illusions that you can create in the studio. You can introduce a sense of mystery by lighting a dark subject dramatically from an unusual angle, and colored bulbs or other unusual light sources, such as ultraviolet, will tint familiar objects in strange new shades. Projected images provide endless pictorial possibilities in the studio. As well as providing abstract or fantasy settings for special effects purposes, projectors can be used to merge images, giving surreal results.

## Using reflections

Many photographers use reflective surfaces to combine unlikely subjects in one shot or to distort the natural shape of an image. Windows, polished paintwork, wet streets and smooth or rippled water are natural reflectors. You can use reflective foil materials for indoor shots. For unusual juxtapositions, try including a reflector's surroundings; for semi-abstract

**Distorted reflection** (above)
*For this portrait the photographer placed the subject in front of a sheet of foil, and then photographed the reflection from an oblique angle. When taking color photographs, you can use foils of differing colors.*

**Found reflection** (above)
*Reflections can be used to give strange and new impressions of ordinary objects. This close-up shot of a window reflected in an eye has a disorientating effect, although it was easily achieved.*

results, crop in tightly. Store windows give a result similar to multiple exposure, as they show the reflection superimposed on objects behind the glass. Stop down the lens and focus midway between the glass and the reflected subject so that both are sharp. A patch of water may give an inverted reflection of an entire scene, which can be photographed and then displayed turned upside down again, so that the image appears the right way up, but slightly distorted. A small patch of a brightly colored scene or subject may be reflected in a pool of water surrounded by dark ground, and appear as an abstract, framed by the dark surrounding area. A curved surface will give a distorted effect similar to that of taking a photograph through a fisheye lens.

# Using lighting

A single artificial light source is an extremely flexible photographic tool. By controlling direction and quality you can create lighting effects that range from the naturalistic to the macabre. Sunlight illuminates scenes from above, so lighting from below gives objects an unnatural look. For the most dramatic results, use a compact light source such as a small spotlight or flash because this gives hardest-edged shadows. When you use this source to light from below – with a face, for example – shadows will occur where you expect highlights, giving an almost negative image. If you direct the source from one side, or from the rear above, you can rim-light the shape of a subject set against a dark background without revealing detail. (See *Using studio lighting*, pp. 132–3 for different lighting effects.)

Using the camera on a tripod in a darkened room widens the possibilities of a single light source. Move the light in an arc over a still life during a long exposure to paint it with light. Or use a flash or lamp to light the same subject in several different places, recording it on one frame of film. This is one of the easiest ways of creating a multiple image.

**Multiple flash**
If the design of your camera makes it possible to lock open the shutter, you can use multiple flash in a darkened area to create special effects. The basic principle is the same as that of painting with light, where you move in darkness and illuminate a large area with bursts of light from a flash unit. Variations of this technique can produce strange effects. You can introduce light from directions where there would not be normally be a light, if you are careful to exclude yourself from the area that is lit, or you can move the subject between firing the flash. Be careful when calculating exposure for this kind of shot. It is best to bracket (see *Setting exposure*, p. 56).

**Overlaid images**
*Use a single flash unit for this effect. Secure the camera on a tripod, set up the subject in darkened surroundings, and lock the shutter open. Fire the*

*flash, then move the subject, in darkness, to the next position required, and fire the flash again. This will create multiple images of the subject. You can overlap the images for a ghostly effect.*

## Colored light sources

The use of colored light sources to illuminate a subject – a technique familiar to theater, television and discos – is often under-rated as a way of creating photographic special effects. Colored lights can "re-tint" subjects, overwhelming their true colors, to suit a mood or theme. In addition, a colored source can separate one subject element from another, or from the background, and harmonize objects of contrasting colors. Under colored lights, white parts of the subject and parts that match the lighting color become indistinguishable, and complementary colors look almost black.

It is sometimes effective to keep at least one small part of the picture lit with white light, as a foil to the other rich colors. Another method is to filter two light sources in complementary colors – strong green and magenta for example; wherever they illuminate the same part of the subject in equal amounts, they form white light and reveal the subject's true colors.

Color-filtered flash units offer the visual potential of colored bulbs with the advantage of mobility and the chance to freeze action. Most advanced flash kits include strongly-colored plastic filters that clip over the unit. These filters also carry information on the number of stops you need to increase exposure, because strongly-colored light affects meter cells of auto-exposure circuits.

**Lighting for mood** (above)
*For this shot the photographer used a fluorescent tube as lighting, to give a cold, remote atmosphere.*

## Unusual light sources

Many objects record in odd, unearthly colors if photographed under a light source that lacks the full range of wavelengths found in normal white light. Photographers use this type of lighting to produce science-fiction effects. Daylight and tungsten-type slide films will react strangely to ultra-violet lamps, fluorescent tubes, and street lamps.

Ultraviolet or black light tubes give out mostly UV wavelengths which the human eye cannot see, but which cause certain materials to glow brilliantly in white or a particular color. All these units give either black or deep purple light. To take UV photographs, set up your lamp in a darkened room on subjects such as white or fluorescent-colored papers, plastics or synthetic fabrics. Most liquid detergents, toothpaste, and powdered chalk also glow well.

**Combining colored lights** (above)
*Lights filtered in three colors were used here; a deep blue to the left, a deep green to the right, and an orange on the background.*

# Projecting images

Projectors are extremely helpful in setting up special effects in a studio. Their basic use is to combine two or more images, which may be entirely unrelated, into one realistic image.

## Projected backgrounds
Projected backgrounds allow the creation of virtually any setting in the studio. The simplest system is to project a slide on to the back of a translucent screen, then set up your studio props in front of this. The screen material should be texture free, thick enough to prevent a cental glare spot from the projector placed square-on behind it, yet capable of showing a sharp, clear image from the other side.

Make sure that your studio lights match the direction, color and quality of the lighting in the background image. You must shade the lamps from the screen, otherwise dark parts of the background will appear gray.

## Projecting onto objects
A flexible and convenient way of mixing images for surreal effects is to use one or more slide projectors to project slides on a flat or three-dimensional surface in a darkened room. With your camera on a tripod, copy the image.

For an unusual image distortion, project a slide on an undulating plain surface such as white curtains or crumpled paper.

To create a superimposition effect, project both images on a flat white screen, then shade out unwanted parts of each image using black cardboard held a few inches in front of each projector lens. Where images overlap, each will appear in the light areas of the other. When copying the result, measure exposure from the projected image as if it were a normal scene.

**Distorting shapes** (above)
*Projecting a slide onto a surface such as crumpled paper, and then rephotographing it, can produce collapsed images like this.*

**Creating a fantasy background** (above)
*A model was suspended in front of a screen, and a projector set up at an angle to create the background image of bars of light.*

**Combining images** (above)
*To produce this image, a slide of dry, cracked earth was projected on to a white boot against a dark background, and the result rephotographed.*

# Camera effects

This group of effects centers on the camera itself. Movement of subject, camera, or both, can be used to produce blur. You can photograph through screens, masks, and improvised lenses to alter the quality of the image, and the shutter can be manipulated to give continuous or composite images.

## Photographing through screens and masks

Use screens as pattern-making devices, by either placing them right in front of the film, or, for a simpler effect, shooting through a screen-like mesh just in front of the subject. Screens change the image into a regular or irregular grid of lines or dots, destroying fine detail. Masks allow you to form unusual picture shapes, or to blend part of one scene with another by double exposure.

Cut out masks from black cardboard, or purchase pre-cut shapes. You can make more elaborate masks photographically on lith film. The smaller the lens aperture you use, the sharper your mask shape will be. A wide-angle lens makes the mask smaller in the frame, a telephoto makes it larger. Pairs of double masks – one shape is a "negative" of the other – allow you to take one image inside or alongside another for multi-image effects.

**Aperture mask on telephoto lens** (above)
*A piece of card with a leaf-shaped hole cut in it was placed in front of the telephoto lens. Unfocused highlights took on the leaf shape.*

**Photographic screen** (above)
*Cake decorations where shot on color slide film. The slide was placed inside the camera, just in front of the film, before photographing the scene.*

**On camera screen** (above)
*This photograph was taken through scrim, which is usually used in front of studio lights to reduce their power. The graphic effect suits black and white.*

# Using simple optics

Low-grade optics can create a soft image quality impossible to achieve with a photographic camera lens, even with a diffuser. Cheap plastic or glass magnifying glasses, toy cameras, or a pinhole, all give slight softness of detail and spread of light.

It is possible to replace the normal lens in most cameras with a simple magnifier. With an SLR camera, you can measure exposure using its TTL meter, but you may have to position the lens at the right focusing distance using a cardboard tube taped between the lens and the camera body.

Pinholes also give a soft image, with very great depth of field. Because extremely long exposures are often necessary, even slow moving objects such as clouds or flowing water may record as featureless blur. You can fit a pinhole to an SLR body by taping aluminium foil over the lens seating, and making a tiny needle

**Using a plastic lens**

*To obtain the softened outlines and colors in this image, the lens of the camera was removed, and a cheap plastic magnifying glass was put in its place. This simple lens was taped on to the end of a length of cardboard tube in order to keep it at the correct focusing distance from the film.*

hole in the center of the foil. You will be able to see the image dimly on the focusing screen. You should increase exposure time to allow for reciprocity failure. You can also make improvised pinhole cameras from boxes of printing paper, cans or developing tanks. Both magnifying glasses and pinholes give low-contrast images, so push-process your results.

You can use a close-up lens so that it affects only one section of the image. This makes it possible to create an extensive depth of field that is impossible with normal lenses. Hold a supplementary lens some distance from the camera lens. Focus the camera lens on the part seen through the supplementary, then control the sharpness of the rest by choice of aperture.

## Using filters

Filters provide a quick and simple way to dramatically alter the appearance of a picture in any number of ways – through color, focus, division of the image and so on.

You can make filter attachments out of everyday materials, but a range of filters and similar devices in glass, optical resin, or plastic is widely available.

It is possible to buy filters which are split across the center, so that one half focuses objects at a different distance than the other –

giving the lens two different focal lengths. The effect of this is that the foreground and background are focused, as with maximum depth of field, but all objects that fall in the middle distance between the two focal lengths record as out of focus.

There are other types that will split the image in different ways. In these filters it is the thickness and shape of the glass that create the effect. Some have different facets, others have prisms in them, and these create various types of multiple image, dependent on the structure of the filter. They can be useful to emphasise movement by repeating it, or to create a sense

**Dual focus** (above)
*To achieve the effect of having both close and distant objects in sharp focus while those in the middle ground remain indistinct, a filter divided across the middle, with a different focal length on each half, was used.*

No filter                    Filter

**Diffusing effects** (left)
*A diffusing, or fog, filter can render an entirely clear and focused image, (far left), diffused and grainy (near left), while still keeping the subject identifiable.*

of confusion. Well-defined objects against plain backgrounds work best with these filters. Remember that a pale background will cause contrast to be flattened, because the light in each of the images will overlap. To split up one part of a scene only – to form several heads on one body, for example – hold the filter in front of that part of the image, about 6in (15cm) away from the camera, with the lens set to a wide aperture, so that the shape of the filter itself does not record.

There are also filters that split up the light in the picture. This effect is achieved by means of patterns of lines engraved on the filter surface, which diffract the light in various ways. They work well on small, but intense light sources, such as candles, city lights, a setting sun, and highlights reflected from water or glass.

**Prism** (above)
*This filter gives blurred colors and repeating lines.*

**Multifacet** (above)
*The angled facets each form an image of the subject.*

**Multicolor** (above)
*Each angled segment gives a different colored image.*

**Starburst** (above)
*The engraved lines create rays around any light source.*

**Diffraction** (above)
*The lines on this filter break up the image into bands or streaks.*

**Diffraction** (above)
*The pattern splits highlights into colored flares.*

# Using movement

Photographers who study movement use slow shutter speed to capture its flow and sway. To achieve blur, keep the camera's shutter open while the subject is moving. Movement against a pale background will often burn out the subject (use this technique to "clear" pedestrians and traffic from a busy street).

## Subject movement

Using a slow shutter speed on a moving subject can transform the image into an abstract of flowing lines. You will need a tripod, slow film, and a lens that stops down well. Light-toned subjects against plain, dark backgrounds give the best results. Try to include a still element that will provide a sharp contrast to the blurred action. You need a tripod and slow film, and in bright light use neutral density filters.

**Moving subject** (left)
*Here a slow film and shutter speed have been combined to transform a moving subject into an abstract blur of color. The pattern of the tiles on the wall remains in sharp focus, providing a dramatic contrast. A tripod is essential for this effect.*

**Moving with the subject** (right)
*For this shot the camera was panned, following the subject as it passed the photographer but at a slightly different speed. The result is that both the background and the subject are blurred, giving an impression of great speed.*

## Camera movement

Camera movement with static subjects can produce a variety of effects. By moving the camera slightly during exposure you can create a streaking of the whole image. This is sometimes so minimal that the softened detail looks like the result of poor lens quality. Shifting, rotating, or moving forward with the camera, during exposures of 1/8sec or longer, will make highlights record as lines.

The more contrasty the scene, the more dramatic the results will be. Subjects such as streets at night, illuminated decorations, and backlit tree foliage are all suitable.

## Zoom

A zoom lens with a long exposure can create an exploding image. Subjects with isolated highlights against a dark background give the best results. Set the camera to a shutter speed of ¼ sec or longer, and zoom from the longest focal length of the lens to the shortest.

## Slit shutter

Slit shutter results are in long strips without frame divisions. To achieve this effect, either tape foil in the focal plane of your camera or place a piece of slit cardboard over the lens hood. The slit should be 1/16in (1mm) wide.

On 35mm cameras cover the lens and advance the entire film on the take-up spool. Then tape down the rewind button, lock the shutter open, and expose by turning the rewind handle steadily. Set your camera on a tripod, and position it so that passing subjects move in the opposite direction to the film.

**Creating blur from a still subject** (above)
*A zoom lens was focused on lights reflected in water and zoomed out during a long exposure. This transformed the points of light and their reflections into blurred streaks.*

**Continuous images** (below)
*Slit shutters produce long strips of image, with no frame marks. Any segment can be selected for projecting or mounting.*

# Film effects

There is a whole range of effects that can be produced by your choice of film and the way that you process it. You cannot preview the strange colors or tones of results on the camera focusing screen, so expect to make test exposures first. It is usually best to choose relatively straightforward camera images and avoid adding optical effects on top of film effects. Instant picture films have their own special effects features. When prints emerge from the camera you can manipulate them by hand to distort the image, changing its photographic look to an impressionistic, painted effect.

## Using infra-red film

Infra-red radiation is present in most light, although it cannot be seen by the eye. Because subjects that appear similar to the eye reflect infra-red in different amounts, infra-red film can transform ordinary-colored scenes into dream-like mixtures of false and accurate colors, or distort the tones of certain subjects to change the look of an image.

**Distorting colors** (above)
*In an infra-red photograph, human skin has an unnatural, waxy surface appearance. Its color is often distorted – here it has a magenta tinge.*

**Color infra-red**
Infra-red color slide film is sensitive to green and red light as well as to infra-red. Through a deep yellow filter, foliage records magenta and most red plants or fabrics appear yellow. Without any filter, results will show a strong overall blue cast. An orange or red filter gives a yellow cast to the highlights. Try a deep green filter for purple foliage.

**Black and white infra-red**
Black and white infra-red film must be exposed through an extremely deep red or a special IR-transmitting filter. With an SLR camera, compose the image first, then cover the lens with the filter. Adjust focus to the IR mark, and measure the exposure with a hand meter.

**Distorting tones** (above)
*Black and white infra-red film creates stark tonal contrasts. It also decreases perspective, because distant haze is not recorded.*

# Mis-matching film

Most color slide films are designed to produce objective reproduction of color, given the recommended form of subject lighting and correct processing. Mis-matching either of these factors creates false colors.

Negative colors present familiar objects in a startling way. The best way to produce these is to process color slide film in the chemicals used for color print film. Because such slides will be contrasty, you should use soft, frontal lighting. For a different effect, expose tungsten film in daylight, then give it negative processing and it will show a yellow cast. You should bracket exposures.

**Mismatched slide film** (above)
*A picture of tulips was taken on slide film and then processed as color negative film, producing startling distortions of color.*

**Mismatched infra-red film** (right)
*This bowl of fruit was photographed on color infra-red film, which was then processed as color negative film. Green foliage, normally recorded as magenta on infra-red, has produced a bright green image, but all other colors are further distorted.*

# Manipulating instant film

Instant pictures have a special structure which can be exploited to create unusual, semi-abstract results. One-step color prints consist of complex image layers and jellied processing chemicals sealed between plastic. These layers respond to manipulation.

During the first seconds after a one-step print leaves the camera its emulsion layers are soft and pliable, and can be manipulated with a blunt tool. This will distort the lines and colors of the image. You can burn or crease the prints or cut open the back and scratch or paint over selected areas, or add parts of other prints.

With peel-apart color prints, try soaking the print in hot water, then creasing or pulling it when you transfer the emulsion to a new surface. You can use the negative portion to make a second color print on paper. Squeegee the negative face down on the paper. Once both have dried, peel them apart.

**Making a montage** (above)
*To combine these images, the back of the print was opened, and the white layer wiped away with a damp cotton ball. Areas of the image were then scraped away and other elements added.*

**Manipulating emulsion** (above)
*This image was distorted by manipulating one-step film emulsion while it was still fluid. Images can be blurred, distorted, or broken up by pressing on them.*

**Adding color** (left)
*This print was opened at the back, and the white layer washed away with a damp cotton ball. Color was then applied in some areas, giving a muted result. In other areas dye was scraped away before color was applied, for a stronger effect.*

# Making multiple exposures

Two or more exposures on one frame of film can combine wide-ranging subjects, structures, and moments in time in the same picture, to create unreal or physically impossible visual situations.

In a multiple exposure, details of one image will be readily visible in the darker areas of the other, and areas of overlap become progressively lighter with each exposure. It is best to select dark-toned backgrounds for each of your component images, and make a preliminary sketch or mark the focusing screen to make sure that they match up successfully. If the medium or light tones of one image substantially overlap those of another, give each element half its correct exposure time. With images that do not overlap, and have dark backgrounds, you can give each part the TTL meter exposure.

Multiple exposure will combine images that differ in viewpoint or scale. To alter size or perspective quickly it is a good idea to use a zoom lens. You can also try changing colored filters for each exposure, or shooting one image blurred, or out of focus, in order to enhance your effect.

**Repeating images** (above)
*This effect was achieved by taking several exposures in quick succession without winding on. Be careful with exposure when using this technique, and try to use dark backgrounds.*

**Combining images**
(right)
*Multiple exposure can combine completely separate images into a convincing whole. A roll of film was shot with images of just the moon, and careful note taken of its position in each frame. The film was rewound and reshot, filling the dark areas with the hand and piano on a dark background, and keeping the area around the moon empty.*

# Darkroom effects

It is possible, through darkroom techniques, to take a perfectly ordinary image and alter its appearance quite dramatically, in terms of the colors and the texture of the image.

## Altering image quality

There are numerous ways of manipulating and combining the image that you have already taken and processed, making use of existing negatives and slides to produce special effects. There are several advantages to working at the post-camera stage – whether in the darkroom or the workroom. You will have more time, greater control over the image, and the opportunity to change course without the need to reorganize subject matter. You can also produce several variations of one image.

**Solarization**

Solarization (or, more accurately, the "Sabattier effect") involves exposing an image to light part way through development. This has the effect of fogging, or darkening, undeveloped areas, and reversing some of the tones. It also forms a fine, clear "Mackie line" along the borders of light and dark areas. For the simplest solarization, make an enlargement on very hard-grade paper and switch on white light briefly in the middle of development. Fogging the paper only gives minimal edge-line effect, though, and a generally flat result. For better results, work on black and white film – preferably a line emulsion because contrast is reduced by fogging. You can contact print your negative on line film, solarize the result, and enlarge this on paper. For solarization in color, first solarize your black and white line image (made from a color original). Then enlarge this

**Solarized slide**
*Here, a slide was contact printed onto lith film. These images were sandwiched and a second lith film contact*

*print made from them. Color negative print paper was exposed to first the slide and then the second lith film image to give the final effect.*

in sequence with the original color slide or negative on color paper. This method has the advantage of leaving your original image unaffected for "straight" printing.

## Posterization

Posterization can be used to convert a normal-looking photograph into one that consists entirely of distinct but flat areas of tone or color. A poster usually relies on simple, opaque pigments to produce a bold, striking effect. a posterized photograph has much the same appearance – all shading and gradation being replaced by abrupt changes from one area of tone or color to another.

Posterization involves making a series of tone or color separations to produce three different negatives and positives on high-contrast lith film. Enlarge the original on several sheets of lith film, using different exposures for tone separations, and different filters for color separations.

To print the separations, set up your enlarger so that the light source covers the area of the film separations evenly, and make three successive exposures, through a different film separation each time.

With color separations, use the deepest cyan filtration to print from the red separation, magenta for the green, and yellow for the blue. This filtration will give an approximation of the original subject colors and a fairly realistic image, but you can print in the "wrong" filter colors for more subjective results.

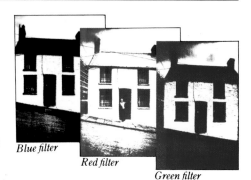

*Blue filter*

*Red filter*

*Green filter*

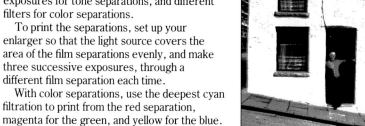

**Posterizing a print** (above)
*With the print on a stand and the camera on a tripod, shots filtered blue, red, and green were taken on black and white film, and combined to give the final print.*

**Color from black and white** (right)
*Enlarged positives of a black and white negative were made on lith film: a short exposure for shadows, and a long one for highlights. Lith film negatives were contact printed from these and taped to a lightbox. Three shots were taken on one frame of color film: one filtered blue, of the shadow negative, one orange, of the highlight negative, and one green, of both.*

## Line images

A line image is a photograph simplified to only black or white, giving it stark, graphic qualities. Subjects for line treatment should have interesting outlines and be sharp throughout.

High-contrast film is very slow and has little exposure latitude, so it is best to shoot on normal film, then either make a print from this original and copy it using line film, or contact print your negative onto line film. The latter gives a positive, which you then contact print to create a line negative. Another method of simplifying an image is to print through a screen with a line pattern onto lith film. You can convert a color slide into a high-contrast negative by contact printing it on to panchromatic lith film.

## Using linear effect screens

An image can be converted to line by printing through a screen. Choose the pattern to complement the particular image. The range of ready-made screens available includes parallel line, wavy line, concentric circle, and cross-line grids in various rulings. You can enlarge a screened image so far that it becomes abstract.

**Simplifying images** (above)
*The extreme contrasts that result from copying on to line film work well on a strong, simple shape such as a spider's web.*

**Increasing contrast** (above)
*This image was enlarged from a normal contrast negative onto lith paper to give a high contrast print with some tone values.*

**Emphasising perspective** (above)
*A line screen can be used to echo a picture's composition – circles converging on a point, as here, or horizontal lines on a flat sea.*

## Grain

A grainy, mealy structure destroys fine detail in an image; pictures have an impressionistic, non-photographic quality. You can produce grainy results in several different ways. One method is to shoot on very fast coarse-grain film, then enlarge a small part of the image. Or take a normal image and copy it on coarse-grain film, or sandwich it with a grain-pattern screen before enlarging. You can buy screens, or make your own by photographing a sheet of even, dark-gray cardboard on coarse-grain film. In general, screen results are not so interesting as genuine image grain, because the pattern is too even. With both methods, grain shows up most strongly in mid-tone parts of the picture, so try to choose low-contrast, softly-lit subjects. (This type of subject also allows you to overdevelop and print on hard-grade paper, to exaggerate the image grain.)

If you wish to produce an entire roll of grainy images, rather than just one or two, you can use the technique of "pushing" development time on an ordinary film, but this will also affect the colors in a color negative or slide. There are also special high-speed developers. These give the best results when used on fast film.

**Grain in the film** (above)
*A very small section of a slide was enlarged on film and push processed. The individual dye globules in the film have become visible.*

**Grain screen** (right)
*The original negative image and a grain screen film (above) were sandwiched between glass for printing, to give an impressionistic grainy result (right).*

## Bleach and tone

After processing the print there are some chemical treatments you can use to alter its appearance. The two most important of these are bleaching and toning, both of which can be carried out on finished prints under normal room lighting.

Toning is the conversion of a silver black and white image into a colored chemical result that retains the same tonal values as the original. Toners are generally purchased as kits, and are available in sepia, blue, red, and many other colors. Choose a color to match the mood of your image – blue gives a cold, snowy look that suits landscapes, whereas sepia gives a warm, antique effect like an old, faded photograph. You can tone images selectively to emphasize a single object, or to convert different areas of the image into a range of bizarre colors.

Start with a fully processed black and white print, and work in normal room lighting. With most toners you bleach the black and white print in one solution, then redarken it in a toner to form the chosen color. If you cover parts of the print in a mask (such as rubber solution) before you bleach the image, the unprotected areas will remain black and white, while the rest of the image will take on the color of the toner. You can subsequently peel off the mask and tone these areas in another color. Partial bleaching in a diluted solution retains the darkest shadows as black – only light and mid-tones change color, giving a subtler effect.

Toners only convert the silver image, leaving the paper base white. However, if you soak the paper in dye, this will stain the gelatin so that highlights turn the color of the dye. You can tone a silver-image black and white negative or positive.

**Altering color**
*This blue image (right) was created by first bleaching the black of the black and white print (above), after washing it, and then re-darkening it in a chemical kit.*

# Bas-relief

Photographs can be made to look like side-lit, low-relief images by combining negative and positive films of the same image, slightly out of register. The best type of image to use is sharply focused and evenly lit, with plenty of strong, simple shapes. Contact print the chosen negative on to a sheet of continuous-tone film, aiming for a positive with similar contrast to the original. After processing, sandwich the positive with the negative, but offset it slightly to one side, and print. A dark "shadow" will appear on one side of all detail and a clear "highlight" down the other. You can also, if you wish, mount the positive and negative sandwich in the same slide mount ready for projection.

**Embossed effect**
*A negative which gave a normal print (above) was manipulated to produce this embossed result (right). The image has been simplified into a pattern of lines and flat tones, and seems to be all on one plane.*

# Adding and altering color

Coloring techniques can be used both to create a color image from a black and white original, and to produce impossible color combinations and distortions. Remember that copying negatives before coloring allows you to make several different interpretations. If coloring prints, bear in mind that glossy prints are less suitable for coloring than matte-finish prints.

## Hand-colored negatives

By hand-coloring a black and white negative, you can make any part of your final image a particular color. Remember that negatives have reversed tones, so you must use tints that are complementary to those of the final colors required. If possible, work on a large negative, avoid dense negatives, and bear in mind that shadows are more easily colored than highlights. When printing, sandwich with unexposed but processed color film.

**Selective coloring** (above and right)
*Complementary-colored dyes were first applied by hand to selected areas of a black and white negative (above). This was then printed on to color paper together with an orange mask, to give an image in the desired colors (right).*

**Overall coloring** (above)
*If you color the entire negative (above left), the lack of neutral tones makes it possible to achieve a variety of results through adjusting filtration when printing. The*

*first print (above center) was filtered 90Y 60M, and the second (above right) 40Y 40M, with the orange mask that was sandwiched with the negative removed for 10 per cent of the time.*

## Hand-colored prints

The application of color to a print allows total control. You can emphasize selected areas, give a full-color realism, or produce bizarre false-color effects. Your original image is also left untouched for straight printing or other forms of manipulation.

Start with a matte-surfaced black and white print that is light, but full of detail. It is best to sepia-tone the image first (see *Bleach and tone*, p. 208), especially with water-based paints, because black will mute colors. If you still require some areas of dense black, you can apply the toner selectively, masking areas that are to remain black and white. Apply color with brushes, cotton swabs, or an airbrush. You can use oil paints, spirit- or water-based pigments, or dyes.

If using water-colors, wet the print first, then blot it off. Treat broad areas first, working rapidly with a large brush or swab. It is best to build up color gradually, in several coats. Next color smaller areas with a fine brush. Let the print dry thoroughly before working on the smallest details.

With oil paints, work on a dry print. Begin with large areas, but allow these to dry for 24 hours before adding details. Flesh tones worked in oils can be highly realistic.

An airbrush – a miniature spray gun – forms convincing false highlights and shadows.

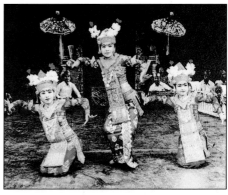

**Using oil paints** (above)
*Starting with a sepia-toned print, large areas were colored first. After 24 hours, when these areas had dried, the details were filled in.*

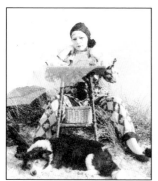

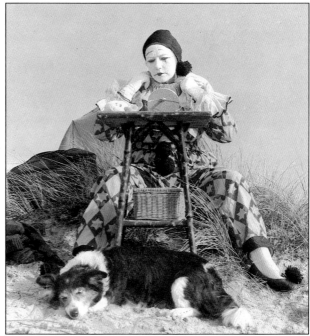

**Using watercolors** (above and right)
*A sepia-toned print was first dampened and then painted with watercolors. Depth of color should be built up gradually, in several layers of weak color. Use broad strokes to cover large areas first, then add the details.*

# Combining images

Some of the most unusual special effects are achieved by combining two wholly different images to give a surreal picture. There are various ways of doing this.

**Montage**
Montage involves constructing pictures from portions of various prints, arranging them so they join or overlap. Usually the work is carried out at a large size – this enables you to retouch, then copy the original to make smaller prints in which imperfections and joinings are less apparent.

Make rough prints from existing negatives and arrange them so that they overlap. Then draw a master sketch of the total image. Often, elements have to be photographed specially. When shooting, be careful to match direction and quality of light in the images.

Make a large print of the background and matched-density prints of each component, sized to conform to the master. Mount the background print, then carefully cut out the desired elements from the other prints, and reduce their edge thickness by sandpapering from the back. Glue elements in place with spray adhesive. You may want to hand-color your montage, or add shadows and other simple shapes with an airbrush.

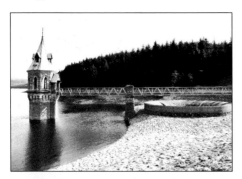 

**Montaged landscape**
*First enlarge the background print, and from this judge the enlargement necessary for the foreground images. Make density-balanced prints of each. Cut out the foreground elements, sand the edges from the back to thin them, and glue down. You may want to print part of the image as a negative, or airbrush some of the details, as here.*

## Multiple prints

The term multiple printing means printing two or more images on to the same sheet of printing paper so that they form one scene. Originals can be black and white or color, negatives or slides, and may be combined to appear realistic, or vignetted.

It is best to start out with just two images. Place the background image in the negative carrier, and sketch the outlines on a sheet of paper on the baseboard. Then place the second element in the carrier, and adjust until it fits where you want it. Make test prints of each original. Cut a dodger to fit the shape in the background where you want your second element, and use the shape from which you have cut this as a mask. Print your first image, with the area where you want the second element dodged out (for the full time for a realistic combination, or part of the time for a ghostly vignetting). Then print the second image into this area, with all the unwanted elements masked. With more elements the principal remains the same, but you may need to use punched holes to position masks, images and dodgers accurately.

**Using a shaped mask** (above)
*In this print the window was dodged out, and the face then printed in through a mask, which was placed directly on the paper to give a clear edge.*

**Vignetted images** (above)
*The first image was printed for the correct length of time, but with the central area dodged for part of the exposure. The second image was printed for half the*
*correct time, and through a mask. To achieve a vignetted effect, a mask should be positioned some distance above the exposed paper, so that the light spills around its edges slightly.*

## Sandwiched images

Sandwiching is a simple but effective way to combine images. It consists of placing two images in the same slide mount or negative carrier, and then projecting, copying or printing them. By careful selection of images it is possible to construct surreal, fantasy situations. Use sandwiching to illustrate a symbolic relationship between items or to combine pictures into scrambled image.

Sandwiched images must fit together successfully – often you will have only one suitable image, and then you must shoot another to sandwich with it. When sandwiching two color slides, images must be weaker than normal – at least one stop overexposed – or the combination will be much too dense. Sandwich simple shapes and textures, and choose subjects that have plenty of light areas (one sandwiched image will show through the highlight areas of the other).

Try a positive/negative sandwich of the same image – make a black and white negative copy of a color slide and recombine it with the slide for a result with black or gray highlights – or process color slide film as color negative, then combine this with a black and white positive image.

**Combining images** (above)
*Here, two black and white negatives were combined in the carrier to give a single print. The smaller figure, photographed against a plain white background, shows only against the black leotard.*

**Overlaying images** (left)
*This print was made from two slides – one of the American flag, the other of an eagle – sandwiched together. The colors of the flag show through only against the light area of the eagle itself.*

# Making photograms

You can use any convenient lamp to make a photogram, but to produce a controlled result it is best to use your enlarger as a light source. Position the head at the top of the column, and stop the lens down so that shadows are sharp. With the red filter over the lens, lay out your subject on paper to assess the position of the shadows. Make exposure tests for a full-bodied black in uncovered areas. To form intermediate tones remove or shift objects part-way through exposure.

To create other sorts of photograms; run water over soot or dye, or sandwich materials between glass. You can also place objects in negative carrier, to magnify their detail.

**Solid objects** (above right)
*This abstract pattern was created using a set of pencils. They were carefully laid out on a sheet of hard-grade paper, and given just enough exposure for a rich black. Overexposure can give unclear edges.*

**Soot patterns** (right)
*For this result, a sheet of glass was passed through the smoke from an oil lamp, and then placed in the negative carrier and printed to give a negative, from which the positive was contact printed.*

**Objects in the enlarger** (right)
*Copper pins were placed on a glass negative carrier and enlarged on to color negative printing paper. Light reflections inside the carrier help to fill in detail and color.*

# Manipulating emulsion

Manipulation of emulsion causes an image to lose its conventional photographic appearance. There are two main techniques. The first involves scraping parts of the emulsion from existing prints; the other coating emulsion on a suitable surface and using this for printing.

If you scratch the damp surface of a print carefully, using a needle or scalpel blade, you can remove emulsion down to the white resin-coated base. Scraping color prints cuts away each dye layer in turn.

Another approach is to buy black and white print emulsion as a liquid and coat this on paper, glass, ceramics, or stone. Working in the darkroom, apply warmed emulsion using a soft brush, or pour it over your material to form an even coat. Work with a rough sponge roller, or a dribble-on technique if you want brushmarks or patches.

**Scraping the emulsion** (above)
*The figure in this picture was drawn by scraping the emulsion from a finished print with a sharp scalpel blade. Scratch marks can be filled in with paint or crayons to add color.*

**Liquid emulsion**
(left and above)
*For an uneven result (left) from a negative which would otherwise produce an ordinary print (above), liquid emulsion was sponged on to the paper.*

# Copying prints

Copying a print need not be just a mechanical process for making an additional record. Looked at creatively, it is also an opportunity to manipulate the image further. Photocopying can produce bizarre results if the controls on the machine are used to distort the image rather than to reproduce it accurately, or if the print is moved during copying.

Rephotographing a print allows you to introduce additional elements, use screens or masks, alter colors, or change the image quality in other ways.

## Photocopying

Interference with the controls or operation of a photocopy machine produces distortions of image shape, tone, and color. A photocopy machine operates by scanning a document placed face down on its glass surface. You can shift or rotate photographic prints during scanning to distort their shape. Try breaking up tone and detail by reproducing images over and over again, or by projecting a color slide into the machine through a screen. If you work fast, you can change an original between scans in color copying and use black and white separation prints to alter color – you can also alter color using the machine's controls.

**Photocopy distortion** (right)
*During photocopying, a simple original photograph was first pushed, then pulled in the opposite direction, and finally twisted, to produce this image.*

## Re-photographing

Copying – the direct re-photographing of a print or slide – is not just a mechanical process for making an additional record. It is also a creative tool for the manipulation of existing images. You can place patterned glass in contact with a bromide print and copy through this for a distorted result.

In order to add pattern to your picture, cut down autoscreen or line sheet film to fit the back of your camera, and copy prints or slides on this. Enlargements will be made up from half-tone dots. To produce spectacular colored patterns use a light box and clear plastic sandwiched between two polarizing filters.

To create a new image you can also place the original print in either relevant or unexpected surroundings and include these in the copy.

**Added texture** (above)
*This shot of birds was rephotographed through a sheet of glass with patches of clear oil on it.*

# Identifying faults

With a working knowledge of the equipment used in photography, and a clear understanding of the artistic and technical principles that are involved, there is nothing to prevent you from taking good photographs. At first you may spoil many of your shots through oversight, lack of thought, or inexperience. Most errors, however, are as easy to avoid or correct as they are to make, so, rather than be disheartened, learn from your mistakes.

## Picture-taking

Many of the most common problems in photography originate here, with how the camera is loaded, set, and handled when the photograph is taken. With a little care and attention they are all fairly easily avoided.

### COMPOSITION
The general appearance of a print is influenced by everything from the lens that was used to the way that the camera was held.

### Tilted image
Check that the horizon is parallel to the upper or lower edge of the frame, or an upright object is parallel to one of the sides, before taking the picture. In some cases it may be necessary to use a tripod. Extreme wide-angle lenses will distort both horizontals and verticals toward the edges of the frame, so if this effect is undesirable, change your viewpoint or lens (see *Wide-angle lenses*, p. 116).

### Part of image obscured
A common fault with direct-vision cameras is to allow camera straps or a finger to block the taking lens. Always check that the lens is clear before pressing the shutter release.

### Part of image not in frame
This fault occurs most commonly with direct vision type cameras, due to parallax error (see *The viewfinder system*, p. 13). Pay close attention to the frame marks in the camera's viewfinder, which tell you how much of what you see will be in frame. If the camera does not have these marks, take a few test shots to find out how much of a scene will be recorded, and be careful not to frame shots too tightly.

### Vignetting
Dark edges and corners on the image may be caused by using a flash with too narrow a beam – a flash designed for a telephoto lens used with a wide-angle lens, for instance – or a lens hood which is too narrow. Always use a flash and lens hood that are suited to the angle of view of the lens. This may also be caused by using a lens of insufficient covering power.

### Superimposed images
This may be caused by accidentally loading the same film twice. When unloading film, wind the leader back into the container, and mark clearly any films that you have already exposed. If this fault occurs in the middle of a film or for a few prints only, it may be that the film was not fully advanced. With a manual advance, always push the lever around fully between shots.

## Red eye

The flash was used too close to the lens. This problem is most common with compact cameras that have a built-in flash. See *Problems with flash*, p. 131 for ways to avoid.

## Subject distorted

This is usually due to using an inappropriate lens. Both a wide-angle and a standard lens, for instance, will distort the features of a head and shoulders portrait, while a telephoto used from a distance will preserve them. Try looking through different lenses with an SLR camera, especially if your own is a direct-vision type. (See also *Using lenses creatively*, pp. 110–21.)

## LIGHTNESS OR DARKNESS OF IMAGE

Since photographs are recorded light, it is important to be careful when loading film, using flash, or manually setting exposure.

## Subject bleached out or insufficiently lit

Flash used too near to, or too far from, the subject. Check the instructions for the flash for the nearest recommended subject distance. If the subject is bleached out, fit an extension cable to the flash and hold it well above the camera, pointing downward. Diffusing flash when working close to the subject may also help. If the background is too dark, either use reflectors to bounce light into these areas, or set up a second flash unit attached to the first. (See also *Problems with flash*, p. 131.)

## Half of image black

Too high a speed was set when using flash on an SLR camera. Do not set a speed higher than that marked X on your camera dial.

## Pale, washed-out colours

This may be the result of a dirty lens or filter. Check the front and back glasses of the lens, and clean them with a special lens cloth or lens tissue. Early-design or cheap zoom lenses may also give low contrast, weak colors. Another possibility is that there is something in the camera's mirror box causing reflections that weaken the image. If your camera has interchangeable lenses, remove the lens and look for loose screwheads and the like. Should you find anything, take the camera to a repair service, or send it to the manufacturer.

## Entire image dark

This is probably due to underexposure. Use an exposure meter, and for critical shots bracket your exposures. (See *Setting exposure*, p. 56.) If the camera has a built-in metering system it may be either malfunctioning, or unable to cope with the subject conditions. If all the frames on a roll are overexposed, either the camera is malfunctioning, or the film speed setting was incorrect. Remember to check this when changing films. See *Assessing your films*, pp. 172–5 for how to detect underexposure at the negative stage.

## Entire image pale and weak

This is most likely to be due to overexposure. Use an exposure meter, and for critical shots bracket your exposures. (See *Setting exposure*, p. 56.) If the camera has a built-in metering system, it may be malfunctioning, or unable to cope with the particular subject conditions. If all the frames on a roll of film are overexposed, either the camera is malfunctioning, or the film speed setting was incorrect. Remember to check this when changing films. See *Assessing your films*, pp. 172–5, for how to detect overexposure at the negative stage on all types of film.

## Area of image "fogged"

When the film is exposed to light – other than that allowed in through the lens when a picture is taken – a stripe or section of film is bleached out or has marked color distortion. Make sure the camera back is properly closed while film is in the camera, and always load film either indoors or in the shade.

## COLOR

Film type and filters are the main factors influencing color – see *Color balance*, p. 37 and *Filters for color*, p. 126–7.

## Orange or yellow color on an indoor shot

This is due to using film designed for use in daylight or with a flash, as opposed to the artificial light indoors. Using a filter when taking the picture can prevent this problem (see *Filters for color*, pp. 126–7), and with color print films corrections can be made through filtration when printing.

## Overall blue hue

Photographs taken under cloud, in high mountains, or from the air may show this. A filter can help, (see *Filters for color*, pp. 126–7), and with color print films corrections can also be made when printing.

## CLARITY OF IMAGE

In most photography the desired result is a sharp image. Blur or fuzziness can be due to a number of factors.

## Subject blurred

Long exposures record blur that is due to subject movement. If you do not want this effect, you can adjust exposure time (see *Using the shutter*, pp. 52–3), although this will mean using a wider aperture, and losing depth of field. It may be better to use a faster film. Choose the film appropriate to the subject.

## Moving subject frozen

It is possible to record as frozen some things that ought to be left blurred, unless for a particular effect. A very high shutter speed can, for instance, make the propellers of an airplane in flight appear completely still. For such subjects a shutter speed between 1/125 and 1/500sec will allow some slight blur to remain in areas of movement.

## Entire image blurred

Camera shook as picture was taken. This fault occurs most often with hand-held photography, using long exposure times or lenses with long focal lengths. In hand-held photography, stand comfortably, with your elbows down. Breathe out gently just before pressing the shutter release. Hold the camera firmly, but not

tightly, and squeeze the shutter release rather than "jabbing" it. If the camera's design permits, press your thumb against the baseplate, in order to balance the force of the finger on the shutter release.

### Image fuzzy
Camera was not focused. If the lens is a fixed-focus types, check the instruction book for the limits of focus. If the lens can be focused, practice focusing in order to accustom yourself to the controls and the viewfinder display. Do not focus too slowly, as the eye may accomodate slight misfocus. Turn the focusing ring back and forth reasonably rapidly, and stop where the image seems sharpest. If the camera is an autofocus type, it is possible that the subject was too dim, or had insufficient contrast for the autofocus to register. See also *Focusing*, pp. 48–51.

## Processing and printing

While many picture faults are caused by incorrect camera handling, some are introduced after the image has been recorded. These will differ according to the type of film that you have used, and so are divided here into general faults,(which show up on black and white), color print, and color slide faults.

It is worth knowing what has gone wrong, even if you send your films away to be processed. Professional laboratories can make mistakes, and it is useful to know when to complain. If you develop your own material, of course, it is essential to be able to detect and correct mistakes.

### GENERAL OR BLACK AND WHI
For a listing of faults which can be dete the negative stage, see *Assessing black* white negatives, pp. 172–3. Listed here a faults, which may occur at the printing sta

### Highlight detail lost
If the film was correctly exposed and developed, try printing on a softer grade of paper, or give extra exposure (see *Controlling print density in small areas*, p. 183) for detail.

### Muddy looking print
Try printing on a harder grade of paper.

### Blurred print from a sharp negative
Check the focus on the enlarger. If this is correct, the blur is probably due to movement of the enlarger during printing. Be sure that your enlarger is placed on a firm base, and avoid moving around while making the print.

### Spots and lines
These are caused by dust and dirt on the negative. Clean the negative before printing. You can also retouch the print if the flecks are not too bad (see *Finishing prints*, p. 187).

## PRINTS FROM COLOR NEGATIVES

For a listing of faults which can be detected at the negative stage, see *Assessing color negatives*, pp. 174. Listed here are further faults, which may occur at the printing stage. With color casts, check that they are not due to incorrect exposure or inappropriate film.

### Brownish streaks on print
Paper was fogged by light before exposure. Always keep your photographic paper in a paper safe, and remove to expose only in complete darkness.

### Blotches of light on print
Paper was loaded into print drum the wrong way around. Familiarize yourself with the textures of the different sides of the paper, so that you can tell which is the emulsion side in darkness.

### Flat image with heavy shadows and a color cast
Temperature of the developer was outside the limits recommended by the manufacturer. Always check temperatures carefully, and if possible use a tempering box for solutions.

### Pale image with a blue cast
Paper was placed in the masking frame emulsion side down. Familiarize yourself with the textures of the different sides of the paper, so that you can tell which is the emulsion side in darkness.

### Bright orange cast
Printing filters were omitted during exposure of the paper. Make a thorough check that everything is in place before switching off the lights and exposing.

### Solarized image with a purple cast
Developer was contaminated with bleach-fix solution. Be careful to keep all stages of processing separate, and clean equipment thoroughly between films.

### Dark image with little contrast
Bleach solution exhausted. Do not use chemicals beyond the recommended number of prints: results will be disappointing.

## PRINTS FROM COLOR SLIDES

You can correct color casts and some exposure faults in slides – for a list of these, see *Assessing color slides*, p. 175 – by making prints from them. In the process, however, new faults may be introduced. With all color casts, check that they are not due to incorrect exposure of the slide, or inappropriate film.

### Dark image with an unexpected cast

Paper was placed in the masking frame emulsion side down. Familiarize yourself with the textures of the different sides of the paper, so that you can tell which is the emulsion side in darkness.

### Strong overall cast

Printing filters were omitted during exposure of the paper. Make a thorough check that everything is in place before switching off the lights and exposing.

### Dull, muddy colors and a pink cast

Developer was contaminated with bleach-fix solution. Be careful to keep all stages of processing separate, and clean equipment thoroughly between films.

### Dark blotches on print

Paper was loaded into print drum the wrong way around. Familiarize yourself with the textures of the different sides of the paper, so that you can tell which is the emulsion side in darkness.

### Incorrect color balance and density

Temperature of the developer was outside the limits recommended by the manufacturer. Always check temperatures carefully, and use a tempering box for solutions if possible.

### Silvery surface and dark, muddy colors

Bleach solution exhausted. Do not use chemicals beyond the recommended number of prints: results will be disappointing.

### Purple cast/light, flat print with cast

Paper was fogged by light before exposure. Always keep your photographic paper in a paper safe, and remove to expose only in complete darkness.

# Glossary

**Aberration** Distortion of color or form in a lens. Corrected by *compound lens* construction or the use of a small *aperture*.

**Abrasion marks** Marks on the emulsion surface of a film caused by scratching. Can be due to traces of dirt trapped between layers of film as it is wound on the spool, or to dirt on the pressure plate.

**Accelerator** Chemical added to a developing solution to speed up the slow-working action of the reducing agents in the solution.

**Acceptance angle** See *Angle of view.*

**Accessory shoe** See *Hot shoe.*

**Adaptor ring** Mount making it possible for accessories such as *filters* to be used on lenses of different diameters.

**Agitation** Inverting or turning a film or paper *tank* throughout processing in order to keep fresh solution in contact with the surface at all times and so ensure even development.

**Air bells** Bubbles of air clinging to the emulsion surface during processing. If the manufacturer's recommended agitation times are followed, air bells can generally be avoided.

**Airbrushing** Method of *retouching* in which color is sprayed over areas of an image by compressed air.

**Analyzer** Chart, grid, or electronic instrument used to determine correct color filtration when making color prints from negatives or slides.

**Angle of coverage** See *Covering power.*

**Angle of view** The angle between the most widely spaced objects in a scene that a lens of a given *focal length* will capture.

**Aperture** Circular hole in or near lens controlling the amount of light that reaches the film and the *depth of field* in an image. May be fixed or adjustable. Size is measured in *f numbers.*

**Aperture priority** Camera mode in which the photographer selects the *aperture,* and the camera adjusts the *shutter speed* to give the correct *exposure.*

**Artificial daylight** Artificial light balanced so that it has the same color as daylight.

**Artificial light** All light not originating from a natural source, usually the sun.

**Artificial light film** See *Tungsten film.*

**ASA** Film *speed* rating system. Numbers are identical to those in the *ISO* system.

**Autofocus** Devices which focus the lens automatically on a predetermined target area.

**Automatic exposure** System that measures light, and controls *aperture* and/or *shutter speed* automatically to give the correct level of *exposure.*

**Available light** Light occurring naturally in a scene, as opposed to light intended specifically for photography.

**Backlighting** Light coming from behind the subject. Usually extra *exposure* is needed for subjects lit in this way.

**Back projection** Projection system often used to create the illusion of location backgrounds in the studio. Location scenes are photographed and then projected from behind a suitable translucent screen in the studio to create a background for objects. Also called rear projection.

**Barn doors** Hinged metal flaps, used to control the beam of *spotlights* and *floodlamps.*

**Bas relief** Pictures manipulated to imitate a form of sculpture in which the subject projects slightly from the background, as on medals or coins.

**Batch numbers** Numbers on film or paper indicating common production.

**B ("Bulb")** Setting at which the *shutter* stays open for as long as release is pressed.

**Bellows** Light-tight, extendable sleeve, infinitely adjustable between its shortest and longest extent. Used to space the lens further from the camera for close-up work.

**Between-the-lens shutter** See *Leaf shutter.*

**Black silver** Finely divided metallic silver formed from *silver halides* after *exposure* and *development* have taken place.

**Bladed shutter** See *Leaf shutter.*

**Bleach** Chemical bath used to remove all or part of an image. Used in film processing, and to prepare a print for *toning.*

**Bleach/fix** Chemical bath in which the bleach and fixer have been combined. Used in many color processes. Also known as "Blix" solution.

**Blister** Blemish on prints or negatives appearing as the result of incorrect processing. Caused by bubbles of gas or processing liquid under the emulsion surface, often occurring due to chemical reactions between different processing solutions, when rinsing is inadequate.

**Blix** See *Bleach/fix.*

**Blocking out** The use of opaque paint on a (large format) negative surface to obscure unwanted details in the image. Used often to silhouette a product in commercial photography. Results in a clean white background when printed.

**Bounced light** Light reflected from a surface on to the subject.

**Bracketing** Taking several pictures of a subject at different *exposure* levels.

**Brightness range** Term describing the difference in luminance between the darkest and lightest areas of the subject, in both negative and print.

**Bromide paper** Printing paper.

**Bulk film** Film bought in long lengths and cut down to reload standard containers, or used in special camera backs.

**Burning in** Increasing printing *exposure* in one area of an image by shading the rest of the image and giving extra exposure time.

**Cable release** Flexible cable for firing shutter from a distance.

**Cartridge** Film enclosed in a light-tight container dropped directly into the camera. Used for 110 and 120 format films.

**Cassette** Cylindrical 35mm film container. Called a *magazine* in the United States.

**Cast** Overall bias toward one color in a photograph.

**Catadioptric lens** Lens using both glass and mirrors to fit a long *focal length* lens into a short *lens barrel*. Also called a mirror or reflex lens.

**CC filters** See *Color compensating filters.*

**Changing bag** Opaque bag inside which film *tanks* can be loaded in normal lighting.

**Chemical fog** *Veil* of metallic silver formed over unexposed parts of a image. Caused by exhausted processing solutions or *overdevelopment.*

**Chloride paper** Printing paper giving a bluish image. Also known as contact paper.

**Chromogenic** Film process in which *silver halides* and *couplers* combine to form dyes.

**Click stops** Lens *aperture* control using a series of audible clicks. Used on *enlargers*, which have to be adjusted in the dark.

**Close-up** An image of a close subject, filling the frame.

**Coated lens** Lens with outer surfaces coated or "bloomed" to prevent reflection.

**Coincidence rangefinder** See *Rangefinder.*

**Cold colors** Colors from the blue end of the spectrum that suggest a cool atmosphere.

**Color balance** Adjustment in color photographic processes to ensure accurate color reproduction.

**Color-balancing filters** See *Color conversion filters.*

**Color cast** See *Cast.*

**Color circle** The colors of the spectrum represented in a circle, so that each color appears opposite its *complementary.*

**Color compensating filters** Pale filters used to correct *casts.*

**Color conversion filters** Filters used to match film type to the light source being used.

**Color development** See *Chromogenic.*

**Color head** Enlarger illumination system that has built-in adjustable filters or light sources, for color printing.

**Color masking** Orange mask built into color negative film to improve reproduction on the print.

**Color saturation** See *Saturation.*

**Color sensitivity** The response of a light-sensitive material to colors of different wavelengths.

**Color separation** Photographing an image through filters to produce black and white images of the red, green, and blue content. Used in some special effects techniques.

**Color toning** Changing the dark areas of a black and white image to a chosen color by converting the *black silver* into a colored compound or dye. The most commonly used color is *sepia.*

**Color weight** A quality of color. *Saturated* blue appears darker or "heavier" than saturated yellow. In black and white photography, blue and green produce the heaviest grays.

**Combination printing** see *Multiple printing.*

**Complementary** A color's "opposite" from the spectrum Yellow is complementary to blue, green to *magenta*, red to *cyan.*

**Composite image** Image made up of elements from more than one image. Achieved through *multiple exposure, multiple printing, sandwiching*, or *montage* techniques.

**Composite printing** see *Multiple printing.*

**Compound lens** Lens with several *lens elements*, which work together to give a sharp image without *distortion.*

**Compound shutter** See *Leaf shutter.*

**Concave lens** Lens that is thicker at the edges than at the center, and bends rays of light outward.

**Contact paper** See *Chloride paper.*

**Contact print** Print of negatives made by placing them directly on to paper and exposing.

**Contact printing frame** Hinged frame to hold negatives flat on paper while making a *contact print.*

**Continuous tone** An image with a full range of tones between black and white.

**Contrast** The difference between the densities or degrees of light present in an image.

**Contrast filters** Filters for black and white films, which darken or lighten particular colors to give greater contrast.

**Convex lens** Lens that is thicker in the center than at the edges, and bends light rays inward to a point of focus.

**Coupled exposure meter** *Exposure meter* linked to a camera's electrical circuits so that the correct *exposure* settings can be given directly.

**Coupled rangefinder** See *Rangefinder.*

**Couplers** Dye-forming chemicals found in color, and some black and white, films. See *Chromogenic.*

**Covering power** The maximum area of clear image that a lens produces. This must exceed the image size of the film format being used.

**CP filters** Acetate color printing filters, used in the filter drawer of an *enlarger*, rather than directly under the lens.

**Critical aperture** Size of *aperture* at which a lens performs best. Usually in the middle of the range of sizes possible.

**Cropping** Removing unwanted areas of an image during printing, by trimming a print, or masking a transparency.

**Cyan** Blue-green color which absorbs all red light, and is *complementary* to red.

**Darkroom** Light-tight room used for processing and printing.

**Darkslide** A sliding plate used to protect sheet film or rollfilm when loading or changing camera backs.

**Daylight drum or tank** Container for processing paper or film. Must be loaded in the dark, but all processing can be carried out in daylight.

**Daylight film** Color film intended for use in daylight or with flash. Gives a yellow *cast* when used in *tungsten* light.

**Daylight loading tank** Film-processing *tank* designed to be loaded in normal light.

**Dedicated flash** Flash designed for use with a specific camera or group of cameras.

**Definition** The clarity of an image. *Slow films* give the greatest level of definition.

**Delayed action** Opening of *shutter* a short time after release is pressed. Built-in on most cameras.

**Density** Amount of silver deposit produced by exposure and development. Measured in terms of incident light divided by transmitted or reflected light.

**Depth of field** Distance between the nearest and farthest points that appear in focus in an image. The closer to the camera a subject is, the shallower the depth of field will be. Also controlled by lens type and *aperture.*

**Desaturated** A color degraded by black, white, or another color.

**Develop** Convert exposed *silver halides* to *black silver.* The first step in processing both film and photographic prints.

**Diaphragm** See *Iris diaphragm.*

**Diaphragm shutter** *Shutter* design incorporating an *iris diaphragm* and *leaf shutter.* The diaphragm and the shutter open simultaneously when a picture is taken.

**Differential focusing** Using minimum *depth of field* to focus on a subject and separate it from an unfocused fore- or background.

**Diffuser** A material that softens light passing through it.

**Diopter** Measure of the light-bending power of a lens.

**Direct vision** *Viewfinder system* in which the subject is seen through a window separate from the main lens.

**Discharge lamp** Light source that provides illumination when an electrical charge is applied to gas particles in a glass tube. As used in electronic flash.

**Distance symbols** Symbols used instead of numbers on some cameras to indicate the distance focused on. Used for lenses with a limited number of focus settings: portraits, groups and landscapes are the options usually given.

**Distortion** Alteration in the shape and/or proportions of an image. Occurs with some lenses such as *fisheye* types, or may be created deliberately for effect.

**Dodging** Decreasing printing *exposure* in areas of an image by shading them for part of the exposure time.

**Double exposure** See *Multiple exposure.*

**Dry mounting** Method of attaching prints to flat surfaces by heating a shellac layer, under pressure, between the print and the mount.

**Drying cabinet** Vented cabinet for drying films after processing. A fan circulates air inside the cabinet.

**Drying marks** Marks on film caused by uneven drying and creating uneven density in the final image.

**Dual lens** Lens with movable *lens elements*, giving two *focal lengths*.

**Dye** Color soluble in its carrier liquid, which colors materials by being absorbed into them.

**Dye coupling** See *Chromogenic*.

**Edge numbers** Reference numbers printed by light along film edges.

**Element** See *Lens element*.

**Emulsion** Light-sensitive coating used on film or paper, on which a photographic image is formed.

**Emulsion speed** See *Speed*.

**Enlargement** A print larger than the negative used to produce it.

**Enlarger** Equipment for projecting film images to produce *enlargements* on paper. Works like a slide projector, mounted vertically to shine downward on to a baseboard.

**Ever-ready case** Soft camera case. The camera may be used without removing it from the case.

**Expiration date** The date printed on a film box, before which material should be used and processed to give reliable results.

**Expose** Allow light onto a light-sensitive film or paper.

**Exposure** The amount of light that is allowed on to film or paper. Controlled by the *shutter speed* or *enlarger* timer, and *aperture* size.

**Exposure calculator** Device for assessing what settings will give the correct *exposure*.

**Exposure index** See *speed*.

**Exposure latitude** The amount by which it is possible to over- or

*underexpose* film and still obtain acceptable results with normal processing. *Fast films* and low-contrast materials give the greatest latitude.

**Exposure meter** Instrument for calculating the correct *exposure* by measuring light falling on or reflected by the subject.

**Extension tubes** Metal or plastic tubes of various lengths used to space the lens farther from the film for close-up work.

**f numbers** System of *aperture* sizes. The higher the number, the smaller the aperture. Each number is counted as one *stop*, and is the *focal length* of the lens divided by the diameter of the aperture. At f4, for example, the diameter of the aperture is one quarter of the focal length.

**False attachment** Part of one object seen behind another, giving the impression that the two are joined to each other.

**Fast film** Very light-sensitive film, with high *ISO* or *ASA* number. Image clarity is not as good as with *slow films*.

**Fast lens** A lens with a wide maximum *aperture*.

**Fill-in** Secondary light source, used to fill the shadows created by main or *key light*.

**Film** Light-sensitive, image-forming *emulsion* on a thin plastic base.

**Film clips** Metal or plastic clips used to prevent the curling of a length of drying film. One grips the top of the film; another, hung at the bottom, is weighted to pull the film straight.

**Film plane** The position in which the film is held at the back of the camera, or in the *negative carrier* of an *enlarger*.

**Film speed** See *Speed*.

**Filter** Lens attachment made of glass or plastic that alters the quality or color of an image. Also the sheets of colored acetate or gelatin used in an *enlarger* to correct color when making prints.

**Filter factor** Number by which the unfiltered *exposure* reading must be multiplied to give the same exposure when using a filter. Varies with filter type, and usually marked on the rim.

**Filtration** Use of a filter. In color printing, the use of color filters to control the color balance of an enlarged image, and so of the resulting print.

**Finder** Abbreviation for viewfinder.

**Fisheye lens** Extreme lens in which correction of barrel distortion has been sacrificed in order to obtain an *angle of view* of up to 220°.

**Fix** Convert unexposed *silver halides* in a film or print to soluble salts. Stage of processing after *developing*, *stopping*, and *bleaching*. Makes image permanent in white light.

**Fixed focal-length lens** Lens with one *focal length*, as opposed to a *dual* or *zoom lens*.

**Fixed-focus lens** Lens fixed at a certain distance from the film, offering no method of adjusting the focus for subjects at different distances from the camera.

**Flare** Halo of additional light, usually appearing around highlights in a photograph.

**Flash** Artificial light source giving brief, bright illumination of approximately the same color of light as daylight.

**Flash factor** Number providing a guide to the correct *exposure* to use with a flash. Divided by the camera-to-subject distance it gives the correct *aperture* setting.

**Flash synchronization** System ensuring that flash coincides with the moment when the *shutter* is fully open.

**Floating element** *Lens element* that moves relative to other elements as a lens is focused, or as the *focal length* is changed on a *zoom lens*.

**Floodlight** Light source used with broad reflector, giving soft and even light.

**Focal length** Distance between lens and point at which it produces an image when focused on infinity.

**Focal plane** Plane at which a lens produces an image – must coincide with the *film plane* in a camera in order to give a sharp image.

**Focal-plane shutter** Pair of blinds located immediately in front of the film. They move across the film with a space between them to expose the *frame*. The size of the space determines *shutter speed*.

**Focusing** Moving lens toward or away from the film in order to obtain sharp images of subjects positioned at varying distances from the camera.

**Focusing scale** Scale of distances in numbers or symbols on the *lens barrel* that indicate the distance for which the lens is focused.

**Focusing screen** Surface on which image is seen in *viewfinder* for composing and focusing.

**Fogging** *Veil* on a film or print which is not part of the image. Formed by chemicals or light.

**Format** The size and shape of an image on film or a print.

**Frame** A single exposure of film.

**Frame numbers** See *Edge numbers*.

**Frilling** Wrinkling and separation of *emulsion* from its base material at the edges.

**Gelatin** Natural protein. Used as the medium for binding *silver halides* to a film base.

**Gelatin filters** Filters cut from dyed *gelatin* and held in front of the lens or studio light. Cheaper than glass or plastic filters, but less durable.

**Ghost** *Flare* spot on an image, caused by reflection of intense light. Can be eliminated with the use of a *polarizing filter*.

**Glaze** Substance used to give prints a glossy surface.

**Grade** Term denoting the characteristics of black and white printing paper. Soft grades give the least *contrast*, hard grades give the greatest.

**Gradation** Contrast range in image. Low-contrast images are described as *soft*, high-contrast images as *hard*.

**Graduate** Container with levels marked on it, for measuring processing solutions.

**Graduated filter** Filter with colored section, gradually fading to clear glass.

**Grains** *Silver halides* that have formed *black silver* through exposure and processing.

**Guide number** See *Flash factor*.

**Half-tone** Image in which the tones are formed by a pattern of dots, giving an impression of a *continuous tone* image although only black and white are present.

**Halides** See *Silver halides*.

**Halogens** Collective term for the elements chlorine, bromine, and iodine, which are combined with silver to produce the light-sensitive crystals used as the basis of most photographic emulsions.

**Hard** High-contrast image, or lighting producing harsh shadows.

**High-key** Image with predominantly light tones, lacking deep shadows. Also describes the lighting that will create such an image.

**Highlights** The palest or brightest areas of an image.

**Holding back** Shortening film *development* time.

**Hot shoe** Fitting on camera to hold a flash unit.

**Hot-spot** Concentration of light in a particular area.

**Hue** The name of a color.

**Hypo** General term for *fixing* solutions.

**Hypo eliminator** Chemical bath used to remove the *fixing* agent from the film, reducing the *washing* time.

**Image plane** see *Focal plane*.

**Incident light** Light falling on to, as opposed to being reflected by, a surface or subject.

**Indicator chemical** Chemical that changes color to show when processing solutions are exhausted.

**Infinity** The point at which objects are so distant that light rays from them are parallel.

**Infra-red** Band of wavelengths beyond the red end of the spectrum. Invisible to the eye, they can be recorded on special infra-red sensitive film.

**Infra-red focus** See *IR setting*.

**Instant picture camera** Camera, usually with simple controls, producing a finished photographic print within minutes of the film being exposed.

**Interchangeable lenses** Different lenses used for the same camera body.

**Interleaving** Method of agitating more than one sheet of photographic paper in the same tray. The bottom sheet is lifted to the top continuously.

**Internegative** Negative made on special color film for making copies of prints, or prints from slides.

**Intersection of thirds** The points at which imaginary lines dividing a picture into thirds vertically and horizontally intersect. Subjects positioned at these points tend to look balanced in a composition.

**Iris diaphragm** Ring of overlapping "leaves," or blades, near or in the lens, controlling the size of the *aperture*.

**IR setting** Focus setting for *infra-red* film.

**ISO** Film *speed* rating. The higher the number the more light-sensitive, or faster, the film is.

**Key light** The principal or dominant source of light in a scene.

**Lamphouse** The part of an *enlarger* that contains the light source.

**Latent image** Invisible image formed on the *emulsion* on film or paper before processing.

**Latitude** The amount one can over- or under- *expose* or *develop* and still get acceptable results. *Fast films* and soft *grade* papers give the most latitude.

**Leader** The beginning of a film.

**Leaf shutter** A *shutter* inside the lens, made up of thin metal "leaves." Also called a bladed shutter. The leaves open to expose the film.

**Lens** Optical device made of glass or plastic and capable of bending light. A photographic lens may be constructed of single or multiple *lens elements*. There are two basic types of simple lens: *convex* (positive), which cause rays to converge to a point; and *concave* (negative), which cause rays to diverge. Both are used in *compound lens* construction in

which several elements are combined to give an overall converging effect.

**Lens barrel** Metal or plastic tube with a blackened inner surface, which holds the *lens elements* and controls.

**Lens cap** Rubber or plastic cover to protect the lens when the camera is not in use.

**Lens element** Piece of glass shaped to bend light in a particular way. They are designed to act with other lens elements in a *compound lens* to produce a sharp image.

**Lens hood** Opaque tube of rubber, plastic, or metal used to shield the lens from stray light.

**Light box** Fluorescent tubes under translucent material used for viewing negatives or slides.

**Light meter** See *Exposure meter*.

**Light tent** Tentlike structure of translucent material on a frame. Placed around a subject to diffuse light for an even effect and eliminated reflections in highly polished subjects.

**Light trap** Way of preventing entry of light into a darkroom or a film container or tank.

**Linear perspective** The apparent convergence of parallel lines with increasing distance in a two-dimensional image.

**Line image** Image made up of black and white only, with no mid-tones.

**Lith film** Extreme high-contrast film. Used mainly for copying images to produce special effects. Must be processed with a special lith developer.

**Long-focus** Lens with *focal length* appreciably greater than the diagonal of the film format with which it is used.

**Low-key** A scene of predominantly dark tones. Also refers to the lighting that gives such an image.

**M-synch** Camera setting for *flash synchronization*.

**Mackie line** Line of light around dark areas in image, caused by exhausted processing solutions, insufficient *agitation*, or *solarization*.

**Macro attachment** See *Close-up attachments*.

**Macro lens** Lens for *close-ups*.

**Magazine** 35mm film container. Called a *cassette* in Britain.

**Magenta** Color composed of blue and red light only, *complementary* to green.

**Magnification** Ratio of the height of the image to the height of the subject. Also applied to the ratio between print size and negative size (i.e. the degree of enlargement), or the ratio of lens-to-image distance to subject-to-lens distance. When subject and image are the same size, magnification is said to be ×1.

**Main light** See *Key light*.

**Mask** Material placed over part of image during shooting or printing. Also refers to the orange tint on color negatives.

**Masking frame** Frame to hold printing paper in place.

**Microprism ring** Focusing aid in the form of a gridlike cluster of microprisms in a circle. Breaks up the image in a shimmering effect when it is not focused.

**Mirror** Device for reflecting images, normally without distortion or diffusion. Mirrors used in photographic equipment are mostly surface coated, unlike hand mirrors which are coated behind glass. This prevents a double image – one from the glass, the other from the silvering.

**Mirror lens** See *Catadioptric lens*.

**Monobath** Solution to *develop* and *fix* in one.

**Monochrome** Single colored. Most frequently applied to black and white photographs, but can also describe sepia or other toned images in one color scheme.

**Montage** Cutting up and mounting parts of separate images overlaid or side by side to form one image.

**Motor drive** Automatic power driven film advance for a camera.

**Mount** Frame and/or backing used to support and protect prints or transparencies.

**Multiple exposure** Making more than one exposure on a film frame.

**Multiple flash** Either using more than one flash simultaneously, or firing one flash several times with the *shutter* locked open.

**Multiple printing** Using two or more negatives for one print.

**Negative** Image in which light and dark areas are the reverse of how they appeared in a scene.

**Negative carrier** Holder for the negative or slide between the light and the lens in an *enlarger*.

**Negative/positive paper** Paper used to print a positive image from a negative. Normally refers to color paper.

**Neutral density filter** Gray filter used to control light levels on cameras with a fixed *aperture*, or allow the use of a large aperture in bright light.

**Non-substantive** Film that contains no *couplers*, and must be processed by the manufacturer.

**Normal lens** See *Standard lens*.

**One-step film** Instant film on which image appears after the print is ejected from the camera.

**Opal glass** Glass with a translucent opal tint, used as a diffuser for enlargers, light boxes, and exposure meters.

**Open flash** Technique of firing the flash while the shutter remains held open on its *B* setting. The flash can be repeated as often as required before the shutter is closed, as in the *painting with light* technique.

**Opening up** Increasing the size of the *aperture*.

**Overdevelop** Excessive *development* caused by prolonged time, increased temperature, or too much *agitation*.

**Overexpose** Allow too much light on to light-sensitive material. Gives a pale, bleached-out image.

**Painting with light** Locking a shutter open in a dark interior, and moving around to illuminate areas with bursts of light.

**Pan and tilt head** *Tripod* head allowing the camera to be tilted up and down or turned through 360° while still remaining stable on the tripod. Can be locked in position.

**Panchromatic** Sensitive to all colors of light.

**Panning** Swinging the camera in a smooth arc to follow a moving subject, keeping the position of the subject in the image constant.

**Panoramic camera** Camera that rotates on a tripod to take in 180° or 360° of a scene.

**Paper safe** Light-tight container for storing printing paper.

**Parallax** Difference between the image seen in viewfinder and that coming into camera lens and on to film with *direct vision* and *twin lens reflex* cameras.

**Peel-apart instant film** Instant film that is ejected from the camera as two sheets which are peeled apart to reveal a positive and a negative image.

**Pentaprism** Prism used in a *reflex* viewing system to bring the subject image to the *focusing screen* the right way up.

**Photo-electric cell** Light-sensitive substance used in *exposure meters*.

**Photogram** Image produced by laying an object directly on to printing paper and exposing.

**Physiogram** Image produced by a moving light source photographed in the dark using a long exposure.

**Pigment** Color insoluble in its carrier liquid. Colors materials by spreading out on their surface.

**Pinhole camera** Camera with a very small hole in place of a lens. Produces a *soft* image.

**Pixels** Tiny squares of light that make up electronic images.

**Point source** Small light source with a compact filament and clear glass bulb, giving hard shadows.

**Polarization** Vibration of reflected light in one plane only, unlike direct light, which vibrates in all planes.

**Polarizing filter** Filter that can block or create polarized light.

**Positive** Image in which light and dark areas correspond with those in the original scene.

**Positive film** Slide film.

**Positive/positive printing** Process for printing a color transparency directly on paper to produce a positive print. Positive/positive materials include silver dye-bleach, reversal chromogenic paper, or photo color transfer types.

**Posterization** Reducing a photograph to areas of solid color.

**Primary colors** Colors from which all other colors can be made. In light, these are blue, green, and red.

**Print** Image on photographic paper created by light passing through a negative or slide.

**Printing in** See *Burning in*.

**Processing** The sequence of steps – *developing, stopping, fixing, washing* – involved in converting a *latent image* on film or paper into a visible and permanent one.

**Projection print scale** Clear film printed with series of density increases from transparent to opaque, for assessing the printing *exposure* necessary.

**Pulling** Shortening film *development* time.

**Pushing** Extending film *development* time.

**Rangefinder** Focusing aid, giving a double or split image when subject is out of focus.

**Rear projection** See *Back projection*.

**Rebate** Border around an image on film or paper.

**Reciprocity failure** Loss of light-sensitivity in extremely short or long *exposures*.

**Red eye** Red pupils seen in photographs of people, caused by flash illuminating the inner surface of the eye.

**Reduction** Removing silver from an image to alter contrast.

**Reflected light reading** Reading the levels of light reflected by the subject, rather than the light falling on to it.

**Reflector** Any large flat surface that can be used to reflect or *bounce* light on to a subject.

**Reflex** *Viewfinder system* that uses a mirror to give an upright image of the scene as it appears in the lens.

**Reflex lens** See *Catadioptric lens*.

**Reticulation** Wrinkling of emulsion, caused by dramatic changes of temperature, or excessive acidity or alkalinity during processing.

**Retouching** Removing marks or correcting color by hand on a finished print.

**Reversal film** Film giving negatives and prints.

**Ring flash** Ring-shaped flash fitted around the lens.

**Sabattier effect** See *Solarization*.

**Safelight** Light that will not affect film in a darkroom. Varies with film and paper type.

**Sandwiching** Combining two or more negatives or slides in the *enlarger* for printing.

**Saturated** A pure color, undiluted by black, white, or other colors.

**Screening** Printing through a screen to convert images into dots or lines.

**Scrim** Screen used in front of lights to diffuse their power by a set amount.

**Secondary color** See *Complementary color*.

**Selective focus** See *Differential focus*.

**Sensitivity** The degree of response to light.

**Sepia toning** Changing the dark areas of a black and white image to brown. This gives the appearance of an old, faded print.

**Shading** See *Dodging*.

**Short-focus** Lens of a *focal length* shorter than diagonal of the film format with which it is used.

**Shutter** Screen protecting film from light until moved by the shutter release to take a photograph.

**Shutter priority** Camera setting at which the photographer sets the *shutter speed*, and the camera adjusts the *aperture* size to give the correct *exposure*.

**Shutter speed** Length of time that the *shutter* remains open. Measured in fractions of a second. Each change of speed counts as one *stop*.

**Silver halides** Light-sensitive silver crystals in film *emulsion*, which form the photographic image.

**Simultaneous contrast** The effect that adjacent color hues have upon each other. Complementary colors, for example, appear to increase their mutual intensity and contrast when juxtaposed.

**Single lens reflex** Camera system in which the image entering the lens is reflected into the viewfinder.

**Skylight filter** Very pale pink filter used to reduce blue *casts* caused by blue sky light, *ultraviolet* light, and haze. May be left on the lens permanently to protect it.

**Slave unit** Device used to fire more than one flash unit simultaneously.

**Slide** *Positive* image on film.

**Slit shutter** An attachment with a narrow slit placed over the lens. Film that is moved past it will record the subject area as one continuous image.

**Slow film** Film with low light sensitivity and *ISO* number.

**Slow lens** A lens with a narrow maximum *aperture*.

**SLR** See *Single lens reflex*.

**Snoot** Cone placed over a beam of light to narrow it.

**Soft** Describes a low-contrast image.

**Soft focus** Diffused, *soft* image.

**Solarization** Partial reversal of tones in a print caused by extreme *overexposure*, or *fogging* by light during *development*.

**Spectrum** Commonly, that part of the electromagnetic spectrum which is visible to the human eye. It appears as colored bands from violet and blue through green and yellow to orange and red, according to wavelength. When all these wavelengths are seen together the light appears white.

**Speed** A measure of a film's sensitivity to light.

**Split-image rangefinder** See *Rangefinder*.

**Spool** A narrow tube with flat disks at either end, around which the film is wound.

**Spotlight** Artificial light source with a strong beam of light of controllable width.

**Spot meter** Narrow-angle exposure meter used to take accurate light readings from any small area of the subject, from some distance away.

**Spotting** Removing specks and marks from prints.

**Sprocket holes** Perforations along the edge of 35mm film.

**Standard lens** Lens of *focal length* similar to diagonal of film format with which it is used.

**Step wedge** See *Projection print scale*.

**Still video** Method of recording an image by electronic means.

**Stop** Measurement of light allowed on to film. Each change of *aperture* size or *shutter speed* equals one stop.

**Stop bath** Processing fluid used to halt *development*.

**Stopping down** Reducing *Aperture* size or *Shutter speed*.

**Supplementary lens** Additional element put over lens to alter focal length, used for close-up work.

**Tank** Light-tight container in which film or paper is processed.

**Telephoto** Extreme *long-focus* lens.

**Tempering bath** Bowl of warm water for holding processing solutions at the correct temperature.

**Test strip** Strip of print given different levels of *exposure* or filtration in different strips to assess results.

**Thick negative** A dark, or dense image.

**Thin negative** Lacking in density, or pale.

**Through-the-lens metering** Metering that calculates the light coming into the camera lens in a target area.

**TLR** See *Twin lens reflex*.

**Toner** Chemical that changes shadows in black and white prints to a color.

**Tone separation** Reducing continuous tones to distinct, separate shades.

**Transparency** See *Slide*.

**Tri-color filters** Printing filters.

**Tripod** Three-legged camera support. Prevents blur due to camera shake when using a slow *shutter speed* or a *telephoto* lens.

**TTL** See *Through-the-lens metering*.

**Tungsten light** Light using a tungsten filament. Most household lighting is tungsten.

**Tungsten film** Color film balanced for use in *tungsten light*. Packs are marked "Tungsten" or "Type B."

**Twin lens reflex** Camera system with two lenses: one allowing light on to the film, and another through which the image is viewed by means of a *reflex* system.

**Ultraviolet (UV) light** Invisible light, recording as haze on film.

**Underdevelop** Decrease *development* time or temperature.

**Underexpose** Allow too little light on to light-sensitive material. Gives a dark image.

**Uprating** Setting a higher *ISO* than that of the film being used.

**UV** See *Ultraviolet*.

**UV filter** Filter that absorbs *ultraviolet* light wavelengths, eliminating haze.

**Vanishing point** Point at which lines converge in the distance.

**Variable-focus lens** Lens on which the focus can be adjusted for subjects at different distances.

**Veil** Deposit of silver on an image, making it appear hazy and indistinct. See *Fog*.

**Viewfinder system** Sighting aid on a camera, allowing you to see what will be recorded on the film.

**Vignetting** Gradual fading of edges of an image to black or white, or into another image.

**Warm color** Colors from the red end of the spectrum that suggest a warm atmosphere.

**Wash** Final stage of processing, in which all chemicals are cleaned from the film.

**Weak** A low-contrast or low-density negative or print.

**Wetting agent** Chemical used to accelerate draining of film.

**Wide-angle** Extreme *short-focus* lens.

**Yellow** Color formed by red and green light only, *complementary* to blue.

**Zoom lens** Lens with a variable *focal length*.

# INDEX

Page numbers in italic refer to illustrations and captions.

# ACKNOWLEDGMENTS

*Designer:* Phil Kay
*Editor:* John Wade
*Typesetter:* Goodfellow & Egan, Cambridge
*Reproduction:* Colourscan, Singapore

**Dorling Kindersley**
*Managing editor:* Jemima Dunne
*Managing art editor:* Derek Coombes
*Senior editor:* Krystyna Mayer
*Editor:* Candida Ross-Macdonald
*Designer:* Rachel Griffin
*Production:* Helen Creeke

**Photographic credits**
p. 18 center: National Museum of Photography
p.152 top right and bottom right: Nigel Holmes

Reader's Digest Fund for the Blind is publisher of
the Large-Type Edition of *Reader's Digest.* For
subscription information about this magazine,
please contact Reader's Digest Fund for the Blind,
Inc., Dept. 250, Pleasantville, N.Y. 10570.